BURNE-JONES

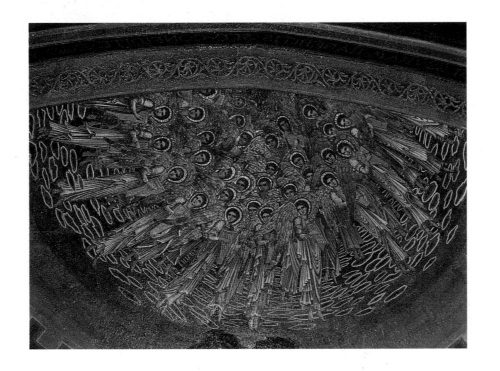

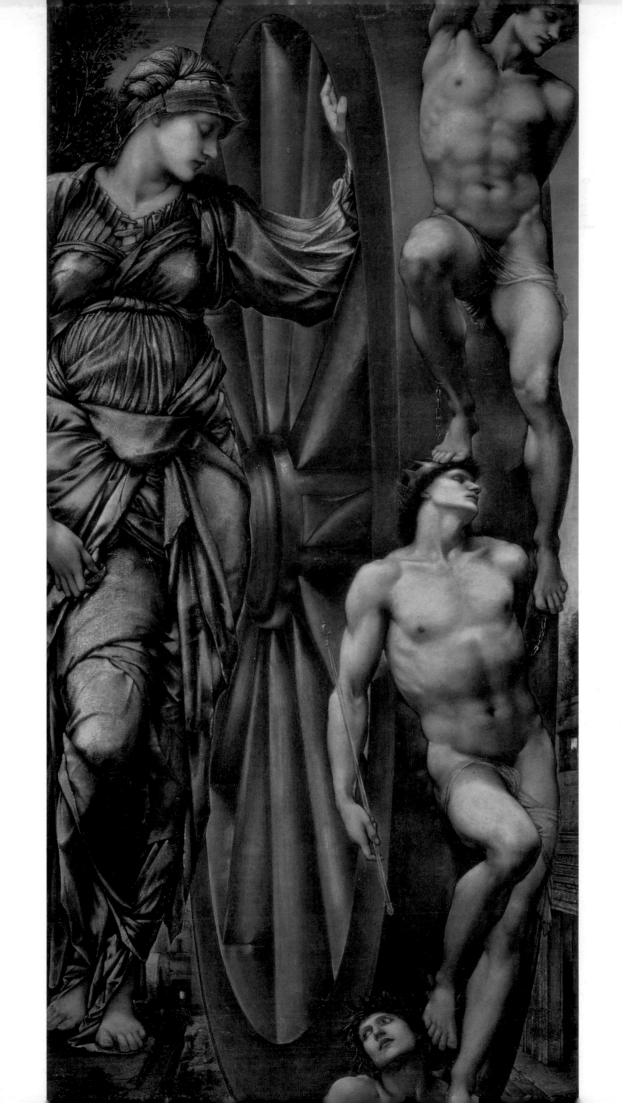

BURNE-JONES

THE LIFE AND WORKS OF
SIR EDWARD BURNE-JONES
(1833–1898)

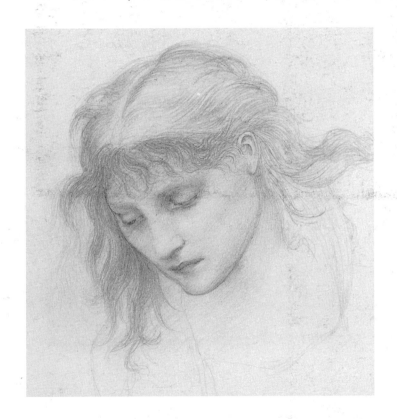

BY CHRISTOPHER WOOD

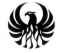

PHOENIX ILLUSTRATED

TO LINDA

ACKNOWLEDGEMENTS

There are many people who have helped me to write this book and assemble all the illustrations. At Sotheby's, Sarah Colegrave and Veronique Gunner both helped me to track down elusive photographs, and even more elusive owners. At Christie's, Martin Beisley, Jane Hollond and Peter Brown were equally helpful. Among the dealers, David Mason, Julian Hartnoll, Peter Nahum, Rupert Maas, Godfrey Pilkington, Gaye Norton of Agnew's, James Harvey of Mallett's and Ann Marie Stapleton of the Fine Art Society have all helped me both with advice and generous loans of photographs from their files. John Christian has, as always, been helpful with advice and encouragement, generously giving me the benefit of his encyclopaedic knowledge of Burne-Jones. Andrew Lloyd-Webber's great enthusiasm for the artist has always been an inspiration to me, and I am very grateful to be able to use photographs from his remarkable collection of Burne-Jones material. Museum staff all over the world have kindly answered my enquiries; they are too numerous to mention individually, but I would particularly like to thank Jane Farrington at Birmingham City Art Gallery and Jane Munro at the Fitzwilliam Museum, Cambridge. The Bridgeman Art Library have, as always, been helpful and efficient. Suzanne Bailey typed my manuscript, and coped brilliantly with the end-lessly complicated lists of illustrations – the hardest task of all. Finally, my thanks to Esmond and Susie Bulmer, for generously allowing me to finish this book at their house in Herefordshire's Golden Valley – a beautiful and inspiring location.

Christopher Wood
September 1997

First published in Great Britain in 1998 by Weidenfeld & Nicolson

This paperback edition first published in 1999 by Phoenix Illustrated
The Orion Publishing Group Ltd
5 Upper Saint Martin's Lane
London WC2H 9EA

A CIP catalogue record for this book is available from the British Library
ISBN 0 75380 727 0

Picture research: Suzanne Bailey and Caroline Stevenson
Designed by: Peter Butler
Set in: Bembo
Printed and bound in Italy

Page one: **Christ in Glory with Angels**, *1880s.. One of the main sections of the mosaics for the American Church in Rome. Although one of his greatest commissions, Burne-Jones never saw the results*

Page two: **The Wheel of Fortune**, *1883. One of Burne-Jones's most Michelangelesque compositions, of which he made at least six versions. This is the largest and finest of them, shown at the Grosvenor in 1883. The subject had its origin in the unfinished Troy triptych.*

Page three: *Study for* The Mirror of Venus.

Opposite: *'Phyllis' preliminary design for a bay window in Peterhouse*

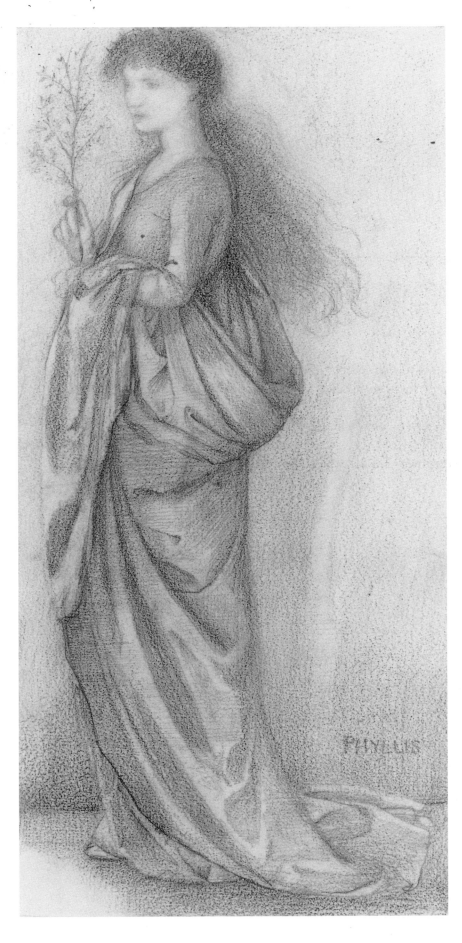

CONTENTS

INTRODUCTION

Burne-Jones was one of the greatest English artists of the nine-teenth century, and one of its most delightful personalities, which is why I have long wanted to write a book about him. In his lifetime, Burne-Jones was internationally famous; now he is famous once again and appropriately this book is to be published to celebrate the centenary of his death in 1898.

Burne-Jones's career spans almost the entire Victorian age. He was born in 1833, four years before the accession of Queen Victoria, and died in 1898, four years before her death. He was born in that most quintessentially Victorian city – Birmingham. Thus Burne-Jones was an absolutely typical mid-Victorian – intensely serious, very earnest, very high-minded; a moralist who lost his religious faith, but wanted to leave the world a better place than he had found it. Not that Burne-Jones lacked a sense of humour; indeed his humour was one of the most delightful aspects of his character. A friend described him as half monk, half Puck. Like many Victorian artists and writers, Burne-Jones's life was shaped by three forces – religion, literature and history. He was also a romantic, and is indelibly associated in the public mind with the romantic, escapist, other-worldly atmosphere of late Pre-Raphaelitism. In an age of romantics and dreamers, he was the greatest dreamer of them all. 'I mean by a picture a beautiful romantic dream', was his most famous and often-quoted definition, 'of something that never was, never will be – in light better than any light that ever shone – in a land no one can define, or remem-ber, only desire …'

More than most artists, Burne-Jones's career was sharply divided between his public life and the private dream world of his imagination, which was to him infinitely more important. This for him was the real world, the world in which he really lived. 'Of course imagining doesn't end with my work,' he wrote, 'I go on always in that strange land that is more true than real.' This dream world, shaped by literature, poetry and myth, was the inspiration for his artistic life, and has its origins in his childhood, which was lonely and introspective even by Victorian standards.

Burne-Jones's imagination was shaped, above all, by literature – Shakespeare, Homer, the great myths, and such Romantic poets as Byron, Scott, Keats and Coleridge. He was also devoted to the poetry of Tennyson, later a close friend. When Burne-Jones finally became a painter, the world of Romantic poetry was to colour his whole vision of art. His pictures were to be full of knights, 'alone and palely loitering', damsels in distress and *belles dames sans merci*. But if his art was inspired by literature, his character was formed by religion. As a teenager, he was passionately religious, and fell under the influence of John Henry Newman and the Oxford Movement. Burne-Jones went up to Oxford intending to enter the Church. Although he never became a clergyman, or even a regular church-goer, he continued to believe passionately in the Christian virtues. He thought that the best and highest form of life was a religious life.

When he became an artist, Burne-Jones transmuted his religious ideals into artistic ones. Beauty was his goddess, and he was her disciple. Beauty was synonymous with truth and goodness; it was the Holy Grail. 'Only this is true,' he wrote, 'that beauty is very beautiful, and softens and comforts, and inspires, and rouses, and lifts up and never fails.' There was a kind of missionary fervour about Burne-Jones that remained with him to the end of his life. He not only believed in the religion of beauty, but believed also that it could make the world a better place. For this reason, he could never accept the Aesthetic doctrine of art for art's sake, even though he was seen as a leader of the Aesthetic School.

Although Burne-Jones began life as a Pre-Raphaelite, and a pupil of Rossetti, it was Italian painting that was to have the greatest influence on the formation of his mature style. He first visited Italy in 1859, and returned there three more times, with Ruskin in 1862, and finally in 1871 and 1873. The effect of these trips on Burne-Jones's art was immense. The influence of Italian Renaissance painting was one of the key elements of his style. In this too, he was typical of his age. Rediscovery of the Italian Renaissance was one of the features of the Aesthetic Movement; it was the renaissance of the Renaissance.

The other key element in Burne-Jones's art was his involvement in design and decoration. In the 1850s he was involved in designing stained glass, and in 1861 was one of the founding partners of Morris & Co. From the start, Burne-Jones was the Firm's best and most prolific designer, and as a result there

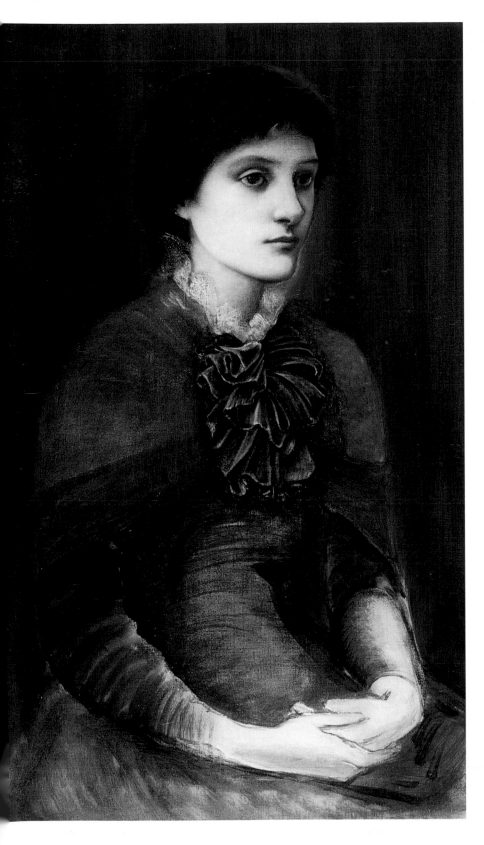

Margaret Burne-Jones, *1880s. Burne-Jones made many drawings and paintings of his beautiful daughter Margaret. She features in several of his pictures, notably as the Sleeping Beauty in the* Briar Rose *series. This portrait dates from not long before Margaret's marriage in 1887 to J.W. Mackail.*

was a constant interaction and exchange of ideas between his paintings and his design work. Nearly all his pictures have their origin in a design for some other medium, most often stained glass, but also tapestries, mosaic, books, furniture, pianos, embroidery, even clothes and shoes. None of the Aesthetic artists was more involved in design than Burne-Jones, and its importance to his art cannot be exaggerated. There is also an extraordinary consistency about Burne-Jones's life. Once he had decided to become an artist, which did not happen until his early twenties, the ideas and ideals which had formed in his youth continued to inspire him for the rest of his life. The Arthurian legends, above all, retained the deepest hold over his imagination. A year before he died, he wrote: 'Lord, how that San Graal story is ever in my mind and thoughts ... was ever anything in the world beautiful as that is beautiful?'

Burne-Jones's life is a reflection of the struggle which faced all Victorian artists – the struggle of how to be a romantic artist in a prosaic age; how to paint lofty, noble and romantic pictures in an age of steam, railway trains, factories, slums and top hats. However hard Burne-Jones tried to immerse himself in the world of King Arthur and the Quest for the Holy Grail, his pictures tell us far more about the Victorian age than they do about Camelot.

Both Burne-Jones and his lifelong friend and collaborator, William Morris, dedicated their lives to championing the cause of art, as an act of defiance against the advancing forces of materialism and scientific rationalism. In this they were entirely typical of their epoch. The Victorian age may have been an age of steam and railway trains but, in its art, its literature and its architecture, it looked nostalgically back to the past, and above all to the Middle Ages. Only the Victorian age could have produced St Pancras, a railway station that looks like a cathedral, and only a Victorian writer, John Ruskin, could have seen visions of angels hovering over Ludgate Hill. At the same time, the Victorians believed passionately in progress, in the betterment of mankind through scientific discovery. Here is the paradox that lies at the heart of the Victorian age, the age in which it was modern to be medieval. The same paradox lies at the heart of Burne-Jones's art also, so if we begin to understand Burne-Jones, we shall begin to understand the Victorian state of mind.

YOUTH
1833–1852

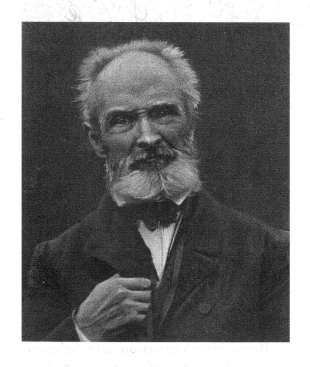

Childhood is often of little or no interest in an artist's life; with Burne-Jones his childhood is of crucial importance to his art. He was no child prodigy. He drew as a child, but did not decide to become an artist until he was at Oxford. The importance of his childhood is that it shaped his character and, more importantly, his imagination.

Burne-Jones was born plain Edward Jones on 28 August 1833, in Birmingham. He only adopted the hyphenated name Burne-Jones later. Four days after his birth his mother died. This was to prove the focal event of Burne-Jones's childhood. It alienated him from his father, who could not bear to touch him for four years afterwards and remained a widower for the rest of his life, condemning Burne-Jones to a lonely, isolated childhood, looked after by nurses and relations.

It is hardly surprising that Burne-Jones developed into an intensely introspective child, inventing a private inner world of his own. One of his nurses, a Miss Simpson, who subjected him to endless Bible reading, asked him, 'What are you thinking of?' 'Camels,' he replied, obstinately determined to protect his secret inner world. This introspective habit remained with him all his life. 'Mind elsewhere, sir?' his studio assistants would say.

Burne-Jones's father, Edward Richard Jones, was of Welsh origin and was a carver and gilder by profession. He was a shy, quiet and intensely pious man.

Left: *Burne-Jones's father*
Opposite: *King Edward's School, from a watercolour by David Cox. Barry and Pugin designed the building, their first partnership.*

Burne-Jones later described him in a letter to his friend Mrs Gaskell as

> a very poetical little fellow – and very tender-hearted and touching – quite unfit for the world into which he was pitched. We had very, very few books, but they were poets all of them ...

Burne-Jones remembers his father reading his own poems to him, until he later became shy of doing so. Edward Jones was also passionately fond of nature, and would walk miles to see a sunset or a cornfield. He was, his son wrote, 'altogether unworldly and pious'. Every year they would visit the mother's grave together where Burne-Jones watched his father weeping, a scene all too familiar in Victorian novels and pictures. Death was an ever-present reality to all Victorian families, high or low, rich or poor.

Lady Burne-Jones later recollected the total simplicity and bareness of the Joneses' house:

> I recollect how destitute the house was of any visible thing that could appeal to imagination; chairs, carpets, tables and table furniture each duller and more commonplace than the other.

All the more reason for the young Burne-Jones to retreat into his own world of the imagination, the world of books, and also of drawing. He later claimed that he was never unhappy, because he could always draw. Drawing was a therapeutic necessity for Burne-Jones, and remained so all his life.

At the age of eleven, the young Burne-Jones went to King Edward's School in Birmingham. Situated in New Street, not far from where he lived, the school was housed in a new gothic building, designed by Barry and Pugin, who were later to design the Houses of Parliament. At first Burne-Jones entered the Commercial class,

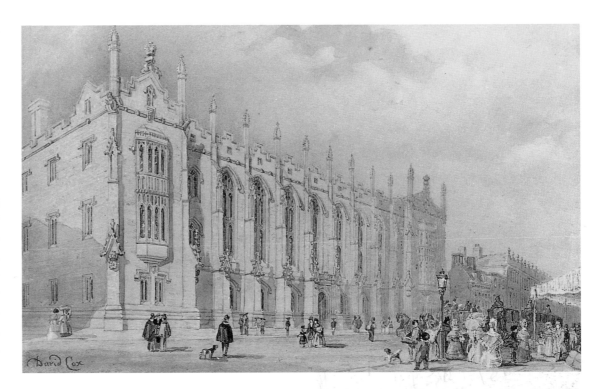

although later, at the age of fifteen, he transferred to the Classical. In spite of one or two bullying incidents, Burne-Jones was happy at school. His humour and his gift of mimicry made him popular with the other boys; he was also good at drawing caricatures of the masters. At King Edward's he made several close friends, some of whom were to follow him to Oxford. Chief among these was Cormell Price, known as Crom, with whom he used to read books in the Old Birmingham Cemetery.

By the age of fifteen, Burne-Jones was clearly a highly intelligent and thoughtful boy, remarkably well-read, and fascinated by ancient history and the great cultures of the past. He was also delicate, and often unwell. The smoky air of Birmingham, and the insanitary slums, were not considered good for children, so Burne-Jones was sent to the country to stay with relatives. Staying with family in Hereford, he met the Rev. John Goss, who introduced him to the ideas of the Oxford Movement, and in particular to the writings of John Henry Newman. These made an immediate and deep impression on the teenage Burne-Jones, who wrote later that Newman had taught him:

> so much that I do mind – things that will never be out of me. In an age of sofas and cushions he taught me to be indifferent to comfort, and in an age of materialism he taught me to venture all on the unseen.

Although religious, Burne-Jones never became a conventional Christian or churchgoer. He was fond of quoting the Samoan chief who, when asked if there was a God, replied:

> We know that at night someone goes by among the trees, but we never speak of it.

Burne-Jones's attraction to the religious life was further reinforced on a visit to another relative in Leicestershire, who took him to visit Mount St Bernard, a recently built Cistercian monastery, designed by Pugin. The monks in their enclosed world of meditation and prayer made a deep impression on him. As late as 1894, he was still writing, 'more and more my heart is pining for that monastery in Charnwood Forest'. While still a schoolboy, Burne-Jones was writing elaborate letters in quasi-medieval language, and signing himself

'Edouard de Byrmyngham'. Visits to Wales, the land of his ancestors, inspired him with a love of Celtic legends, and he found the Welsh coast especially inspiring:

> I got all my strongest impressions of the beauty of ships and the sea from the Welsh coast.

From Hereford he wrote letters headed 'Land of Caradoc'. In 1850, aged seventeen, Burne-Jones visited the British Museum, mainly to see the Nimroud Assyrian sculptures. A letter to his father demonstrates just how wide his cultural curiosity already was:

> I was quite surprised at the clearness and beauty of the sculpture. The bas-reliefs seem to be as perfect as when they emerged from the workman's shop, tho' not quite so clean. They seem to have a very good idea of anatomy, in which they far outstrip the Egyptians; the feet and hands seem to have been their chief study and the muscles of the arms are finely portrayed.
>
> The Ethnographical gallery gratified me, the Central Saloon pleased me. The Zoological gallery gratified me, the Mammalia Saloon delighted me, the Lycian, Nimroud, Phigalian, Elgin, Egyptian, Etruscan and above all the Fossil rooms put me into exstacies. I spent a considerable time in the Egyptian rooms, which in point of antiquity excel even the Assyrian.

A remarkable letter to have been written by a seventeen year old. It displays a cultural eclecticism worthy of Walter Pater, and already anticipates the raptures of the high Victorian aesthete. Once Burne-Jones had taken up a subject, his desires to know everything about it quickly became obsessive. Everything for him was a serious matter. Even at sixteen he was writing long letters about religious history, and the tenets of Calvinism. Already when young he had great powers of concentration, and that infinite capacity for taking pains so essential

in an artist. He remained devoted to the British Museum all his life.

Another schoolfriend was George MacDonald, and it was when visiting the MacDonalds' home in Handsworth that he first met George's sister Georgiana, his future wife. From her we have the first recorded description of Burne-Jones's appearance.

> Rather tall and very thin, extremely pale he was, with the paleness that belongs to fair people, and he looked delicate but not ill. His hair was perfectly straight, and of a colourless kind. His eyes were light grey ... The shape of his head was domed, and noticeable for its even balance ... from the eyes themselves power simply radiated, and as he talked and listened ... not only his eyes but his whole face seemed lit up from within. I learned afterwards that he had an immovable conviction that he was hopelessly plain. His ordinary manner was shy, but not self-conscious, for it gave the impression that he noticed everything. At that time he sat as many men do who are not very strong, sunk down rather low in his chair with an appearance of the whole spine seeking for rest.

She also remarked on the beauty of his voice.

> At once his power of words stuck me and his vehemence. He was easily stirred, and then his speech was as swift and clear as possible, yet well ordered and going straight to the mark. He had a beautiful voice.

Later that year, 1852, Burne-Jones decided, together with his schoolfriends Cormell Price and Richard W. Dixon, to go to Oxford University and take Holy Orders. The Rev. John Goss recommended Exeter College, although King Edward's boys usually went to Pembroke. As Exeter College was also the choice of the young William Morris, the two young men were

thus destined to meet. At the entrance examination they actually sat next to each other, but without making each other's acquaintance. Burne-Jones narrowly missed a scholarship, but his father was happy to send him at his own expense. So in January 1853, the young Burne-Jones went up to Oxford. As is so often the case, it was university that was to shape the course of his life. It was at Oxford that he was to make the greatest friends, and also to take the momentous decision to abandon Holy Orders and become an artist.

Opposite: **Astrologia**, *1865. The model was Miss Augusta Jones, described by Georgiana in the* Memorials *as 'a noble-looking girl'. Exhibited at the Old Watercolour Society in 1865.*

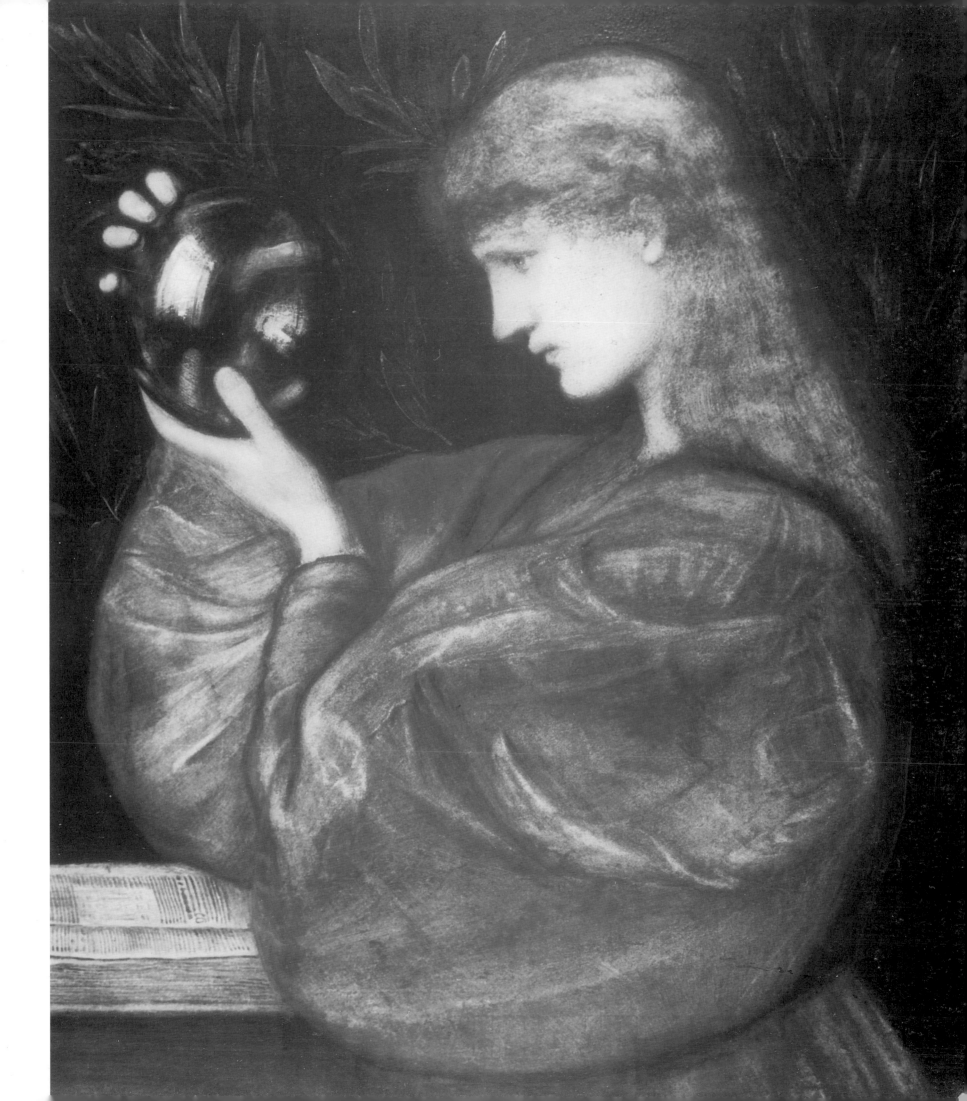

OXFORD
1853–1855

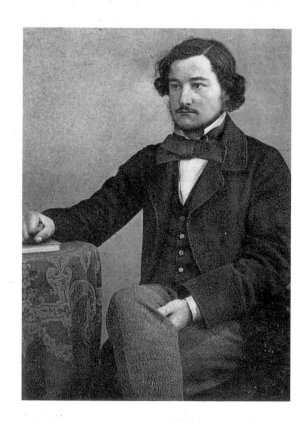

Burne-Jones was at once captivated by the beauty of Oxford, 'set amidst winding streets full of the sound of many bells'. Soon after arriving, he wrote: 'Oxford is a glorious place; godlike! at night I have walked round the colleges under a full moon, and thought it would be heaven to live and die here. The Dons are so terribly majestic, and the men are men, in spirit as well as name – they seem overflowing with generosity and good nature.' In the mid-nineteenth century, Oxford was still an unspoiled medieval town, and later Burne-Jones recollected:

> It was a different Oxford in those days from anything that a visitor would now dream of. On all sides, except where it touched the railway, the city ended abruptly, as if a wall had been about it, and you came suddenly upon the meadows … The chapel of Merton College had lately been renovated by Butterfield, and Pollen, a former fellow of Merton, had painted the roof of it. Many an afternoon we spent in that chapel. Indeed I think the building of Merton and the cloisters of New College were our chief shrines in Oxford.

It was not long before Burne-Jones and Morris met, and quickly became inseparable friends, often going for long walks around Oxford and the surrounding countryside. It was the beginning both of a lifelong friendship, and of artistic collaboration. They were an unlikely looking pair, Burne-Jones tall, thin and thoughtful; Morris short, stocky, ebullient and hugely energetic.

Left: *William Morris at Oxford*
Opposite: *Exeter College, Oxford*

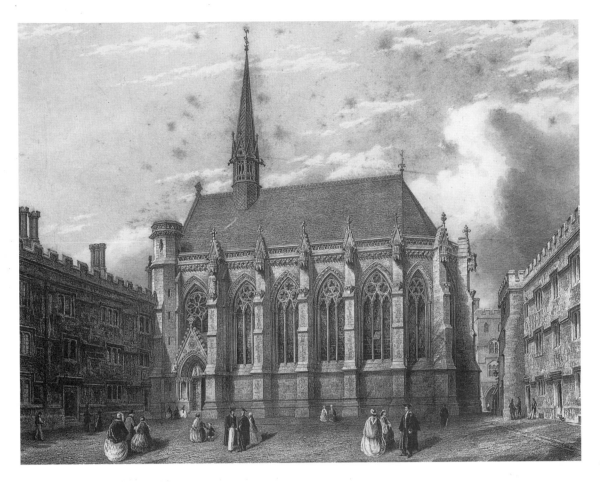

regular letters to his Birmingham friend Crom Price, who was to join them the following year, describing what books they were reading. He mentions Pope, Dryden, Moore, Keats, Shelley and above all Tennyson's 'Locksley Hall', which he discussed at length, describing Tennyson as 'the only poet worth following far into dreamland'. He especially liked Tennyson's poem 'Tears, idle tears ... I know not what they mean ...', which made him feel exquisitely miserable. Another favourite book among the group was Charlotte Yonge's *The Heir of Radclyffe*, an instant success when it was published in 1853. The authoress was a close friend of John Keble, and the book reflects the ideals of the Oxford Movement. Its hero, Sir Guy Morville, was the perfect role-model for Burne-Jones and his friends – aristocratic, high-minded, impetuous; he dies of a fever while chivalrously nursing his enemy, attended by a priest who administers the last rites. The book appealed both to older Tractarians and younger romantics. Another book frequently mentioned in *The Heir of Radclyffe* is Fouqué's *Sintram*, which also became a great favourite with the group. Sintram, like Sir Guy Morville, occupied a Gothic castle set amid craggy mountains, where he wrestled with his soul, usually with the aid of soothing ministrations from beautiful but chaste young maidens.

When playing a parlour game, Sir Guy declares, as a forfeit, that his favourite character in fiction is 'Sir Galahad – the knight of the Siege Perilous – who won the Saint Grael'. Sir Galahad had also become a favourite character for Morris and Burne-Jones, who had by this time discovered the Morte d'Arthur story among Tennyson's early poems. It was not until 1855 that they discovered Sir Thomas Malory's version, which was to have an even greater impact. Inspired by Tennyson's version, Burne-Jones and his friends decided to found an order devoted to Sir Galahad. In a prophetic letter to his friend Crom, Burne-Jones writes:

Burne-Jones became known as Ned, and William Morris as Topsy, after the curly-headed boy in *Uncle Tom's Cabin*. Morris came from a totally different background from Burne-Jones. His family were middle-class and, by comparison with the Joneses, wealthy. They lived near Walthamstow in north London, on the edge of Epping Forest. Morris was a normal, healthy, outdoor boy, who had spent much of his youth on a pony exploring the Essex countryside. He later claimed that he knew Epping Forest 'yard by yard, from Wanstead to the Theydons and from Hale End to the Fairlop Oak'. He also knew many of the old Essex churches and their monuments and brasses.

Morris was sent to Marlborough when he was thirteen, as his father, shortly before his death, had secured a place for him there. Although physically robust, the young Morris did not enjoy sport, preferring to wander the nearby downs, or in Savernake

Forest. In 1852 he left Marlborough to study privately for Oxford. Like Burne-Jones he was already passionately interested in religion, and intended to study for the Church. He was also of Welsh descent, and liked Romantic poetry and the novels of Walter Scott.

The budding friendship of Morris and Burne-Jones was strengthened by their mutual disappointment in the religious atmosphere of the university. They found the teaching languid and indifferent, the lectures uninspiring and most of their fellow-students only interested in sport and dissipation. Instead they formed their own group of like-minded souls, mostly Birmingham men at Pembroke College. 'We were almost always at Pembroke College,' he wrote later. The group included William Fulford, Richard Watson Dixon and Charles Faulkner, in whose rooms at Pembroke they met regularly for reading and religious discussion. Burne-Jones wrote

'Remember, I have set my heart on founding a Brotherhood. Learn Sir Galahad by heart. He is to be the patron of our order ...' and he signs himself 'General of the Order of Sir Galahad'. The purpose of the Brotherhood was to make a 'crusade and holy warfare against the age ... the heartless coldness of the times'. Their aim was to be a lay brotherhood, dedicated to working among the poor in the cities, alleviating poverty and spreading the Christian message. Inevitably, they saw themselves as latter-day knights in search of the Holy Grail. All this is typical of the highly charged moral atmosphere of the 1840s and 1850s. The same combination of profound

Left, above and opposite: **The Fairy Family**. *This was Burne-Jones's first commission, while he was still at Oxford. The illustrations were never used until a modern edition was published in 1985.*

concern for social issues and passionate belief in the Christian values can be found in the writings of Froude, Kingsley and Carlyle, all of whom would have been familiar to Burne-Jones and his Oxford friends.

The other contemporary writer both read and admired by the group was, of course, John Ruskin. They read avidly each of his books as they appeared, *Modern Painters*, *The Seven Lamps of Architecture* and *The Stones of Venice*. Ruskin's ideas about Gothic architecture, and his view of the role of the medieval craftsmen, had a deep influence on Morris, who was later to try and put them into practice. Ruskin's thesis was that Gothic architecture was morally superior, because it allowed room for individual initiative by the craftsman. Classical, Egyptian and earlier civilizations only produced repetitive and mechanical orna-

mentation, which degraded the craftsman. Burne-Jones was more impressed by Ruskin's insistence on accurate observation of nature in all its forms, and in minute detail. Following Ruskin's clarion call to Victorian artists to go to nature, 'selecting nothing, rejecting nothing', Burne-Jones began to draw in the woods and fields round Oxford. He wrote in a letter in 1853 that Ruskin 'is the most profound investigator of the objective that I know of …'. In another letter he described him as 'in prose what Tennyson is in poetry, and what the Pre-Raphaelites are in painting, full of devotion and love for the subject'.

Burne-Jones and Morris must have discovered the existence of the Pre-Raphaelite Brotherhood soon after their arrival at Oxford in 1852. Millais, Holman Hunt and Charles Alston Collins had worked in Oxford before this, and had both friends and patrons in the city. Ruskin's 'Edinburgh Lectures' of 1854 contained discussion of the Pre-Raphaelites, and were certainly read by Burne-Jones. In this year Burne-Jones first saw Millais' *Return of the Dove to the Ark*, in the collection of the Oxford publisher Thomas Combe. During the summer, he went to the Royal Academy in London, where he saw Holman Hunt's *Light of the World,* and its pendant, *The Awakening Conscience.* He wrote after the visit: 'I saw the Pre-Raphaelites had indeed come at a time when there was need for them, and resolved after my little ability to depend and claim a patient hearing from them.' During this summer, Morris visited Belgium and Northern France and returned full of enthusiasm for early Flemish painting and French cathedrals. Burne-Jones missed his Oxford friends during the summer vacation and wrote that he 'longed to be back with Morris and his glorious company of martyrs'. He wrote later that 'his heart burst into a blossom of love' for his Oxford friends.

It was also in 1854 that Burne-Jones made one of his many visits to the medieval

ruins at Godstowe, just outside Oxford, thought to be the burial place of Fair Rosamond, the mistress of King Henry II murdered by his jealous Queen Eleanor. Of this visit, Burne-Jones wrote:

The day has gone down magnificently; all by the river's side I came back in a delirium of joy the land was so enchanted with bright colours, blue and purple in the sky, shot over with a dust of golden shower, and in the water a mirror'd counterpart, ruffled

by a light west wind – and in my mind pictures of the old days, the abbey, and long procession of the faithful, banners of the cross, copes and croziers, gay knights and ladies by the river bank, hawking-parties and all the pageantry of the golden age – it made me feel so wild and mad that I had to throw stones into the water to break the dream. I never remember having such an unutterable ecstasy … as if my forehead would burst. I get frightened of indulging now in dreams, so vivid that they seem

CHAPTER THREE

ROSSETTI

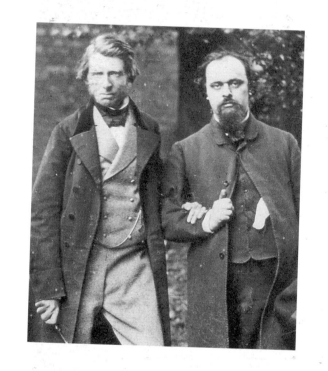

The next five years, from 1855 to 1860, were to be the crucial formative years of Burne-Jones's career. With his adored Rossetti as mentor and guide, he was to plunge headlong into the art world of London. Before long, he had met anyone who was anyone, above all the other Pre-Raphaelites, Millais, Holman Hunt and Ford Madox Brown. Rossetti also introduced him to his great hero, Ruskin, who predictably whisked him off to Denmark Hill and took him under his capacious wing. In these years Morris and Burne-Jones were to design and decorate their first pieces of furniture; both were to be involved in the escapade of the Oxford Union murals in 1857–8. Most importantly, Burne-Jones was to become involved in designing stained glass. He was also to woo and wed his beloved Georgiana MacDonald in 1860. The pattern of these years is the emergence of Burne-Jones's own artistic personality, in which not only Rossetti but also G. F. Watts were to play an important part. In 1859 Burne-Jones was to make his first trip to Italy, which would shape the whole future of his art. The meeting of Rossetti and Burne-Jones brought together two groups – the Pre-Raphaelites and the Birmingham/Oxford circle of Burne-Jones and Morris – and this shaped the future direction of the whole Pre-Raphaelite movement. The connection between Rossetti and Burne-Jones is therefore one of the most important master–pupil relationships in English art.

Left: *John Ruskin and D. G. Rossetti by W. D. Downey*
Opposite: **The Blessed Damozel,** *1860. One of the finest of Burne-Jones's early watercolours, commissioned by Thomas Plint of Leeds. Based on Rossetti's poem, it was meant to be a diptych, with another panel below, but this was never completed.*

The first, and greatest, influence on Burne-Jones's formative years was to be Rossetti. Painter and poet, founder of the Pre-Raphaelite Brotherhood, with his exotic name and Italian looks, it is not difficult to imagine the fascination which Rossetti held for his contemporaries. He cast an irresistible spell over the young Ned Jones. Although only five years older, Rossetti must have seemed to Burne-Jones a god-like figure, infinitely worldly-wise, an artist of genius and a fascinating talker and conversationalist. He revered him just as Palmer had revered Blake. In return, Rossetti gave Burne-Jones the encouragement he needed, to become an artist, and to believe in himself. 'He taught me', wrote Burne-Jones later, 'to have no fear or shame of my own ideas … to seek no popularity, to be altogether myself … not to be afraid of myself, but to do the thing I liked most.' It was Rossetti who turned Burne-Jones into an artist, gave him confidence in his own talent. Above all, he taught Burne-Jones to believe in his own imagination, to create his own ideal world, just as Keats and Tennyson had done in their poetry. Up to this point, Burne-Jones had not been sure of his vision. After Rossetti, he never doubted again.

Much has already been written about Rossetti's Bohemian life-style, his love affairs and his tragic end; all of it has now become part of the Pre-Raphaelite legend. Everything about it must have seemed a total contrast to the prim puritanism of Burne-Jones's background in Birmingham. Rossetti's life and character were full of paradox. He was born in London, but of Italian parents. He never visited Italy, yet his passionate and sensuous temperament was clearly much more Italian than English. His paintings and his poetry have an exotic and dreamy sensuality about them that is quite un-English, yet Rossetti and the other Pre-Raphaelites took a John Bullish pride in all things English. Rossetti could be moody, temperamental and unpredictable, but at the same time he had a down-to-earth streak of

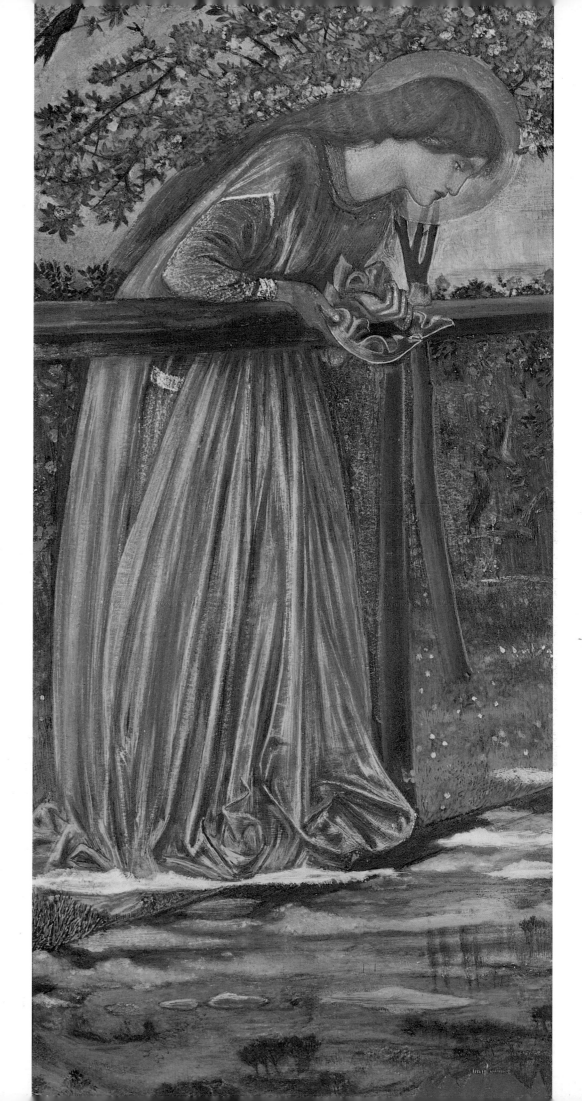

cockney humour, and was quite at home in the pubs, music-halls and fogs of Victorian London. He seemed to lack the moral inhibitions that plagued most mid-Victorians, yet he could also feel remorseful and guilty. 'Gabriel was half a woman,' Burne-Jones declared, which perfectly sums up the subtle complexities of his character. He was a bohemian prince of disorder, high-handed towards patrons, devious over money, but generous to his friends; arrogant, mischievous, constantly disorganized and constantly in love, altogether a most un-Victorian Victorian. And yet this colourful and unlikely figure completely dominated the Victorian art world in which he lived, a fact borne out by countless contemporary diaries and letters. His own letters are delightful, witty and entertaining, and one of the best sources about Pre-Raphaelite circles. He has continued to fascinate writers and historians ever since, and there are more books about Rossetti than any other Pre-Raphaelite.

Burne-Jones always thought that his first year in London was the happiest of his life. He was poor, often hungry and occasionally homeless, but never had London seemed to him more beautiful than when he watched the dawn rise over the Thames embankment. Every morning he would go to Rossetti's dusty studio in Chatham Place at Blackfriars by the river, and join him for his big meal of the day, usually bacon and eggs, and bread and jam. They then worked together all day, and in the evening Rossetti would introduce Burne-Jones to the delights of Victorian nightlife. First they would go to a public house, where Rossetti would read *Morte d'Arthur* aloud leaning on the bar. Then they might go to the theatre, or to the Judge and Jury, a kind of ale-house and music-hall combined. Or if they were too hard up, they would sit up in the studio, talking into the small hours. Over forty years later, Burne-Jones would still write rapturously of this year with Rossetti. 'There was a year', he wrote,

in which I think it never rained or clouded, but was blue summer from Christmas to Christmas, and London streets glittered, and it was always morning, and the air sweet and full of bells; and then I saw that I had never lived till then, or been born till then. How did I even speak to him? I don't know. What had I to say fit for his hearing? For I was with him every day, from morning till it was morning again and at three and twenty one needs no sleep. His talk and his look and his kindness, what words can say them? … I loved him and would have been chopped into pieces for him and I thought him the biggest; and I think so still!

Can ever a pupil have written more movingly of his master?

Rossetti believed in teaching by example, and had little faith in art schools or academic methods. Burne-Jones felt however that he needed to learn the basic skills, so he enrolled at art school, first Gandish's in Newman Street, then Cary's in Bloomsbury Place. He even went to night school as well. As a result, he made rapid progress, and his drawings quickly began to improve. His style, inevitably, owed much to Rossetti; these early drawings, with their medieval figures, enclosed spaces and dense black and white hatching, can look very like Rossetti's work of the same period. Burne-Jones was the first of his Oxford group to come to London. Morris stayed in Oxford working in the office of the architect, G. E. Street; here he met his friend and future partner, Philip Webb. In the late summer of 1855 Street moved his office to London, and with it Morris and Webb. This proved a boon to the young Burne-Jones, as he and Morris were able to share lodgings. They settled in Upper Gordon Street, Bloomsbury, convenient both for Street's office and the art schools that Burne-Jones was attending. Rossetti even persuaded Morris to take up painting as well, though this was not to last long. It was all part of Rossetti's belief that any creative person

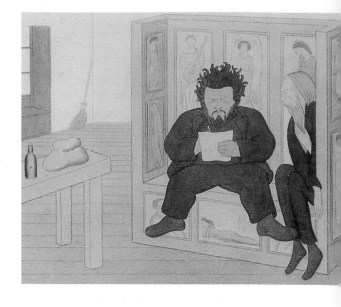

Above: *Max Beerbohm, 'Topsy and Ned Jones settled on the settle in Red Lion Square'. One of Beerbohm's book of caricatures of the Pre-Raphaelites,* Rossetti and his Circle, *published in 1922.*
Opposite: *'Going to the Battle', 1858. One of Burne-Jones's earliest drawings, closely related to, and inspired by, Rossetti's very similar watercolour,* Before the Battle. *The theme of three ladies seeing their knights off to battle is also described by Morris in* The Defence of Guinevere.

could take up painting. From his days at the Royal Academy schools, he had developed a hatred of academic formulae, which he regarded as artificial and deadening. He believed above all in sincerity and in one's own imagination, and this is the message he passed on to his disciples. It was the perfect philosophy for Burne-Jones, Morris and their high-minded Oxford friends, as it combined a sense of creative mission with rebellion against the artistic establishment.

At Rossetti's suggestion, Morris and Burne-Jones then moved to Red Lion Square in Bloomsbury, into the same rooms that Rossetti had shared with the painter W. H. Deverell in the early days of the Brotherhood, thus providing a pleasing sense of Pre-Raphaelite continuity. The rooms were unfurnished, and as Morris objected to shop-bought furniture he began to design his own. These were mas-

sively simple, medieval-inspired pieces, tables, chairs, wardrobes and settles, which Rossetti described as being like 'incubi and succubi'. The chairs he thought were 'such as Barbarossa might have sat in'. The cupboards and settles had large flat areas suitable for decoration, and they all set to work painting them. Rossetti painted scenes from Dante, and from Morris's own poetry, but very little of this early furniture has survived. A year later Burne-Jones began to decorate a wardrobe designed by Philip Webb with scenes from Chaucer's 'Prioress's Tale'(see p. 28). This survives in the Ashmolean Museum, Oxford. Although intensely medieval and Rossettian in character, it clearly shows Burne-Jones developing his own distinctive style and colouring. It is inscribed 'EBJ to WM' and was probably given to Morris as a wedding present in 1860. It was this joint effort at furniture-making that was to lead to the decoration of Morris's Red House, and the founding of Morris & Co. in the 1860s.

The bohemian life-style of Red Lion Square, combining intense seriousness with bouts of laughter and horseplay, has also entered Pre-Raphaelite legend, and was later immortalized in one of Max Beerbohm's cartoons. The most frequent visitor was Rossetti, who quickly introduced Morris and Burne-Jones to all the other members of the Pre-Raphaelite circle – Millais, Holman Hunt, Ford Madox Brown, William Bell Scott, Arthur Hughes and the watercolourist George Price Boyce. William Morris had bought Arthur Hughes's picture, *April Love*, after seeing it at the Royal Academy in 1856. After first meeting Holman Hunt, Burne-Jones wrote,

A glorious day it has been – a glorious day, one to be remembered by the side of the most notable ones of my life; for whilst I was painting and Topsy was making drawings in Rossetti's studio, there entered the greatest genius that is on earth alive, William Holman Hunt – such a grand looking

fellow such a splendour of a man ... and all evening through Rossetti talked most gloriously, such talk as I do not believe any man could talk beside him.

And while he talked, Rossetti would play-

fully pass his brush through Hunt's expansive beard. Another visitor to Red Lion Square was Ruskin who, greatly admiring some of Burne-Jones's drawings, declared, 'Jones, you are gigantic.' This occasioned much mirth among Burne-Jones's friends,

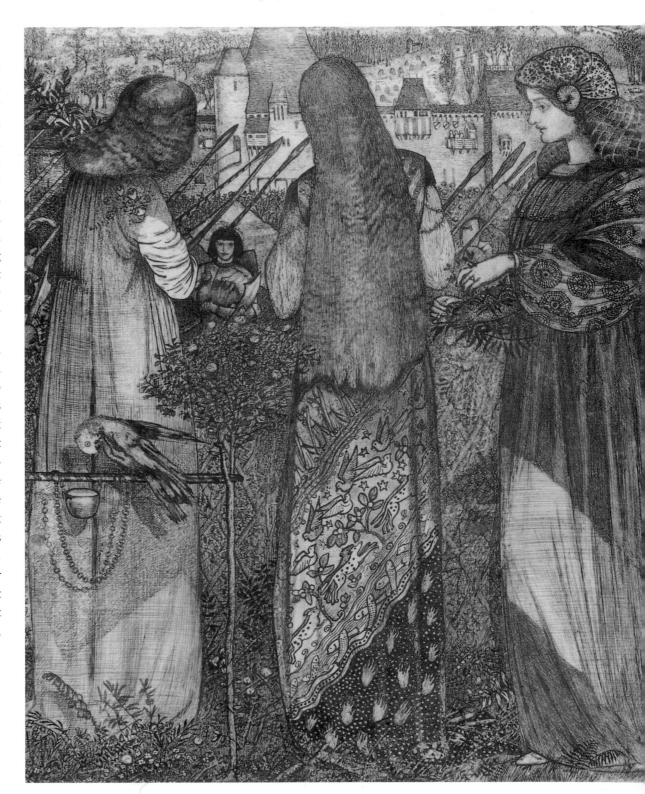

who thereafter referred to him as 'gigantic Jones'. Rossetti thought sufficiently highly of Burne-Jones's work to introduce him to two northern patrons, Thomas Plint of Leeds and James Leathart of Newcastle, both of whom commissioned work from him, as did Ruskin and G. P. Boyce.

In the mid 1850s Rossetti was concentrating on watercolours based on stories from Dante and the *Morte d'Arthur*. These works are usually small but intensely brilliant in colour and imbued with a romantic and medieval atmosphere. They are usually set in a flat, one-dimensional space, with little background or perspective. They reflect the influence of medieval manuscripts and of William Blake, of whom Rossetti was an early admirer and collector. Watercolours such as *Paolo and Francesca* (1855), and *The Wedding of St George* (1857) are typical, and another Pre-Raphaelite artist, James Smetham, described the latter as

one of the greatest things, like a golden dim dream, love credulous all gold; gold armour; a sense of secret enclosure in 'palace chambers far apart', but quaint chambers in quaint palaces, where angels creep in through sliding doors and stand behind rows of flowers, drumming on golden bells with wings crimson and green.

For Smetham, as for many people, these watercolours by Rossetti are the supreme expression of the Pre-Raphaelite movement. They also had an impact on the work of Burne-Jones, and his early drawings, such as 'The Knight's Farewell', 'Sir Galahad' and 'The King's Daughters', clearly show him trying to emulate his master's style. By 1860 Burne-Jones was producing his own watercolours which, in their different way, are already the equal of Rossetti's. 'Jones is doing designs,' declared Rossetti, 'which quite put one to shame, so full are they of

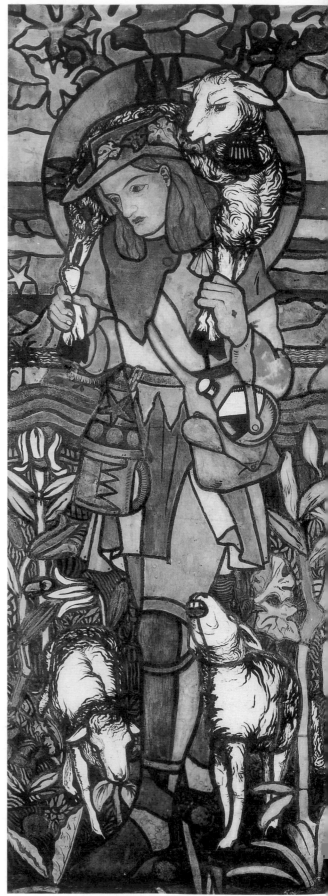

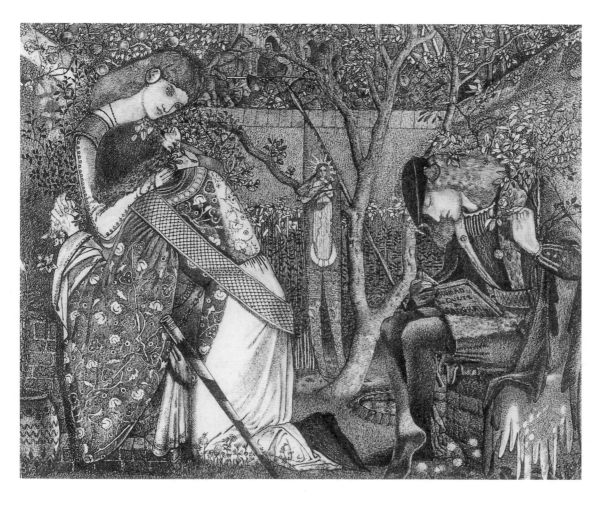

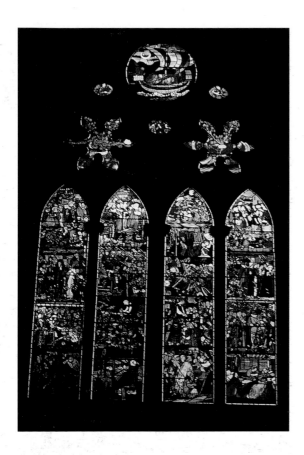

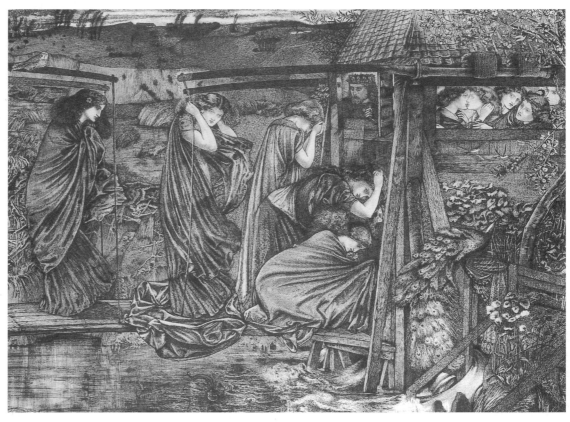

Above: *The St Frideswide windows, Christ Church, Oxford, 1859. One of the finest of Burne-Jones's early windows, commissioned by Christ Church College for the Cathedral of St Frideswide (an early English female martyr). It consists of a number of small scenes crowded into four main windows with lights above; the glass was by James Powell & Sons.*
Above right: *'The Wise and Foolish Virgins, 1859. One of the finest of Burne-Jones's early drawings', carried out at the same time as the St Frideswide windows. It shows an obvious debt to Rossetti's* Mary Magdalene at the Door of Simon the Pharisee *(1858).*
Opposite left: *'The Knight's Farewell', 1858. A fine early drawing showing the same intensely medieval spirit as Rossetti's watercolours of the same period. This is the type of drawing Ruskin criticized for excessive 'gothic quaintness'. It was probably executed after Burne-Jones's work on the Oxford murals.*
Opposite right: **The Good Shepherd**. *A cartoon, Burne-Jones's first design for stained glass, for James Powell of the Whitefriars Glass Company. Rossetti wrote to them that 'the colour of the whole is beyond description'.*

everything – Aurora Leighs of art.'

Burne-Jones, unlike Morris, had no private means, and therefore it was important to him to make a living by selling his work as soon as possible. To this end Rossetti introduced him to his architect friend, Benjamin Woodward, designer of the Oxford University Museum and the Oxford Union. Woodward was looking for artists to design stained glass for the firm of Powell's, known as the Whitefriars Glass Company. Charles Winston, who had worked for Powell's since the 1840s, advocated the medieval method of making stained glass. This was the so-called 'mosaic' method of building up a design using small pieces of brightly coloured glass surrounded by black leading. This ran counter to the nineteenth-century practice of painting figures on increasingly large pieces of clear glass. Winston passionately believed in the superiority of the medieval method, in which the designer effectively paints using the glass panels themselves to build up his composition. Burne-Jones soon became

involved in this, and it was to become one of his main preoccupations for the rest of his career. Not only that, Burne-Jones's designs for stained glass provide the genesis for a great many of his paintings. The importance of stained glass in Burne-Jones's work simply cannot be exaggerated, and so great was his output that a separate book would be needed to encompass it.

Burne-Jones's first design was entitled *The Good Shepherd*. Rossetti wrote enthusiastically of it to Powell's: 'Jones has just been designing some stained glass which has driven Ruskin wild with joy: the subject is the Good Shepherd … the colour of the whole is beyond description.' Before long Burne-Jones had become deeply involved in designing stained glass. For this he made both drawings and cartoons, and also a finished oil or gouache version. Many of these have survived, and are much admired and collected, as they are often highly finished objects in their own right. They also formed the genesis of many of Burne-Jones's paintings, and are therefore art-

historically important. Burne-Jones's imagination was undoubtedly stimulated by his design work, which he would later develop in another medium. For this reason, many of his pictures are of a tall, elongated shape, following the shape of church windows.

By 1859, Burne-Jones had designed the magnificent St Frideswide windows in Christ Church Cathedral, Oxford, the finest of his early works. This is a set of five windows, divided into sixteen compartments showing scenes from the life of St Frideswide. From a distance it gives an overall impression of deep, brilliant colours; as one draws closer each scene and figure fits into place, forming a very dense mass of narrative detail. Burne-Jones made the cartoons into a screen, which he kept in his studio until 1865, when he sold it to Birket Foster. William Burges, the architect, writing of the Oxford windows in the *Gentlemen's Magazine* of July 1862, declared that

> Mr Jones is a colourist, and consequently declines to trust the choice of tones of his colours to the glass painter, he therefore makes a finished colour painting in oil, and the result is that the best modern stained glass windows are due to his design.

Before long Burne-Jones was working for some of the leading architects of the day, including William Burges and William Butterfield. In 1859–60, Burges was restoring Waltham Abbey, and Burne-Jones designed the window for the east end, representing the Tree of Jesse, with a rose window above of Christ in Majesty surrounded by seven circular windows representing the Days of Creation. He designed a window for Butterfield in the parish church of Topcliffe, Yorkshire. Although it is one of Burne-Jones's finest windows, it led to a quarrel over the figure of the Virgin clasping the Dove to her bosom, which Butterfield thought sacrilegious. Burne-Jones refused to change it, and wrote later,

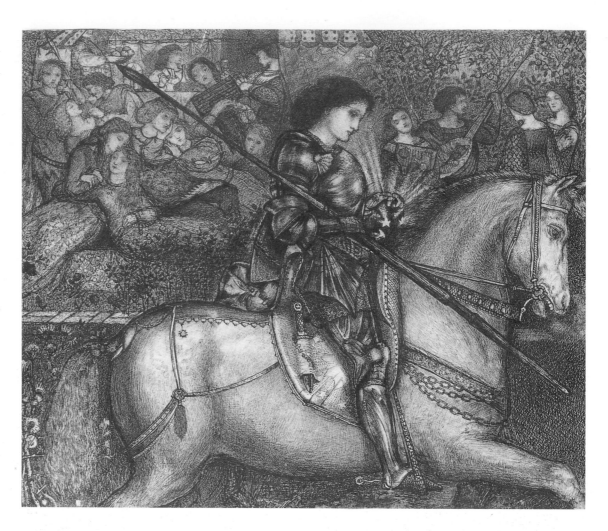

Once, in the ardour of youth, I tried an innovation. It was a mistake. I drew an Annunciation with Mary taking a Dove to her bosom; and when the architect who had commissioned me (he was a very good architect – Butterfield it was) objected, I wouldn't alter it. So he would never give me anything more to do, and he was quite right – and I lost a chance of a lot of work.

He might also have lost another commission when a bishop called at Red Lion Square, and Rossetti roared at the maid, known as Red Lion Mary, 'Send the bloody bishop up!'

It was Rossetti's influence and contacts which led to the celebrated episode of the Oxford Union murals. In 1857 Rossetti and Morris visited Benjamin Woodward in Oxford, who showed them the new Oxford Union building, on which he was working.

Above: *'Sir Galahad', 1858. This drawing was made at Little Holland House in 1858, when Burne-Jones was recuperating there. Sir Galahad was Morris's and Burne-Jones's hero in the* Morte d'Arthur; *at Oxford they had planned to found an order devoted to him.*
Opposite: *'Study for* Buondelmonte's Wedding'. *Burne-Jones made many studies of Buondelmonte's wedding, the event which led to the wars between the Guelphs and the Ghibellines in medieval Italy.*

Built in a mixture of Flemish and Venetian gothic, the Union contained a large debating hall, which Rossetti suggested might be decorated with murals. Woodward readily agreed, and £500 was fixed as a fee, to cover expenses. The artists were therefore to do the work for nothing. Rossetti and Morris returned to London to muster their friends. This new Brotherhood turned out to consist of seven, like the first one –

Rossetti, Morris, Burne-Jones, Arthur Hughes, Val Prinsep, J. R. Spencer Stanhope and J. Hungerford Pollen. Prinsep and Stanhope were young painters; Pollen was an architect who had recently decorated the ceiling of Merton College Chapel, much admired by Morris and his friends. Madox Brown, Holman Hunt and William Bell Scott were also invited, but declined.

Thus began what was referred to later as the 'jovial campaign' in which the Pre-Raphaelites combined high seriousness with high jinks and horseplay. It was to be the last and the happiest group effort by the Pre-Raphaelites. 'What fun we had! What jokes! What roars of laughter!' recalled the painter Val Prinsep later. Rossetti was

the planet around which we revolved – we copied his very way of speaking. All beautiful women were "stunners" with us. Wombats were the most beautiful of God's creatures. Medievalism was our *beau idèal*, and we sank our individuality in the strong personality of our adored Gabriel.

It was decided to decorate the walls with ten scenes from the *Morte d'Arthur*. The spaces were in the upper part of the room, above a narrow gallery, and were punctuated by windows, around which the artists had to work. Burne-Jones's mural was *Merlin Imprisoned Beneath a Stone by the Damsel of the Lake*, and he found himself working alongside Spencer Stanhope, who

was to become a close friend, and disciple, though a few years older than Burne-Jones. A man was employed to mix the colours; the artists carried out the rest of the work themselves, mostly up ladders. For models they used each other. Burne-Jones modelled as Sir Launcelot for Rossetti, who also persuaded the young poet Swinburne, then at Balliol, to sit for him. Morris, typically, finished his mural first, and started to decorate the roof with patterns. A great deal of soda water and paint was thrown around, much of it over each other, and endless practical jokes were played on the hot-tempered Morris. More fun was had in the evenings when they met at their lodgings, for conversation and readings. 'Top, read us

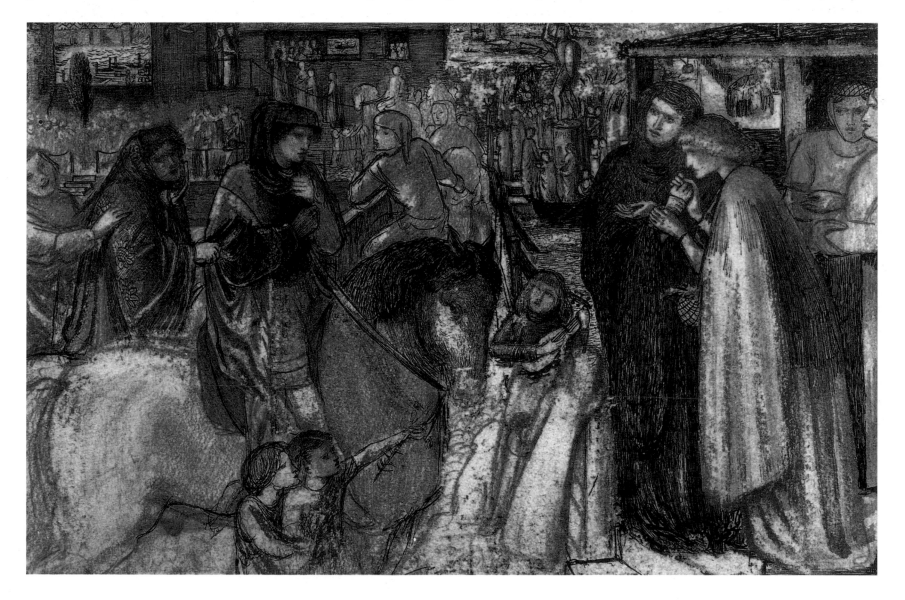

one of your grinds,' Rossetti would demand, from his usual position prone on the sofa. From their letters and drawings, even now after 100 years, one gets an incredibly strong feeling of the delight the Pre-Raphaelites took in each other's company.

The Oxford murals were to have one other important consequence – Jane Burden. Visiting the theatre one evening, and looking out for suitable models, Burne-Jones and Morris noticed a striking, dark-haired girl sitting behind them. Tall and graceful, with gypsy looks and masses of wavy hair, they declared her a stunner, and asked if she would consent to sit for them. She agreed, and the rest is Pre-Raphaelite history. She was to be the greatest of the Pre-Raphaelite models, an inspiration to the whole group, the ultimate Pre-Raphaelite love goddess, in turn Guinevere, Isolde, Beatrice, the Blessed Damozel, *La Belle Dame Sans Merci*. She also became Jane Morris in 1859.

The summer of 1857 dragged on, with no sign of the murals being finished. Rossetti returned to London after hearing reports of his fiancée Elizabeth Siddal's ill-health. Arthur Hughes finished his mural, and hurried back to London to the more profitable activity of painting pictures. Burne-Jones and Spencer Stanhope stayed on, to try to finish their sections. The windows had been whitewashed over and painted with wombats, because the glare from the light made it hard to see the murals properly. In 1859, the Union committee asked a William Riviere to complete the three remaining bays, alienating

Right: **Clara von Bork** *and* Opposite: **Sidonia von Bork**, *1860. Sidonia was a beautiful and high-born sorceress, whose fatal beauty causes men to fall in love with her. The story was taken from Wilhelm Meinhold's* Sidonia the Sorceress, *a favourite book of both Rossetti and Morris. Clara von Bork was Sidonia's virtuous sister-in-law, who is brought to a gruesome death.*

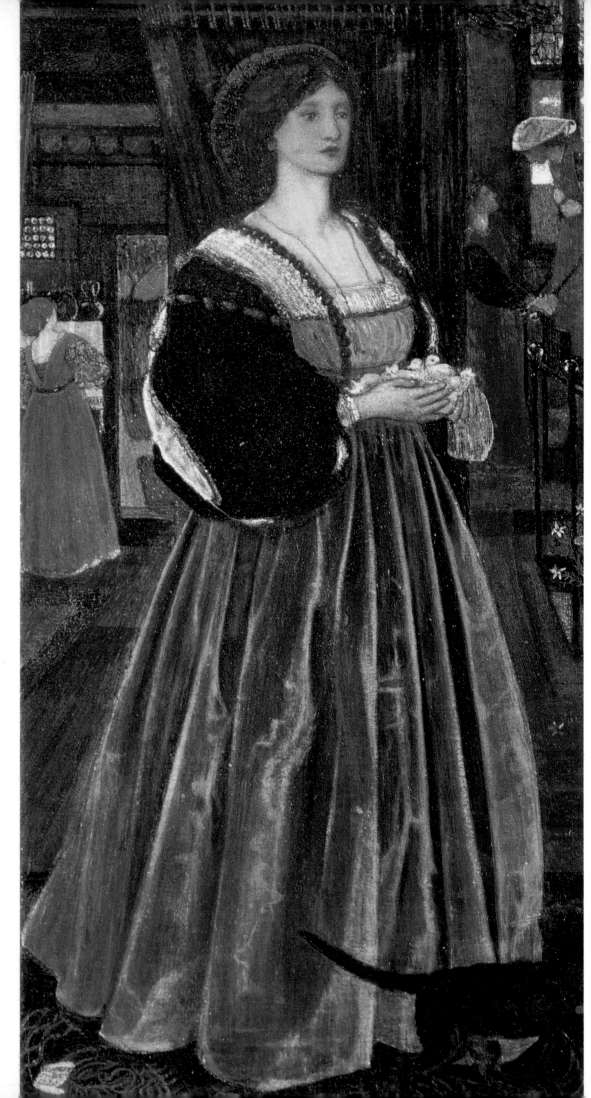

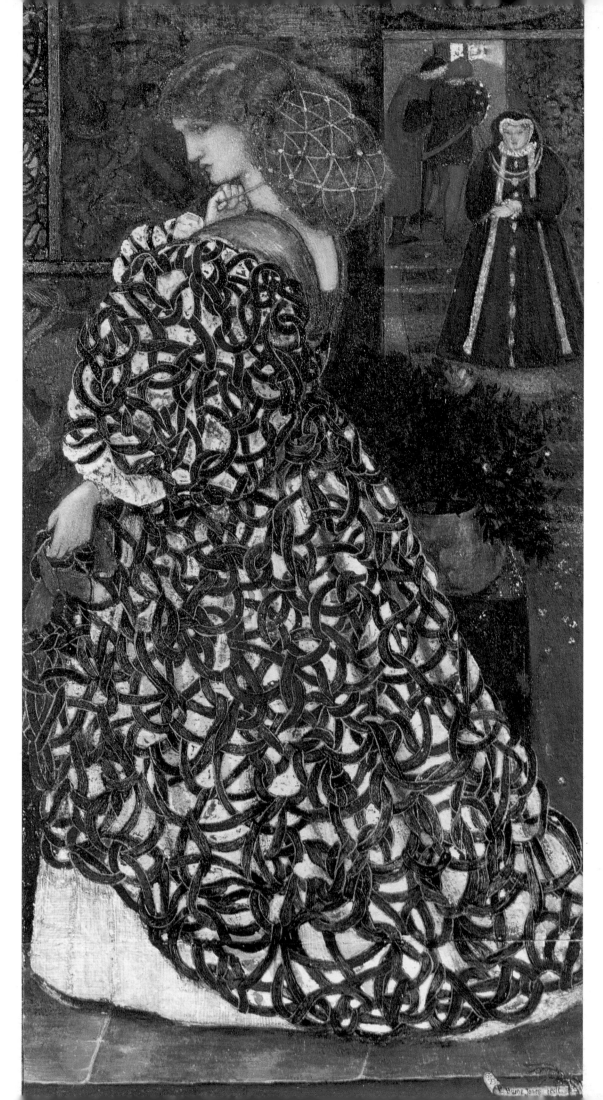

Rossetti, who refused to have anything further to do with the project. Within a few years, the murals began to fade and, in spite of restoration in the 1930s, they are now only a pale shadow of their former glory. The Oxford murals therefore form part of that unhappy history of English murals in the nineteenth century, from the Houses of Parliament onwards. Only later in the century, with the development of Gambier Parry's 'spirit fresco' technique, did it become possible to paint a durable fresco in England. However, Rossetti, Burne-Jones and several of the other artists developed themes from the Oxford Union into watercolours and pictures, so the project cannot be written off as a total failure.

Another indirect result of the Oxford project was the founding of the Hogarth Club in 1858. This was a combined club for artists and exhibition space. Rossetti and his friends had been discussing the idea for some time, but the responsibility for organizing it fell mainly on Burne-Jones and Spencer Stanhope. It was intended as a focal point and meeting-place for younger artists, particularly those outside the Royal Academy establishment. The membership largely consisted of artists in Rossetti's orbit – all the Pre-Raphaelites, including G. P. Boyce, John Brett, J. W. Inchbold, R. B. Martineau, W. L. Windus and Henry Wallis. Other painters who joined included Frederic Leighton, G. F. Watts and John Ruskin. The architects G. F. Bodley, G. E. Street and Benjamin Woodward also joined. The honorary members included Thomas Carlyle, David Cox, Francis Danby, William Henry Hunt, J. F. Lewis, William Mulready and the French painter Delacroix, whom Rossetti regarded as 'the greatest painter of modern times'. Burne-Jones exhibited his drawings and stained-glass designs at the Hogarth exhibitions, while the club lasted, from 1859 to 1861.

Also in 1858, Burne-Jones fell seriously ill. The strain of living and working with Rossetti was beginning to tell. He went to

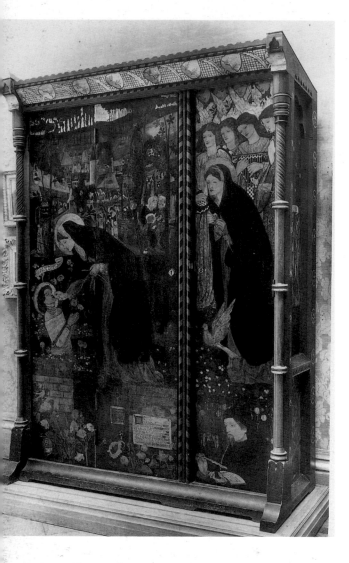

Above: *The Prioress's Tale Cabinet. Designed by Philip Webb, this cabinet was decorated by Burne-Jones, and was his first serious effort at oil painting. It was given by Burne-Jones to William and Jane Morris as a wedding present in 1860.*

Opposite: **The Annunciation** (*The Flower of God*) *1862. This gouache of 1862, like many of the early watercolours, is inspired by illuminated manuscripts of the fifteenth century which Burne-Jones had studied in the British Museum.*

recuperate at Little Holland House, a celebrated meeting-place of the Victorian worlds of art and literature, presided over by the hospitable and motherly Mrs Prinsep, sister of the photographer Julia Margaret Cameron. Burne-Jones later acknowledged that Mrs Prinsep was 'the nearest thing to a mother I ever knew'. Mrs

Prinsep's garden parties were legendary and at these Burne-Jones was introduced to a wider circle, including Tennyson, Thackeray, Dickens and Browning. He also came more under the influence of George Frederick Watts, who went to stay at Little Holland House for three days and stayed thirty years. Rossetti had already taken Burne-Jones to the house, explaining, 'You must know these people, Ned; they are remarkable people; you will see a painter there, he paints a queer sort of picture about God and Creation.' Watts was to remain a father-figure for Burne-Jones, and it was he who encouraged him to study the Elgin Marbles, and Italian painting, to expand and develop his style. 'Watts compelled me to try and draw better,' Burne-Jones wrote later. By this time, Ruskin too was worried by the excessive influence of Rossetti over Burne-Jones. He complained of the 'stiffness and quaintness and intensity' of Rossetti's followers, and thought that they needed more 'classical grace and tranquillity'. From Burne-Jones's stay at Little Holland House dates his gradual move towards a more classical style. Rossetti and Morris were sorry to see their friend move out of their orbit, but they both realized it was for the best. Thanks to Watts, Burne-Jones made his first visit to Italy in 1859, travelling with Charles Faulkner and the Prinseps' son, Val. They concentrated on Northern Italy, visiting Genoa, Pisa, Florence and Venice. Burne-Jones made notes and drawings constantly, and his sketchbook from this trip contains studies of figures from Botticelli, Ghirlandaio, Mantegna, Benozzo Gozzoli, Carpaccio, Signorelli and Orcagna. Like many Englishmen before or since, he fell in love with Venice.

By 1860, Burne-Jones was beginning to produce watercolours which show not only technical mastery, but his own style beginning to develop. *The Blessed Damozel*, the watercolour commissioned by Plint in 1857, demonstrates how Burne-Jones was

already evolving his own version of the Rossettian idiom (see p. 19). There is less of the medieval quaintness here, of which Ruskin complained, but more refinement and elegance in the figure although the theme and inspiration are still totally medieval. Much the same can be said of the watercolour of *The Flower of God*, which dates from 1862. Both show Burne-Jones's preference for gouache over oil painting. Using watercolour and oil mixed together, he was able to achieve the richness of colour and the texture he wanted, without recourse to oil. *Sidonia von Bork* and its pendant *Clara von Bork* are even more remarkable evidence of Burne-Jones's developing powers. The subjects were taken from Wilhelm Meinhold's *Sidonia the Sorceress*, published in 1847. It tells of a high-born but cruel sorceress, whose fatal beauty causes men to fall in love with her. The book was greatly admired by Rossetti, and Morris reprinted it at the Kelmscott Press in 1893. In Burne-Jones's version, Sidonia is shown plotting her next crime at the court of the Dowager Duchess of Wolgast, who is seen to the right. The design of the dress was taken from Giulio Romano's *Portrait of Isabella d'Este* at Hampton Court, also a picture with a distinctly sinister and menacing mood.

Before Burne-Jones left for his first Italian trip, William and Jane Morris had married. By the time he returned, they were already planning their new house in Kent, Red House, designed by Philip Webb. It was the decorating and furnishing of this house which led to the foundation of the Firm, or, as it was first known, Morris, Marshall, Faulkner & Co., later Morris & Co. In 1860 Burne-Jones at last married his childhood sweetheart, Georgiana MacDonald. Rossetti, too, had finally married the ailing Elizabeth Siddal. So the Red Lion Square days were over. All three artists were to remain close friends and collaborators, but the Pre-Raphaelite story now entered a new phase.

MORRIS & CO.
THE 1860s

The 1860s is now widely regarded as a watershed decade in Victorian art. This was the crucial period when the first phase of the Pre-Raphaelite movement came to an end, and the Aesthetic Movement began. It was a move away from the moralistic, Ruskinian ethos of the 1850s, towards a new, broader, aesthetic philosophy. Its most notorious propagandist was to be the American artist Whistler, who moved from Paris to London in 1859, bringing with him the new, revolutionary dictum of the French writer Théophile Gautier, 'l'art pour l'art'. This came to be translated as 'Art for Art's Sake'. In simple terms, it meant that a painting, or any work of art, had as its primary purpose beauty, rather than any moralistic or narrative intent. A work of art had to be an object of beauty, and that was its sole *raison d'être*. This doctrine might seem fairly innocuous now, but it was certainly revolutionary in the 1860s. Among English writers, its advocates included Swinburne, Walter Pater and Matthew Arnold. The Aesthetic Movement was by its very nature diverse and eclectic, and embraces a wide spectrum of Victorian art, from the later Pre-Raphaelite, Symbolist and Classical Movements, and the Arts and Crafts Movement in both architecture and the decorative arts. One of its main tenets was that artists should be involved as much as possible in architecture and design, and this was one of the stated aims of Morris & Co.

Left: 'Maria Zambaco', 1871. One of the most beautiful of all Burne-Jones's drawings of Maria Zambaco, made when their affair was still at its height.

Right: **The Madness of Sir Tristram**, *1862. This is a watercolour worked up over a cartoon for one of the set of stained-glass windows commissioned by Walter Dunlop of Bradford. It depicts Sir Tristram (in the* Morte d'Arthur), *driven mad by false reports of Iseult's love for Sir Kay Hedius, living like a wild man in the forest, fed by herdsmen and shepherds.*

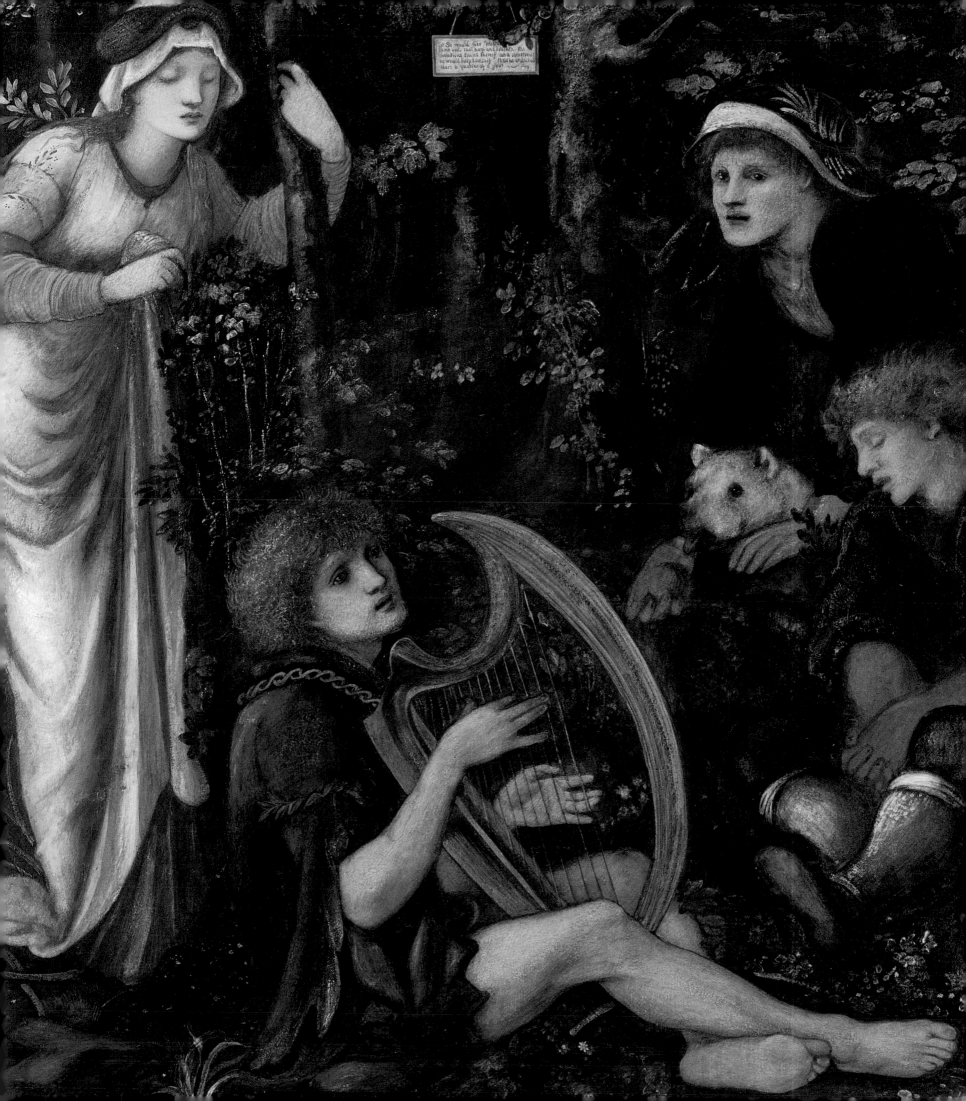

It impinged on many other aspects of Victorian life and culture – theatre, music, fashion, social life, even religion. Rossetti, Burne-Jones and Morris can all be regarded as founders of the Aesthetic Movement; later they would be seen as its leaders, so for all of them the 1860s was a vital decade.

For Burne-Jones, in his late twenties, newly married and with a career to make, it was also to be a crucial phase in which he forged his own style and began to build up his own network of patrons.

In the summer of 1860 William and Jane Morris moved into the Red House, near Bexley in Kent, designed for them by their friend Philip Webb. Although gothic and medieval in shape, with steep roofs and towers, it was built of brick, and was highly restrained in the detail, like all Webb's work. It was set in an orchard, which Morris retained and incorporated into the garden. Here he laid out beds of typical English flowers, enclosed by rose trellises, in an attempt to emulate the medieval gardens he had seen in illuminated manuscripts. To

complete the illusion, Jane Morris walked in the garden wearing long, medieval dresses designed for her by William, to pose as Guinevere or La Belle Iseult. These dresses were also used by Burne-Jones for his pictures of *Clerk Sanders*, *King Rene* and *Tristram*, of the early 1860s. For these young and idealistic artists, medievalism was more than just dressing up, it was a way of life, a way of bringing beauty and integrity into the mundane and materialistic mid-Victorian world.

As with Red Lion Square, Morris was determined to furnish the Red House entirely himself. It was to be a veritable 'Palace of Art', a phrase taken from a poem by Tennyson. This also became something of a group effort. Morris designed hangings, which were then embroidered by his wife Jane. Burne-Jones designed hangings, stained glass and murals. Philip Webb designed furniture, fire-dogs, candlesticks and glass. Rossetti and others came to stay, and usually became involved in designing or decorating something. Morris had

inscribed the motto 'If I can' on one wall; Rossetti replaced this with his own motto, 'As I can't'. Burne-Jones planned to execute two large sets of murals in the house; the Fall of Troy on the stairs, and in the drawing-room a set of seven murals on the theme of the marriage of Sir Degravaunt. In the hall he was to paint a ship with rows of shields over the side. None of these schemes was ever completed, except for three of the Sir Degravaunt series, *The Marriage*, *The Musicians* and *The Wedding Feast*. As always with Burne-Jones, the ideas and drawings remained, to be re-used later.

Weekends at the Red House were the usual mixture of high art and high jinks. There were bear fights and scrimmages, during one of which Charles Faulkner leapt clear out of the Minstrels' Gallery, landing with a crash on the floor. Morris was, as usual, teased unmercifully, and received a black eye from a well-aimed apple thrown at him by Faulkner. Out of all this activity grew the idea of 'the Firm'. In April 1861, Morris, Marshall, Faulkner and Company came into being. The other partners were Rossetti, Burne-Jones, Philip Webb and Ford Madox Brown. On 11 April a circular was published, setting out the aims of the company: 'The growth of decorative art in this country, owing to the efforts of English Architects, has now reached a point at which it seems desirable that Artists of reputation should devote time to it ...' This was one of the main tenets of the Aesthetic Movement, that artists should become involved in decoration and design. The circular also listed the areas in which the Firm should specialize – Mural Decoration, Carving, Stained Glass, Metal Work and Furniture, which was to include Embroidery, Stamped Leather and 'every article necessary for domestic use'. Premises were taken above a jeweller's at 8 Red Lion Square, not far from the old studio. There was an office and showrooms on the first floor, and workshops on the third floor and in the basement. The staff consisted of

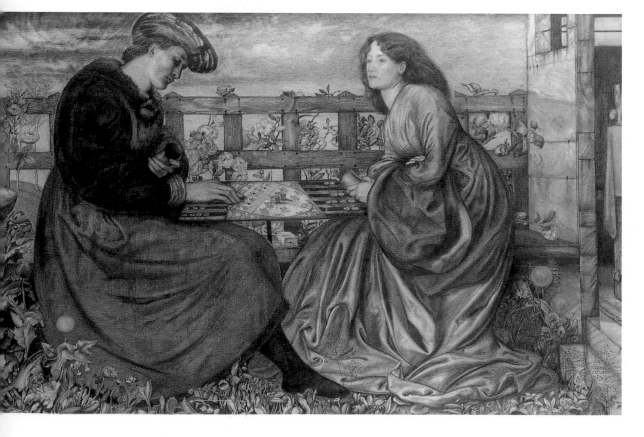

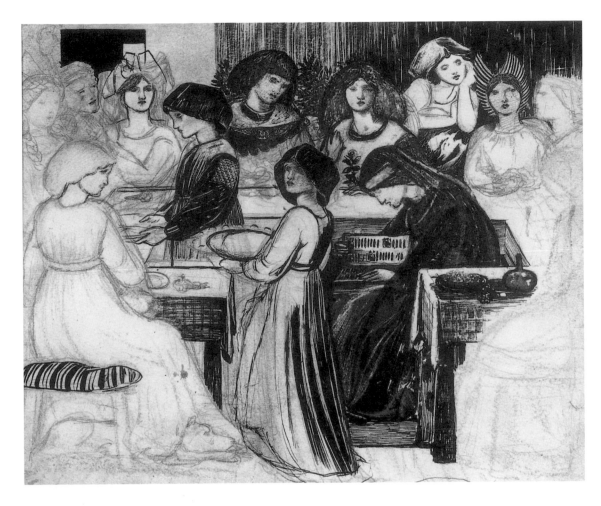

under the aegis of the Oxford Movement or the Cambridge University Camden Society, both High Church groups which encouraged elaborate ritual and rich decoration. Any decoration which intensified the devotion of the worshipper was therefore encouraged. Ruskin's *Seven Lamps of Architecture* also had an influence, particularly in encouraging the use of polychromatic materials in gothic architecture – different colours of brick and stone outside, and coloured marbles, stained glass and painted murals and roofs inside. Architects such as Pugin and Butterfield had been combining modern materials with the gothic style since the 1830s, so Morris and his friends were not the first into the field. What was new was the fact that they were all artists, and that they insisted on artists being involved at all stages of design.

To begin with, the success of Morris & Co. was entirely due to their stained glass. In the 1860s they received a number of important commissions, mainly due to

Above: *A Study for* The Marriage of Sir Degravaunt. *A study for a series of murals for the drawing-room at the Red House. Only three of the murals were completed.*

Right: *The Ladies and Animals Sideboard, 1860. Painted in the week before Burne-Jones's marriage, and always kept by him. The front shows kind ladies feeding animals; on the ends are cruel ladies tormenting an owl, and being attacked by a swarm of angry bees.*

Opposite: *'The Backgammon Players'. This design first appeared on a cabinet designed by Philip Webb. Later Burne-Jones made a painting of the subject, for which this is a black chalk study.*

twelve boys from a Home in the Euston Road, and two men who had experience of making stained glass.

The early Victorian period had seen a positive explosion of church-building, and this is what gave Morris & Co. its opportunity. Many of these churches had been built

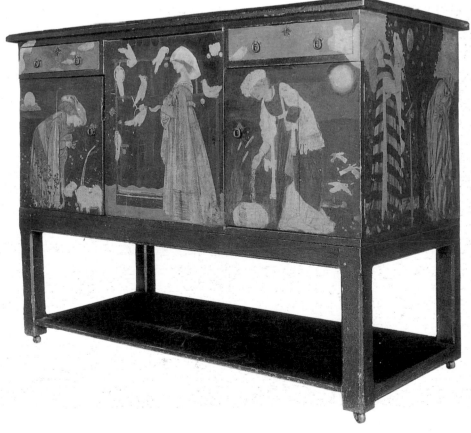

Above: **King René's Honeymoon**. *King René of Anjou was something of a hero figure to the Pre-Raphaelites in the early 1860s. The story of the art-loving king is told in Walter Scott's* Anna von Geierstein.

Right: **Phyllis and Demophöon**, *1870. This was the watercolour criticized at the Old Watercolour Society in 1870, which led to Burne-Jones's resignation. The subject comes from Ovid's* Heroides *and Chaucer's* Legend of Good Women *(see p104).*

Opposite above: **The Madness of Sir Tristram**, *1862. A stained glass window from the set designed by Burne-Jones and made by Morris & Co. for the music room of Harden Grange, near Bingley, Yorkshire, belonging to Walter Dunlop. Burne-Jones developed this design into a watercolour (see p. 31).*

Opposite below: *'Cinderella', a tile design. Burne-Jones designed tiles only during the early 1860s. Most of them were later developed into watercolours and paintings.*

Morris and Webb's contacts with many of the leading architects of the day, notably G. F. Bodley, J. P. Seddon and William Burges. Their first major commission was All Saints, Selsley, in Gloucestershire, by Bodley. This required a large number of windows, which were designed by Burne-Jones, Rossetti, Madox Brown, Webb and Peter Marshall. This led to other commissions, including two more for Bodley churches, St Michael's in Brighton, and St Martin's, Scarborough. In 1862 the Firm exhibited at the International Exhibition, which led to more commissions, and sales of tiles, embroideries and painted furniture worth £150.

Burne-Jones was involved in all these church commissions, designing either stained glass or murals. At first, some of his stained-glass windows were not entirely successful but, during the 1860s, the quality of his work steadily improved, both in design and colour. He also became involved in secular commissions, especially decorating cabinets designed for Philip Webb. On these he painted scenes which were later to be developed into paintings, such as *The Backgammon Players*, *Ladies in a Wood* (which became *Green Summer*) and *Cophetua and the Beggar Maid*. He also decorated a cabinet devoted to one of his favourite heroes, St George, which was shown at the 1862 Exhibition. Also at the 1862 Exhibition was a bureau commissioned by J. P. Seddon, decorated with a series of incidents from the honeymoon of King René of Anjou, as related in Walter Scott's *Anna von Geierstein*. King René was described by Scott as being interested in all the arts, and he became a hero-figure to the Pre-Raphaelites in the 1860s. The Seddon bureau was another group effort, with panels by Rossetti, Madox Brown, Prinsep and Burne-Jones, representing the multi-talented king as Architecture, Music, Painting, Sculpture, Gardening, Glass-Blowing, Metalwork, even Sewing. The bureau was criticized unfavourably in 1862 by most of the critics who described it as 'unnecessarily crude

and ugly'. This did not deter Morris & Co.'s admirers, who recommissioned several of the designs in other forms. By the later 1860s, the Firm stopped producing this type of painted furniture, mainly because the artists could no longer spare the time to do it. By 1864, pressure of business had forced Morris to give up the Red House and move back to London. He settled in Queen Square in Bloomsbury, which became the new headquarters of the Firm. He and his family lived on the upper floors.

In the 1860s Burne-Jones also designed tiles, mainly in sets, such as *The Triumph of Love*, *Cinderella*, *The Sleeping Beauty* and *Beauty and the Beast*. As tiles, Burne-Jones's designs were mostly quaint, primitive and often comic, but they are all important as

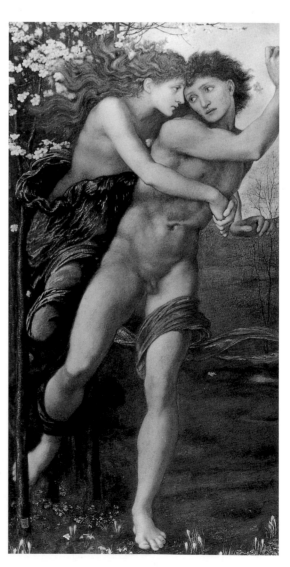

the source of inspiration for future paintings. Sets of tiles were bought by Birket Foster for his house at Witley, and by Queen's College, Cambridge, for the dining hall. Later large tile commissions were generally passed on to William de Morgan, who worked closely with Morris & Co. Burne-Jones also designed stained glass for secular use, such as the set of windows produced for a Mr Walter Dunlop of Bradford, based on the story of Sir Tristram in Malory's *Morte d'Arthur*. Four of these were by Burne-Jones: *The Wedding*, *The Madness*, *The Burial of Tristram* and *King Mark Preventing Isolde from Slaying Herself*. Once again, most of these designs were developed into watercolours and paintings. Similarly, his picture *Morgan-le-Fay* began as a design

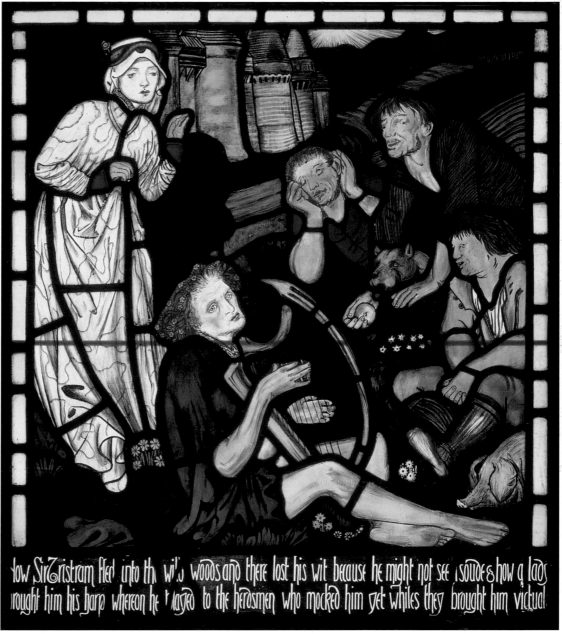

for embroidery. Another series of stained-glass windows, designed for the Combination Room of Peterhouse, Cambridge, derives from embroidery panels made for Ruskin in 1863, illustrating Chaucer's *Legend of Good Women*. All this underlines the constant interaction between Burne-Jones's design work and his paintings. Also in the 1860s, Burne-Jones made a number of illustrations for the Dalziel Brothers, for the Dalziel Bible, as well as their various magazines, such as *Good Words*. Burne-Jones was introduced to the Dalziels by Holman

Hunt in 1861, who recommended him as 'the most remarkable of all the younger men of the profession for talent'. Dalziel visited Burne-Jones's studio in 1862, and wrote that 'the room was crowded with works of various kinds, in every sort of method, all showing wonderful power of design, vivid imagination and richness of colour'. Some of Burne-Jones's illustrations were cut on to the woodblocks by his wife Georgiana. In 1862 Burne-Jones and his wife made his second trip to Italy, accompanied by Ruskin. In Paris they visited the

Louvre, where they would doubtless have seen Fra Angelico's *Coronation of the Virgin* and Giorgione's *Concert Champêtre*, both pictures admired by the Pre-Raphaelite group. In Italy they went first to Milan, then to Parma to study Correggio. Ruskin then parted from the Burne-Joneses', as he was suffering from one of his periodic depressions. The Burne-Joneses then went on to visit Verona, Padua and Venice, where they joined up with Ruskin again. In Padua Burne-Jones made drawings of Giotto's

frescoes of the Virtues and the Vices in the Arena Chapel. In Milan, Ruskin made him copy two pictures by Luini, and in Venice, details of pictures by Tintoretto and Veronese. Burne-Jones himself preferred narrative painters such as Gentile Bellini and Carpaccio. The grand rhetoric of Venetian religious painting was not really for him; he was more drawn to the poetry and mystery of Giorgione.

On their return to England, Ruskin had expressed his desire to leave England for

good and settle in the Alps. Burne-Jones was extremely concerned about this, and tried to change Ruskin's mind. To divert him, he suggested building a house in the Wye Valley instead, for which Burne-Jones proposed to design a set of embroideries based on Chaucer's *Legend of Good Women*. Like so many of Burne-Jones's projects, this remained unfinished. Ruskin's depression lifted; he decided not to go to the Alps, or to the Wye Valley, as Burne-Jones had suggested. Only cartoons and sketches of *The*

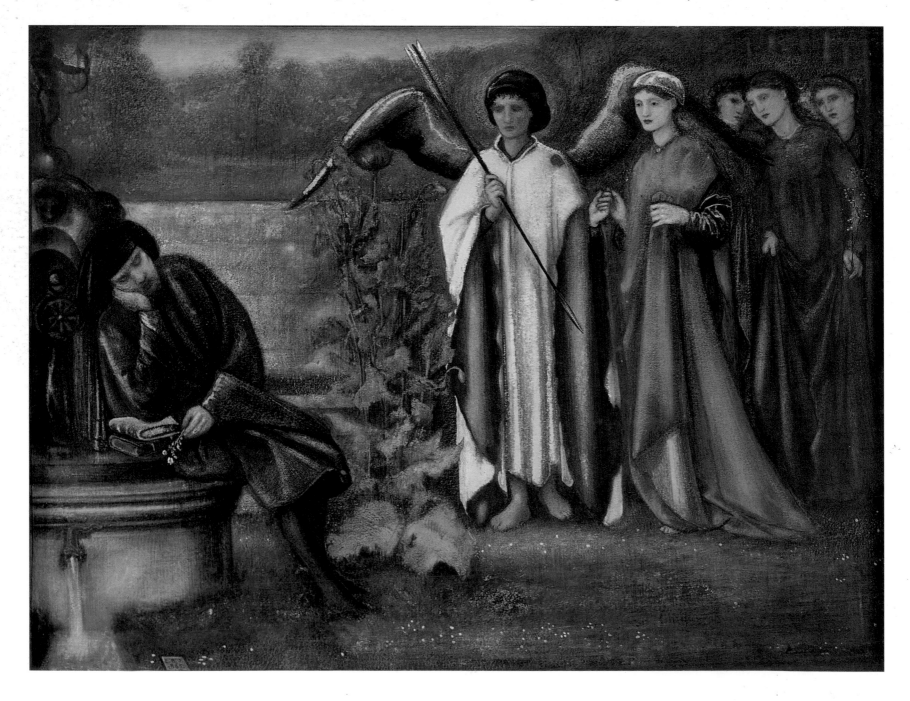

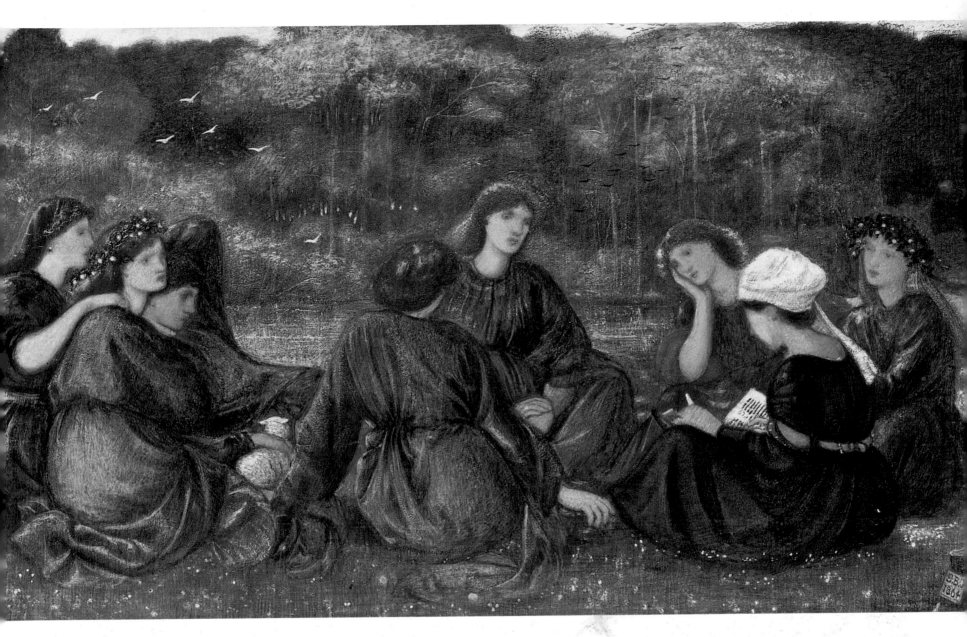

Opposite: **Chaucer's Dream of Good Women**, *1865. Burne-Jones and Morris were devoted to Chaucer's poetry all their lives. Burne-Jones first treated this subject in a set of tiles; then as a set of embroideries for Ruskin. These were not completed, so this subject was later worked up into a painting.*

Above: **Green Summer**, *1864. This picture sums up the aesthetic and Italianate influence on Burne-Jones's style in the mid 1860s. The figures are Giorgionesque, and the subject is really a matter of mood, colour and design. It could just as well be entitled* A Harmony in Green. *This is the smaller version, painted in 1864; a larger version was painted in oil in 1868.*

Legend of Good Women survived, to be recycled and used in other projects. Several reappeared as stained-glass windows in the Peterhouse Combination Room.

Ruskin could be both interfering and dictatorial towards artists, and during the 1860s his influence over Burne-Jones was on the wane. Burne-Jones was also moving away from the gothic medievalism of Rossetti and Morris. Rossetti's style was also changing in the 1860s, as he began to paint more in oils, and on a larger scale. The Aesthetic Movement had a distinct impact on Rossetti's work, and the influence of Italian Renaissance art is also very evident

from the 1860s on. Burne-Jones was by this time meeting other like-minded young artists, in particular Henry Holiday, Simeon Solomon and Albert Joseph Moore. He also met Whistler, and would have seen his celebrated picture, now in the Tate Gallery, *Symphony in White*, begun in 1861. George du Maurier and Edward Poynter were also part of the circle at this time. All of these artists had studied in Paris or on the Continent, and they brought with them a new aesthetic attitude, marking the end of the narrow, gothic phase of the Pre-Raphaelite movement. The new doctrine placed greater emphasis on decorative considerations,

new direction in which Burne-Jones's art was moving in the 1860s.

Swinburne had been a friend of Burne-Jones since 1857, when they met in Oxford. Thanks to the Pre-Raphaelites, Swinburne too became infected with their passion for all things medieval, and in 1858

Left: *A Study for* Dorigen of Bretaigne Longing for the Safe Return of her Husband. *This is sometimes referred to as 'Dorigen cursing the Rocks'.* Below: **The Lament**, *1866. This picture of 1866 shows Burne-Jones's style moving away from his early medievalism, towards a more Aesthetic and Classical style, reflecting the influence of Albert Joseph Moore.* Opposite: **Dorigen of Bretaigne Longing for the Safe Return of her Husband**, *1871. The story is from 'The Franklin's Tale' by Chaucer. The long narrow window is similar to that in* Laus Veneris.

and was both anti-narrative and anti-moralistic. They also brought a new awareness of the great European traditions, especially Greek sculpture, and the paintings of the Italian Renaissance. Like all great artists, Burne-Jones had remarkable powers of assimilation, and all these influences were to be absorbed into his own unique style. He remained devoted to medieval subjects, and especially the Morte d'Arthur, all his life, but developed an extraordinarily hybrid style, in which Pre-Raphaelite, Aesthetic, Italianate and Classical influences are all fused. His gouache *The Lament*, of 1866, already shows him moving towards a simpler, more monumental style. The composition consists of only two figures, one playing a musical instrument, a favourite Aesthetic subject, and the other listening. The figures and their draperies have a distinctly Classical air; the background is simple and uncluttered, with a rose on the right. The prevailing red and blue colours are intended to arouse a mood of sorrow and lamentation; the narrative element is reduced to the absolute minimum. This picture clearly shows the

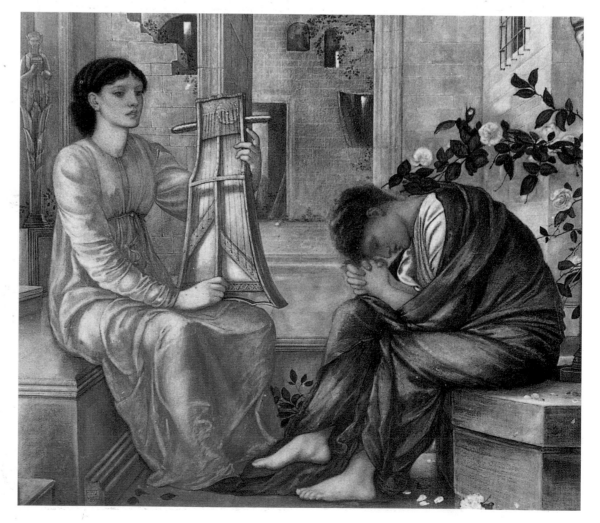

published his Arthurian romance *Tristram and Lyonesse*. He also wrote a verse play *Rosamond*, published in 1860:

Ay, and love
That makes the daily flesh an altar cup,
To carry tears and rarest blood within
And touch paired lips with feast of sacrament
So sweet it is, God made it sweet.

This told the story of Fair Rosamond and Queen Eleanor, the jealous wife of King Henry II. Rosamond was a heroine in Pre-Raphaelite circles, and Rossetti, Burne-Jones, Frederick Sandys and others all painted versions of her story. Her burial place at Godstowe was a place of pilgrimage for the Pre-Raphaelites in the 1850s. By the early 1860s, Swinburne was living in London, working on his *Poems and Ballads*. At this time, the relationship between Swinburne and Burne-Jones was very close, and clearly each of them influenced the other. Georgiana Burne-Jones records how Swinburne would often rush into their house to read the latest verse of a poem. There is an undoubted similarity of mood between Swinburne's highly lyrical and romantic poems of this period, and Burne-Jones's pictures, such as *Green Summer*, which is very close in mood to the poem 'In the Orchard', conjuring up a deliberately sultry and lazy atmosphere.

The grass is thick and cool, it let's us lie,
Kissed upon either cheek and either eye,

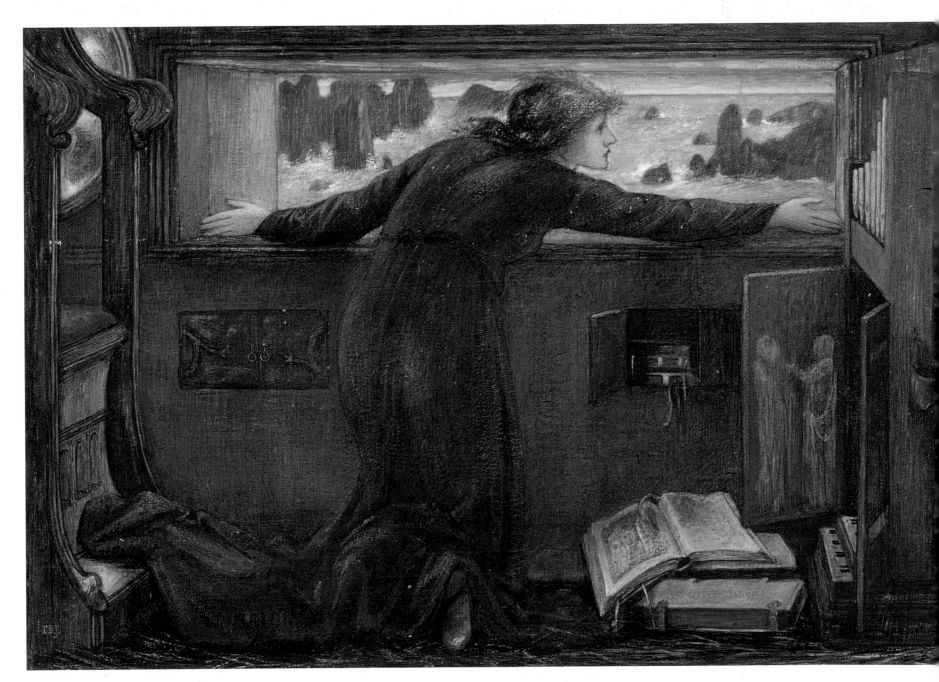

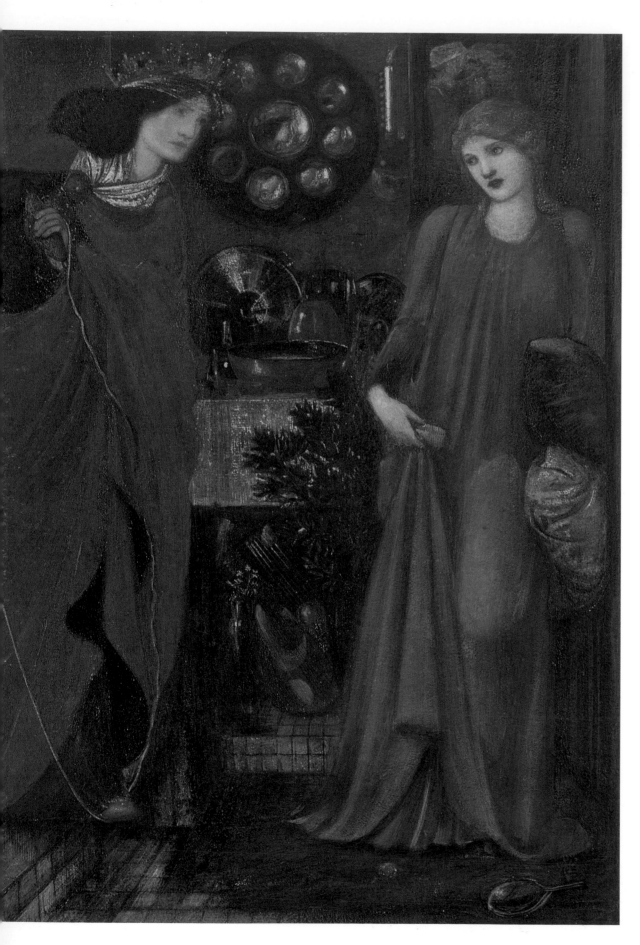

I turned to thee some green afternoon
Turns towards sunset and is loth to die.

Swinburne's poems 'Laus Veneris' and 'St Dorothy' inspired pictures of the same titles by Burne-Jones. When *Poems and Ballads* was published in 1866, the dedication read:

To my friend Edward Burne-Jones these poems are affectionately and admiringly dedicated

Simeon Solomon, a highly talented Jewish artist from an artistic family, was also a close friend of Swinburne and Burne-Jones at this time, and they formed for a while a somewhat unlikely trio. Solomon's watercolours of the 1860s are very similar to those of Burne-Jones, although Solomon was particularly interested in Old Testament subjects, and Judaic ritual.

Through Swinburne, Solomon also became interested in the dangerous subjects of homosexuality and lesbianism, both of which feature more or less overtly in his work. Solomon's work is the precise pictorial equivalent of Swinburne's poetry, and conveys exactly the same tense atmosphere of repressed sensuality. In Burne-Jones's work, sensuality is always kept more under control, and he was not prepared to follow those paths down which Solomon ventured, and which were to lead to his tragic disgrace in the 1870s.

It has been claimed that Burne-Jones developed the hermaphroditic tendencies in his art due to Swinburne's influence, but this is a hard thing to prove. Swinburne wrote a poem entitled 'Hermaphroditus' in 1863, inspired by a Greek sculpture in the Louvre, so undoubtedly this was a topical subject at the time:

Choose of two loves, and cleave unto the
best;
Two loves at either blossom of thy breast
Strive until one be under and one above
Their breath is fire upon the amorous air …

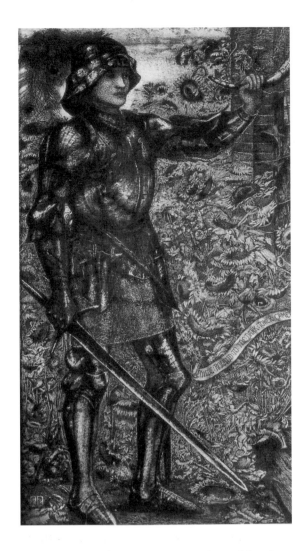

Yet by no sunset and by no moonrise
Shall make thee man and ease a woman's
sighs,
Or make thee woman for a man's delight.

Androgynous, almost sexless figures were to become a feature of Burne-Jones's mature style, so there can be no doubt that both Swinburne and Solomon influenced his work in this direction. Burne-Jones converted it into something quite different, and quite his own, but it is an important element in his highly complex, eclectic style.

Another artist moving in much the same direction as Burne-Jones in the 1860s was Albert Joseph Moore. He came from an artistic family, and though eight years younger than Burne-Jones, had begun exhibiting by 1857. Moore was also a friend of Whistler and Rossetti, and very much part of their circle. He and Burne-Jones do not seem to have been close friends, but they must have been aware of each other's work. Like Burne-Jones, in the 1860s Moore was moving from an early Pre-Raphaelite phase, towards his own version of the Aesthetic style. His work was also highly eclectic, fusing Classical, Aesthetic and Japanese elements. But his recipe was rather different from that of Burne-Jones. Moore was a great admirer of the Elgin Marbles, and the invariable subject-matter of his pictures is girls in Grecian robes. He tends, therefore, to be labelled a Classicist, but his compositions and his colour-sense owe more to Japanese art, which he and Whistler both studied avidly between 1865 and 1870. Whistler's *Six Projects* (Freer Gallery, Washington) show a similar fusion, but are painted in a far looser, more Impressionistic style.

Burne-Jones's art was developing along similar lines in the 1860s. His figures became more refined, more elegant and more Classical; his composition also became clearer and simpler, and less cluttered with narrative detail. There is a generic similarity between Burne-Jones's female figures, espe-

cially those standing, reclining or sleeping, such as *The Seasons* or *The Sleeping Princess*, and those of Moore. Unlike Burne-Jones, Moore was not remotely interested in historical or literary subject-matter. In Moore's pictures we find everything from a Greek robe to a Chinese vase or a modern violin, but absolutely no reference to any literary or historical theme. Not for him either Camelot or Parnassus. He preferred not to give his pictures titles at all, and said to patrons, 'Call it what you like.' In this sense, Moore's pictures are totally subjectless, and he is therefore the highest of the high Aesthetes. His real preoccupation was colour, and he was one of the most subtle and sensitive colourists in the whole of

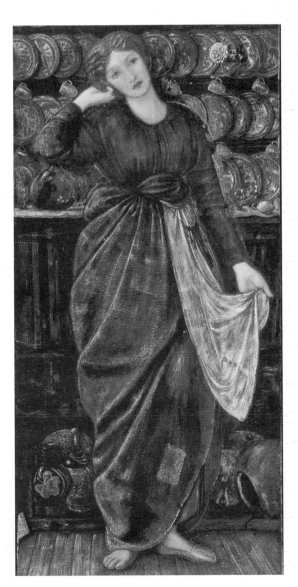

Above: *'Childe Roland', 1861. A beautiful early drawing, which belonged to Ruskin and to the publisher F. S. Ellis. It illustrates Browning's poem from* Men and Women *(1855), a book much admired by Rossetti and his circle. The sunflowers seem to anticipate the Aesthetic movement.*

Right: **Cinderella**. *A gouache exhibited at the Old Watercolour Society in 1864, where it hung as a pendant to* Fair Rosamond. *Both were praised for their intense colour. The blue and white plates on the dresser echo the taste for collecting oriental porcelain begun in the 1860s by Rossetti and Whistler (see p. 35).*

Opposite: **Fair Rosamond and Queen Eleanor**, *1861. The story of Fair Rosamond, the mistress of King Henry II murdered by his jealous wife, Eleanor, was a favourite with the Pre-Raphaelites. Bell Scott, Arthur Hughes, Rossetti and Sandys all painted the subject, and Burne-Jones made several versions. Swinburne also wrote a poem, 'The Queen Mother and Rosamond' (1860).*

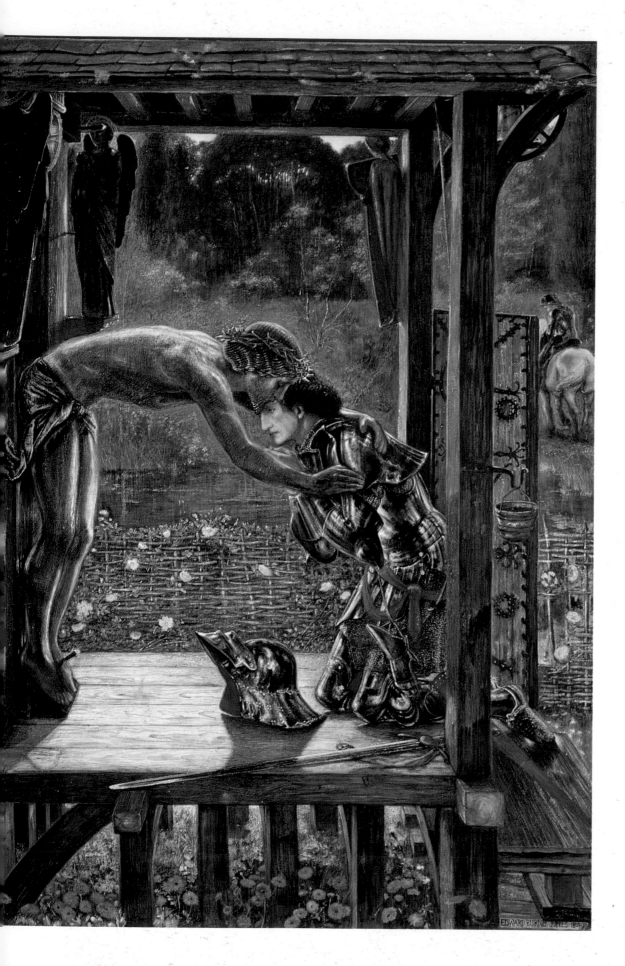

English art. After 1870, Moore's style and that of Burne-Jones diverged, but there is no doubt that there are underlying similarities. Moore believed that beauty, colour, harmony and line were the only things that mattered. Burne-Jones would have agreed with that philosophy, but he was in addition a medievalist, a moralist and a literary romantic, and remained so all his life. Burne-Jones and Moore simply represent different ends of the same Aesthetic spectrum.

Burne-Jones made his public debut at the Old Watercolour Society in 1864. He showed four watercolours, *Cinderella, Fair Rosamond, The Merciful Knight* and *The Annunciation*. They were badly received, and the reviews were hostile, especially from the *Spectator* and the *Athenaeum*. Burne-Jones was both hurt and discouraged, but he continued to exhibit at the RWS until 1870, when his watercolour of *Phyllis and Demophöon* was rejected on grounds of indecency. This unhappy episode was to end in Burne-Jones's resignation from the Society. After this, he was unwilling ever again to join any artistic group or society, and it was only with the greatest reluctance that he was eventually persuaded to become an Associate of the Royal Academy (ARA).

Through the 1860s, Burne-Jones was kept going by a small but loyal band of devoted patrons, mostly introduced by Rossetti and Ruskin. In particular, Thomas

Left: **The Merciful Knight**, *1863. The subject is from the life of the Florentine knight St John Gualberto, founder of the Valombrosan Order in 1039, who was miraculously embraced by a wooden statue of Christ when praying at a wayside shrine, after forgiving the murder of his kinsman. It was among Burne-Jones's favourite early works.*
Opposite: **Merlin and Nimue**, *1861. According to Malory, Nimue was a 'lady of the lake' who was brought to the court of King Arthur at Camelot by King Pellinor. Merlin 'fel in a dotage' on her, and followed her to Cornwall, where she imprisoned him under a stone. It was a favourite subject of Burne-Jones, who made several versions of it.*

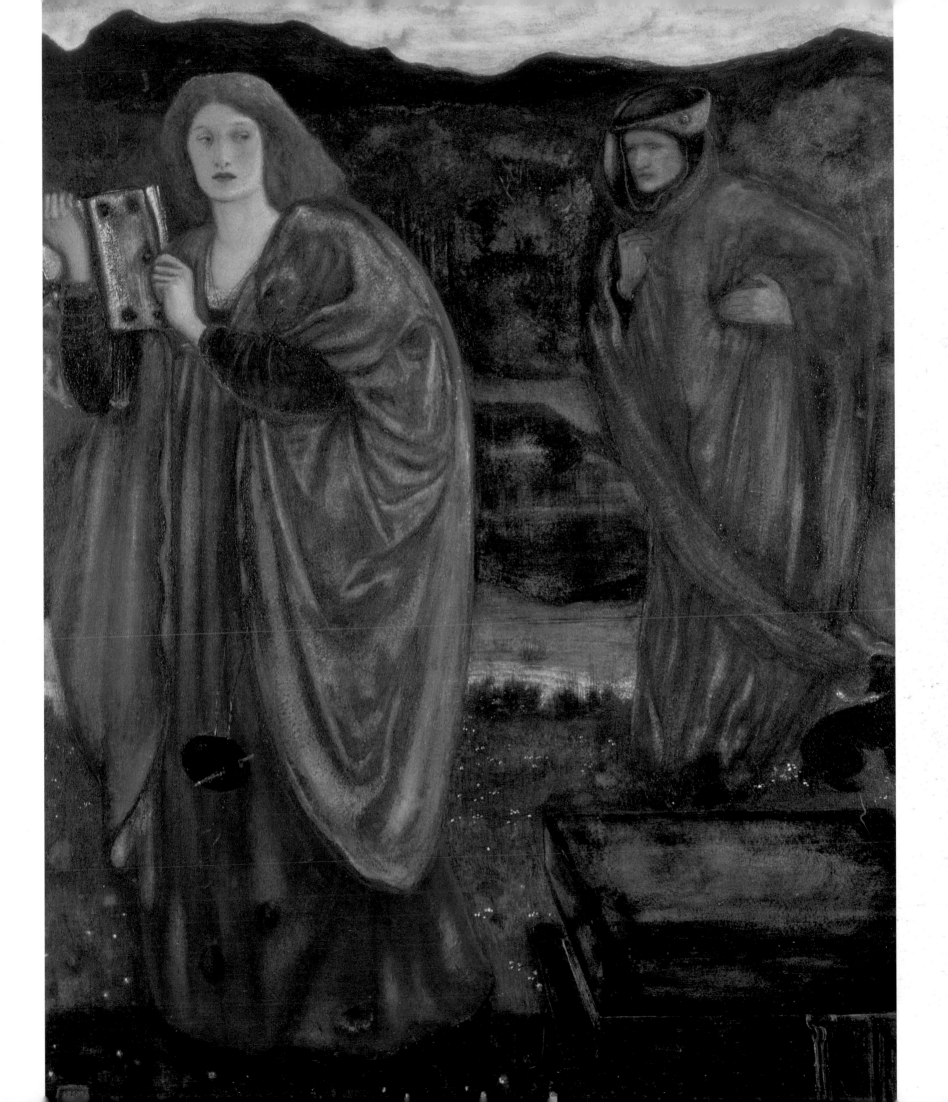

Plint of Leeds owned at least five of Burne-Jones's pictures, including *The Waxen Image* (1856), *The Wise and Foolish Virgins* (1859), *The Blessed Damozel* (1860), a small version of *Sidonia von Bork* (1860), *Rosamond and Queen Eleanor* (1861), as well as a number of pen and ink drawings. He also owned a triptych of *The Adoration of the Magi*, which was unfinished when Plint unfortunately died in 1861. His death caused much embarrassment in Pre-Raphaelite circles, as Plint had paid out large advances to numerous artists, and received nothing in return. The executors demanded that these pictures be completed, and appointed a leading dealer, Ernest Gambart, as their agent. Gambart made himself unpopular among Pre-Raphaelite artists, and Rossetti took his revenge by portraying him as Judas in one of his cartoons. Another important early patron was James Leathart of Newcastle, who owned six early watercolours, *Fair Rosamond and Queen Eleanor* (1860), *Merlin and Nimue* (1861), *The Merciful Knight* (1863), *Sidonia von Bork* and *Clara von Bork* (both 1860), and *Valentine's Morning* (1863).

He bought the *Fair Rosamond* from Plint's executors. William Miller of Liverpool, another northern patron, began buying about 1861. William Graham, MP for Glasgow, who was to be one of Burne-Jones's devoted patrons, began to buy in the late 1860s, as did F. R. Leyland, the Liverpool shipping magnate. Major Gillum, a wealthy amateur, was another buyer, as well as several fellow-artists – G. P. Boyce, H. T. Wells, Spencer Stanhope and Birket Foster. Burne-Jones was very much an artist's artist, and it was artists who recommended him to many of his patrons. It is to the credit of these self-made Victorian businessmen that they were discerning enough to perceive the quality of Burne-Jones's early watercolours and buy them, unpopular though they might be with the critics. So by the end of the 1860s, Burne-Jones was not only developing his own artistic personality, but beginning to stand on his own feet financially. By 1867 he felt secure enough to take a tenancy of a large house in North End Road, Fulham. Called The Grange, it had a large walled garden, and in

Above: *Burne-Jones painting, by George Howard Burne-Jones by his lifelong friend, patron and fellow-artist, George Howard, later 9th Earl of Carlisle.*
Above left: *The Grange, North End Road, Fulham*
Opposite left: *'Princess Sabra led to the Dragon', 1866. The* St George *series was one of Burne-Jones's first cycles, originally commissioned by Birket Foster for his house at Witley, Surrey. The pictures were finally finished by Fairfax Murray, but Burne-Jones made many drawings and studies for them.*
Opposite right: *Two Studies of Draped Figures.*

those days almost rural surroundings. It was to be Burne-Jones's home for the rest of his life. He also employed two studio assistants in the 1860s, first Fairfax Murray, then Thomas Matthews Rooke, who was to remain his faithful follower for the rest of Burne-Jones's career.

In spite of Burne-Jones's increasing independence and prosperity, he and Morris remained close throughout the 1860s. Burne-Jones was still heavily involved with Morris & Co., mainly producing stained-glass designs. In 1865 Morris appointed Warrington Taylor as

manager of the Firm. Morris had proved a chaotic administrator, and Taylor tried to introduce more organized and systematic methods. He turned the Firm into a professional organization instead of a happy-go-lucky group of amateurs. Inevitably, he aroused some dislike and suspicion from the artists, Burne-Jones included, but they managed to maintain a good working relationship. With the change in Burne-Jones's style in the 1860s, his stained glass begins to change too, away from the dense gothic style of his early glass towards a more con-sciously decorative approach. His figures become larger and more elegant, his line more flowing and his range of colours much wider, with greater use of pale colours. Burne-Jones's stained glass was becoming more Aesthetic, and less gothic. This change was also reflected in Morris's poetry. During the 1860s he was working on *The Earthly Paradise*, a series of twenty-four tales modelled on Chaucer's *Canterbury Tales* and Boccaccio's *Decameron*. Unlike Morris's earlier *Defence of Guinevere*, a tense and dramatic rendering of the Arthurian

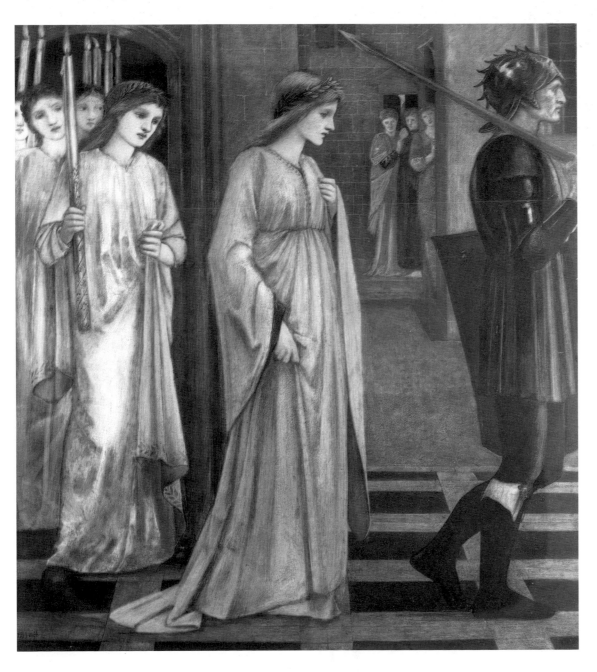

legends, *The Earthly Paradise* is a long and rambling story, related in a much more relaxed and flowing style. Each tale is narrated by a different character, and Morris drew on Greek, Scandinavian, Celtic, even Arabian sources. The prologue contains the famous exhortation:

> *Forget six counties overhung by smoke,*
> *Forget the snorting steam and the piston*
> * stroke,*
> *Forget the spreading of the hideous town …*

Presumably Morris and Burne-Jones also tried to forget that most of their patrons had made their money out of smoke, snorting steam and piston strokes.

From the start, it was intended that Burne-Jones should provide all the illustrations for *The Earthly Paradise*, with the intention of producing a sumptuously illustrated volume. For four years, from 1864 to 1868, Burne-Jones worked on the project, producing a great many drawings and studies. These show his increasing mastery of figure drawing, and his ability to produce

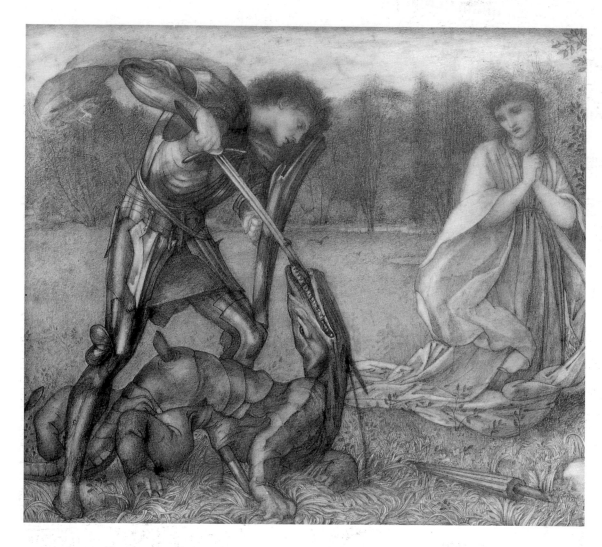

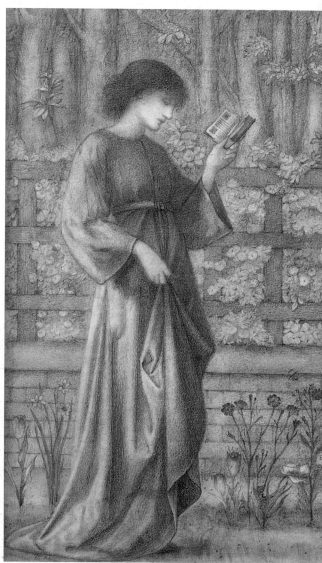

a series of interlinking narrative scenes. His red chalk drawings of this period are also particularly remarkable; the figures emerge from a grainy, all-over background of chalk. His figures become more Italianate and graceful, and their attitudes and groupings more deliberately pretty and decorative.

One of Burne-Jones's main sources of inspiration for *The Earthly Paradise* was a fifteenth-century book much admired by him and Morris, the *Hypnerotomachia Poliphili*. The book concerns the wanderings of an unhappy lover, Poliphilus, in search of his love, Polia. In form it is a medieval romance, but the author has overlaid it with classical references and allusions, and the woodcut illustrations are full of classical buildings and inscriptions. Exactly the same mixture of medieval and Classical pervades Burne-Jones's work. In

the *Pygmalion* series, for example, which had its origins in *The Earthly Paradise*, the theme is Classical, and the figures Italianate, but the atmosphere is that of medieval courtly love. This mixture was to remain a characteristic of all Burne-Jones's work for the rest of his career. *The Earthly Paradise* was eventually published in 1868, without illustrations, but the work Burne-Jones put into it was not to be wasted. The many designs and drawings he made for the book, especially the *Cupid and Psyche* series, were to furnish him with ideas for pictures for the rest of his life. In all, *The Earthly Paradise* was to provide the inspiration for no fewer than thirty-five paintings, making it by far the most important source for his art. The *Cupid and Psyche* series became a mural frieze painted for George Howard at 1 Palace Green, Kensington; the *Pygmalion*

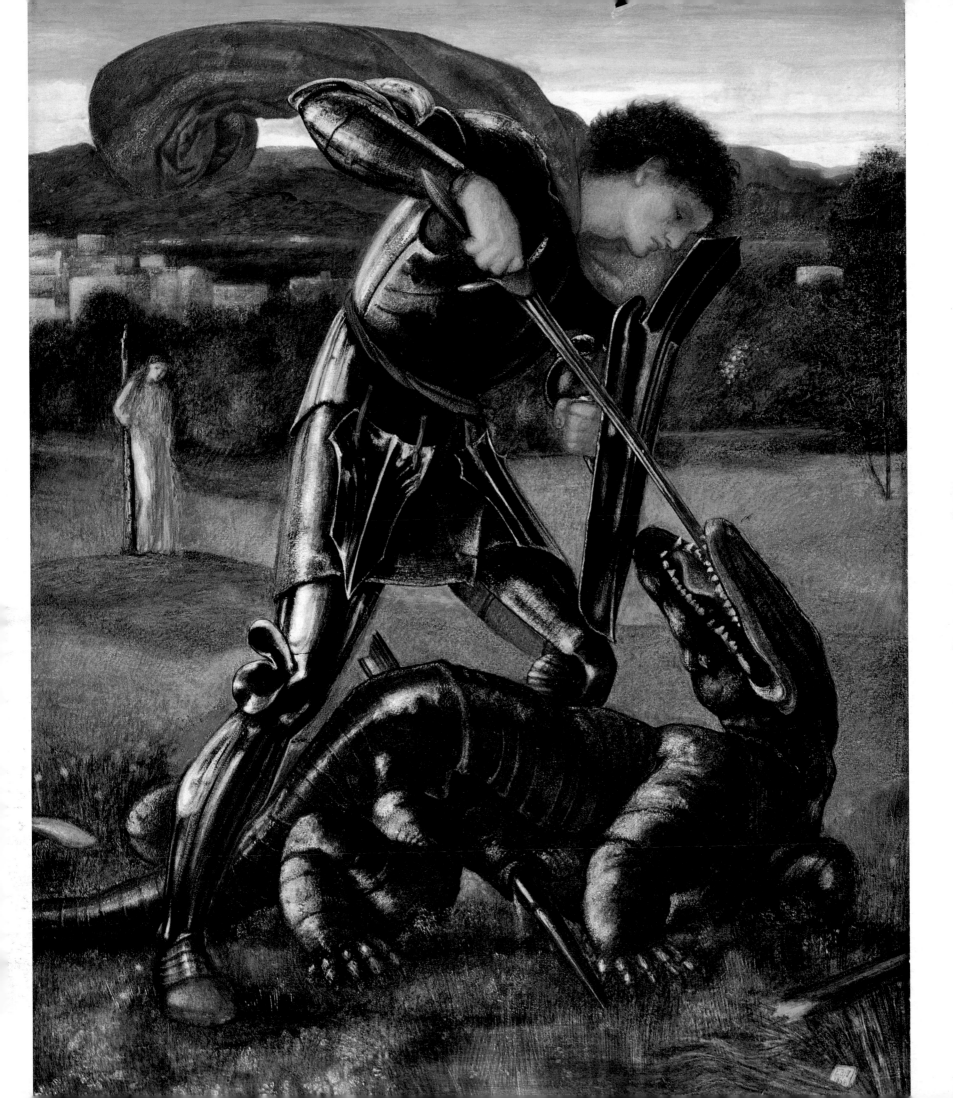

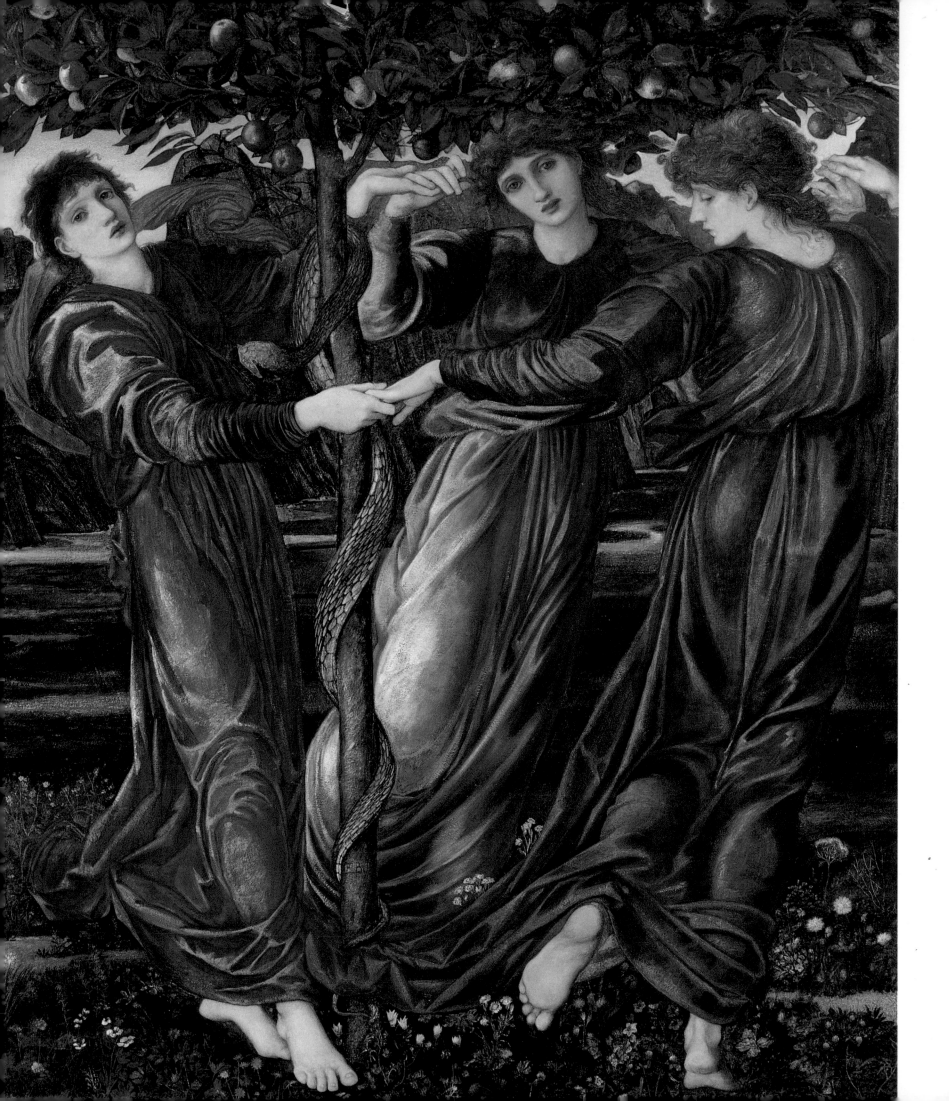

story resulted in two sets of four pictures; *The Doom of Acrisius* led to the Perseus series of eight pictures commissioned by Arthur Balfour for his music room in Carlton Gardens; drawings for the *Orpheus* story ended up on William Graham's piano; *Danae or the Brazen Tower* inspired four separate pictures; both *The Mirror of Venus* and *The Wedding of Psyche* had their origin in the same source. This gives some idea of just how important *The Earthly Paradise* was to Burne-Jones's development.

As Burne-Jones became more and more busy, he developed the confidence to work on a steadily larger scale. This entailed more preparatory studies, for draperies, nude figures, draped figures, details of hands, faces, feet and other accessories. He also made many compositional studies, some of which were worked up into finished versions later. All of this has contributed to his vast output. Pressure of work also led to his employing his first studio assistant in 1866, Charles Fairfax Murray. Murray later became a noted dealer and collector, particularly of Pre-Raphaelite drawings and Italian paintings, but he remained Burne-Jones's assistant for a number of years. One of his first jobs was to help Burne-Jones complete the *St George* series for Birket Foster's house at Witley in Surrey. Working from detailed drawings by Burne-Jones, Fairfax Murray completed the pictures, but they are not of equal quality. They are very much 'workshop' productions and not by Burne-Jones's own hand. This is a pity, as the idea of a *St George* series came from the murals by Carpaccio in the Scuola di San Giorgio in Venice. This, and Carpaccio's other series, the St Ursula legends, were among Burne-Jones's favourite Venetian pictures.

At the end of the 1860s, Burne-Jones became involved in a romance of his own, with the beautiful Greek sculptress, Maria Zambaco. She was the daughter of Mrs Casavetti, one of the Greek colony in London, and a friend and patron of

Above: *Caricature of William Morris and his wife Jane.*

Opposite: **The Garden of the Hesperides,** *1870s. The story is from the legend of Jason, also treated by William Morris, in 'The Life and Death of Jason' and* The Earthly Paradise. *The picture dates from the early 1870s, and reflects the influence of Burne-Jones's Italian trips, and particularly his love of Botticelli. The model for the girl on the right was Maria Zambaco.*

Rossetti. Burne-Jones fell passionately in love with her and, during their turbulent affair, he made many beautiful drawings and paintings of her. She appears in several pictures, including *Venus Epithalamia*, *The Garden of the Hesperides*, *Beatrice*, *The Mill* and the notorious *Phyllis and Demophöon* which resulted in Burne-Jones's resignation from the Old Watercolour Society. One of Burne-Jones's portraits of Maria Zambaco shows her holding a book with an illustration of his *Chant d'Amour*; in the background Cupid holds an arrow with his name on it. His drawings of her are some of the finest he ever made. To Burne-Jones she must have seemed the embodiment of Circe, the Greek enchantress. The affair, like all affairs, had its comic side. The couple were rumoured to have made a suicide pact, and agreed to end it all by wading into the Serpentine in Hyde Park. They found

the water too cold, so turned round and came out again.

Rossetti, ever the ironic commentator, wrote to Madox Brown in 1869 that

> Poor old Ned's affairs have come to a smash together, and he and Topsy, after the most dreadful to-do, started for Rome suddenly, leaving the Greek damsel beating up the quarters of all his friends for him and howling like Cassandra. I hear today however that Top and Ned got no further than Dover, Ned being now so dreadfully ill they will probably have to return to London.

Return to London they did, and Burne-Jones to his wife. Georgiana already knew of her husband's affair, thanks to the mischief-making of Rossetti's sinister friend and agent Charles Augustus Howell. Howell brought Maria Zambaco to call on Georgiana when her husband was out. Burne-Jones returned to the house and, finding Maria there, fainted clean away, hitting his head on the mantelpiece.

Georgiana's anger was mainly directed towards Howell. In her *Memorials of Burne-Jones*, written over thirty years later, she described Howell as 'one who had come amongst us in friend's clothing, but inwardly he was a stranger to all that our life meant'. Of Maria Zambaco she made no

mention. Burne-Jones was equally angry with Howell, and had nothing to do with him thereafter, and tried to see that Ruskin and Rossetti did not either. It was Howell who had persuaded Rossetti to dig up Elizabeth Siddal's coffin in Highgate Cemetery to recover the manuscripts of his early poems.

Thereafter life at The Grange resumed its tranquil course, but the Zambaco affair had left its mark. Burne-Jones continued to confide in his numerous women friends, whose company was important to him. Georgiana confided increasingly in William Morris, whose own marriage was in danger of disintegrating. It was in the 1870s that Rossetti's obsession with Jane Morris was at its height, to which she must have responded to in some degree. She confided later to Wilfred Scawen Blunt that she never had been Rossetti's mistress. The marriage of Edward and Georgiana Burne-Jones was never quite the same again, and after 1870 it seemed to their friends that they had agreed to lead separate lives. For Burne-Jones, it was the beginning of his disillusionment. He wrote later,

> A painter ought not to be married …
> children and pictures are too important to
> be produced by one man.

He was careful to avoid scandal in the future, but remained susceptible. He continued to confide in several lady friend – Frances Graham, Mrs Norton, Mrs Gaskell – writing long and affectionate letters to all of them. Sentimental friendship of this kind was an accepted custom of the Victorian period.

The 1870s were to bring him further tribulations, and eventual triumph.

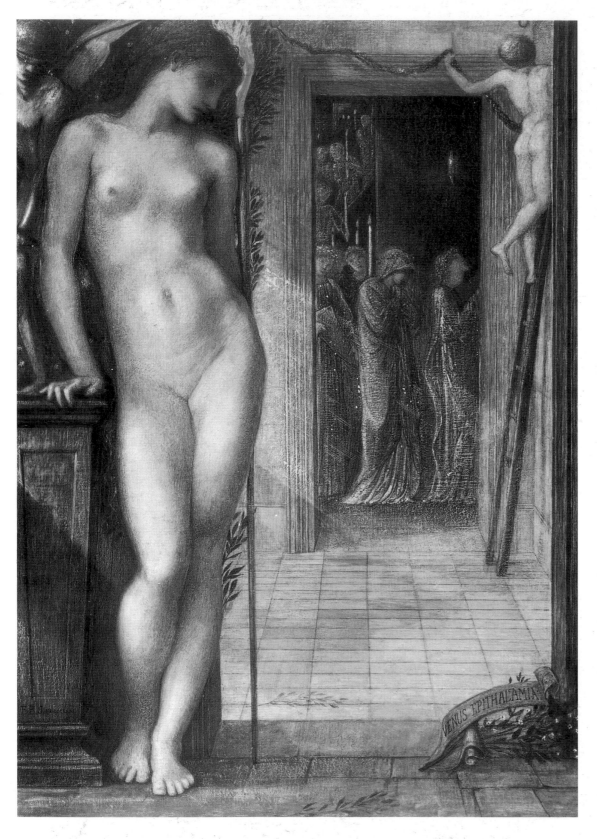

Left: **Venus Epithalamia**, *1871. A tribute to Maria Zambaco, here portrayed as Venus, Goddess of Love. Behind her is the blindfold Cupid, a reference to Maria as the victim of love. She stands alone and pensively aloof from the preparations for her wedding which takes place in the background.*

Opposite: **Maria Zambaco**, *1870. Painted at the height of Burne-Jones's affair with Maria Zambaco, this portrait shows her holding a book open at an illustration of his own* Chant d'Amour. *The arrow in the foreground has his name on it, and Cupid draws a curtain, a traditional device in depicting Venus.*

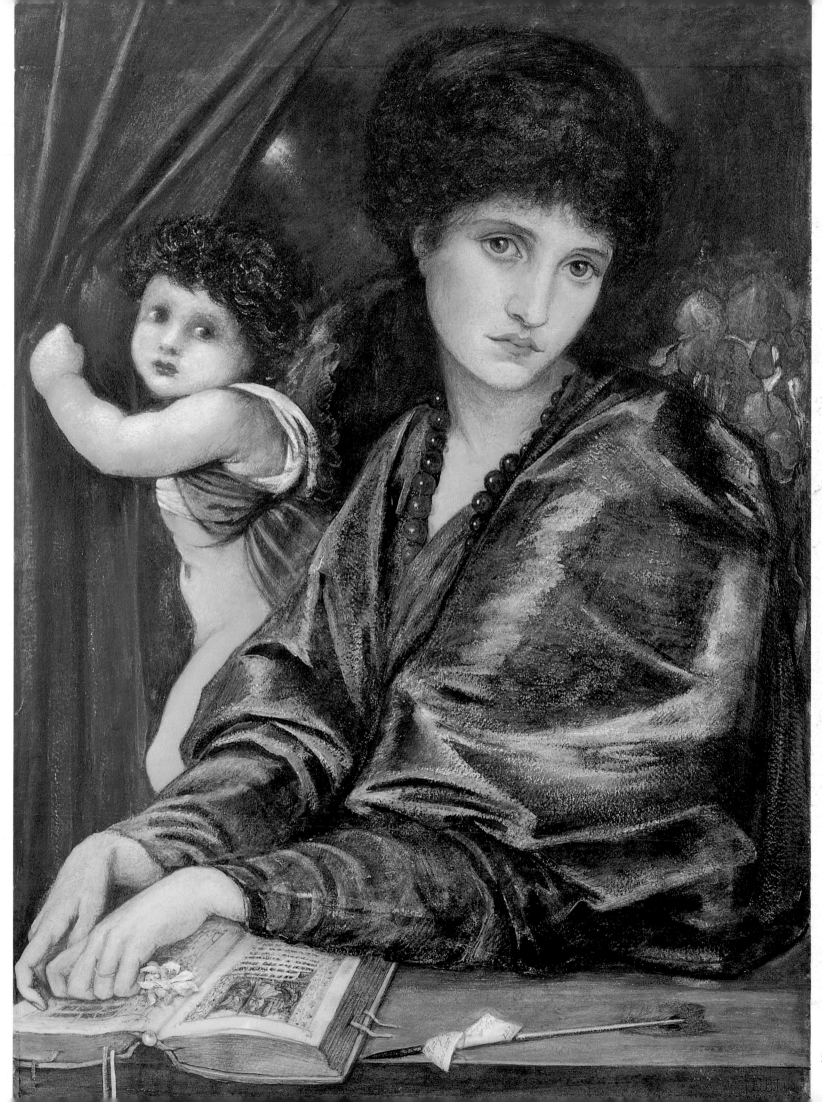

51

THE AESTHETIC MOVEMENT – THE 1870s

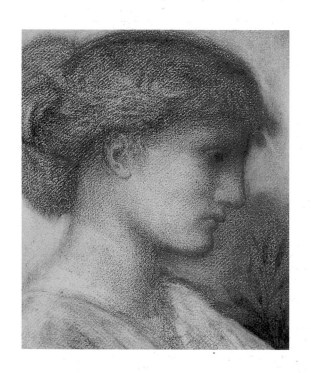

The first of the trials and tribulations to beset Burne-Jones in the 1870s was the furore at the OWS over his watercolour of *Phyllis and Demophöon* (see p. 34). His mistress Maria Zambaco had modelled for the figure of Phyllis, but what caused the problem was the nudity of the figure of Demophöon. An anonymous letter was sent to the Society, which panicked, and requested that Burne-Jones withdraw the picture, which he did. Later Burne-Jones wrote to resign his membership. Frederick Burton, angered by the treatment of his friend and colleague, resigned at the same time.

Worse was to come in 1871. A minor poet called Robert Buchanan wrote a venomous attack on Rossetti, Swinburne and their circle, entitled 'The Fleshly School of Poetry'. The article denounced their poetry as decadent, immoral and excessively sensual. Although Buchanan was exposed as an embittered and jealous failure, the effect on Rossetti was disastrous. He became increasingly withdrawn and reclusive, paranoid about conspiracies against him and dependent on the drug chloral. He cut himself off from many of his old friends, including Burne-Jones, who was deeply saddened by the change in his great hero and mentor. He must also have felt that Buchanan's charges were levelled against him. As if this was not bad enough, Simeon Solomon was arrested in 1873 on charges of indecency, and sentenced to a short term of imprisonment.

Left: *'Study of a Woman's Head'. Typical of the grainy drawings Burne-Jones produced in the late 1860s.*
Opposite: **Zephyrus and Psyche**, *1865. Another episode from the story of Cupid and Psyche. At Cupid's command, Zephyrus is carrying the unconscious Psyche to a place of safety; instead of killing Psyche, as Venus ordered, Cupid wishes to save her for himself.*

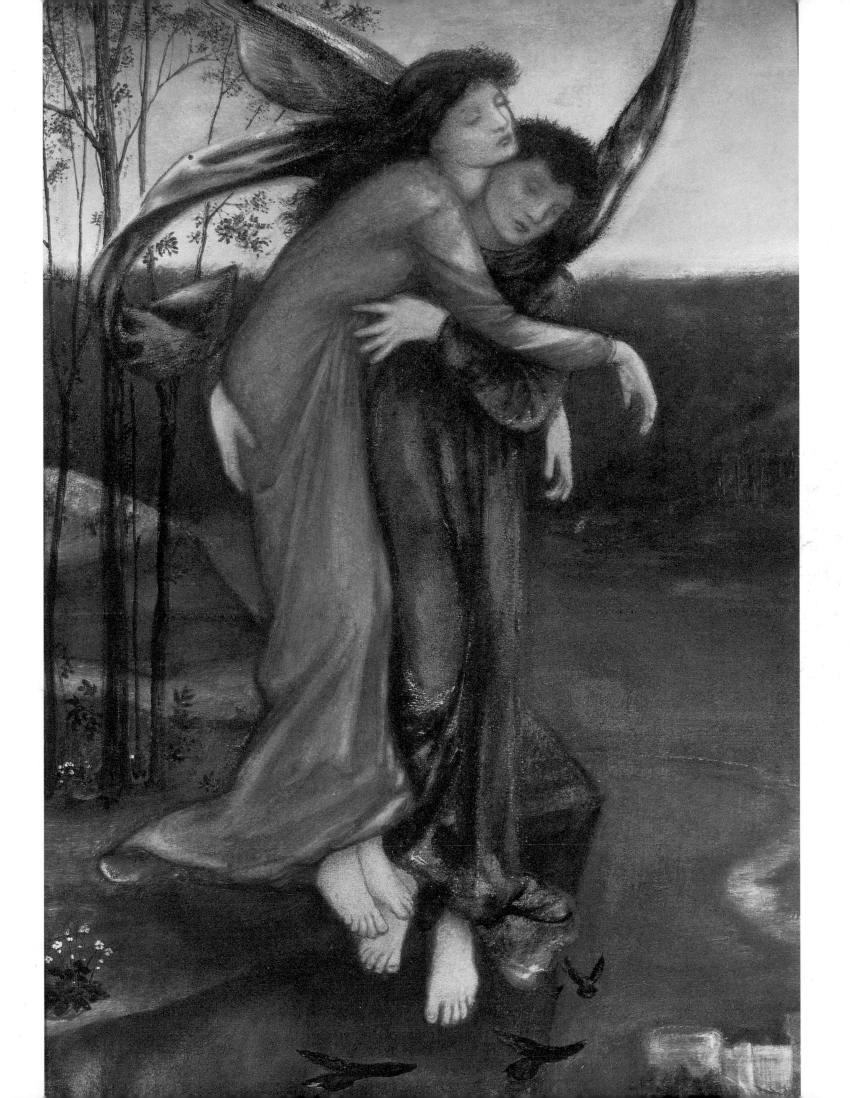

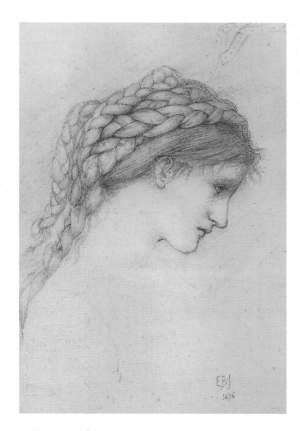

Above: *'Study of the Head of a Girl with Braided Hair'*, 1876. *Typical of Burne-Jones's more delicate and refined drawing style of the 1870s.*

Right: **Souls by the Styx**, c.1873. *This melancholy subject was inspired by Virgil's* Aeneid, *which Morris and Burne-Jones were working on together in the early 1870s. It depicts souls awaiting their passage to the underworld across the River Styx.*

Opposite: **The Aeneid** *(2), 1874–5. Iris appearing before Turnus. The* Aeneid *is the most beautiful and elaborate of the illuminated manuscripts produced by Burne-Jones and Morris. It was completed after their death by Graily Hewitt, Louise Powell and Fairfax Murray.*

He thereafter became a complete social outcast, shunned by all his former friends, including Swinburne. The Palace of Art was under siege, and Burne-Jones's response was to go to ground. Between 1870 and 1877 he did not exhibit in public at all, except for two pictures shown at the Dudley Gallery in 1873, *The Hesperides* and *Love among the Ruins*. He was kept going by his faithful patrons, such as William Graham and Frederick Leyland. To escape the trou-

bles and distractions of England, he made two more trips to Italy, in 1871 and 1873, in search of reassurance and renewed inspiration. He felt in need of both as he had sixty pictures, in oil and watercolour, unfinished in his studio.

These two last trips to Italy were to have the effect of widening and deepening Burne-Jones's appreciation and understanding of Italian art. The Italian painters of the Renaissance were to provide a key element

in the evolution of his own distinctive style. He remained at heart a medievalist, but it was a medievalism filtered through the distorting mirrors of the Italian Renaissance and Greek sculpture. All this was typical of the time, and typical of the Aesthetic Movement. Watts, too, often said that his ideal was the form of Phidias and the colour of Titian.

In 1871, Burne-Jones visited Genoa, Florence, Pisa, San Gimignano, Siena,

Orvieto and Rome. Although he disliked Rome as a city, the highlight of the trip was a visit to the Sistine Chapel to see the Michelangelo frescoes. According to his wife, Burne-Jones lay on his back and studied the frescoes from end to end, with the aid of opera glasses and a rug. On his return to England, he wrote, 'I love da Vinci and Michelangelo most of all,' although he also included in his list of favourites Signorelli, Mantegna, Giotto, Orcagna, Botticelli, Andrea del Sarto, Uccello and Piero della Francesca. A fairly eclectic list. During the 1870s, Burne-Jones's figures became increasingly large, monumental and Michelangelesque, especially in his stained-glass window designs. But the mood transmitted by the figures of Burne-Jones is entirely different from those of Michelangelo; Burne-Jones's figures are hesitant, pensive, wistful, almost effeminate, unlike the heroically confident muscularity of Michelangelo's figures. In their expressions, Burne-Jones's figures are more reminiscent of Botticelli and Leonardo. They represent the Italian Renaissance as interpreted by a high Victorian Aesthete.

Burne-Jones's new-found admiration for Michelangelo distanced him even further from his former mentor, Ruskin. In a lecture in Oxford in 1870, Ruskin had strongly attacked the artists of the Italian High Renaissance, especially Michelangelo and Tintoretto. He criticized Michelangelo on four grounds – hasty execution, violence of transitional action, physical instead of mental interest, choice of evil rather than good. He also complained that Michelangelo's influence had been unfortunate, as he tended to attract 'weak and pedantic persons'. Ruskin might have had Burne-Jones or Watts in mind when he wrote this. But Ruskin's moralistic tone was increasingly out of step with the Aesthetic 1870s. Younger writers such as Walter Pater and John Addington Symonds were championing the High Renaissance, Greek sculpture and a return to Classical myth.

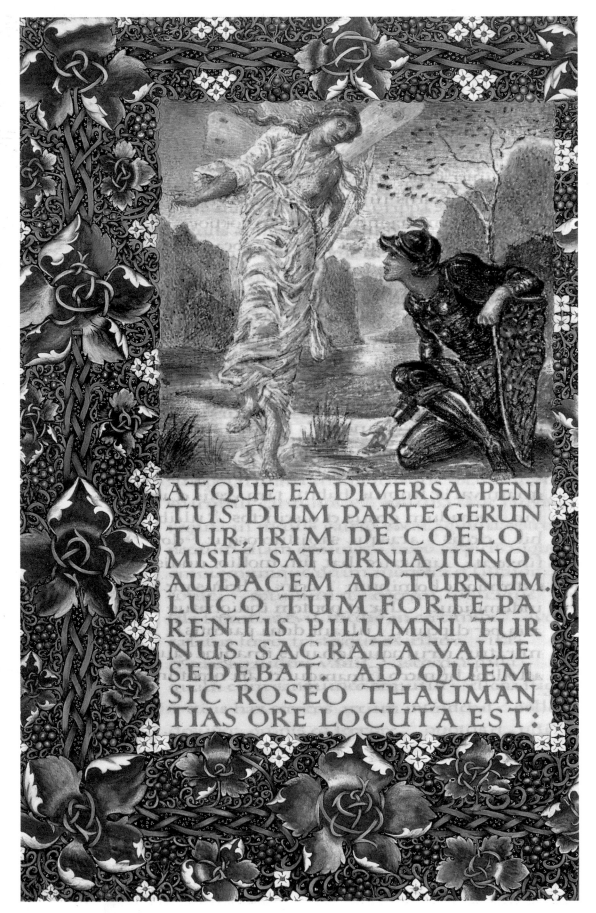

Symonds, in his book *The Italian Renaissance* (1875–6), singles out Michelangelo as 'the prophet and Sybilline seer; to him the Renaissance discloses the travail of her spirit; him she imbues with power; he wrests her secret, voyaging, like an ideal Columbus, the vast abyss of thought alone.' He also contrasts the 'joyous and sedate serenity' of Phidias, with the 'strange and awful sense of inbreathed agitation' in Michelangelo. It was part of Burne-Jones's genius that he was able to absorb all these different influences, and artistic currents, into his own style, and yet not be overwhelmed by them. In 1873 Burne-Jones made his last trip to Italy, this time accompanied by Morris. This trip was not a great success. They went first to Florence, to visit Spencer Stanhope, who was living there, and then to Siena, to see Fairfax Murray. Morris became increasingly depressed by Italian blue skies, and longed for English cloud and rain. From Siena he left for home, leaving Burne-Jones to travel on alone to Volterra, San Gimignano, Bologna and Ravenna. Here Burne-Jones began to

feel ill, so he also cut short his trip and went home.

Burne-Jones returned to his crowded studio, and the sixty unfinished works awaiting him. In spite of the depressions and uncertainties that were to haunt him all his life, and the periodic crises of confidence, the 1870s were to see the gestation and completion of some of his greatest works, such as the *Briar Rose* series, *Love among the Ruins*, *The Days of Creation*, *Laus Veneris* and the *Perseus* series. This was the decade when Burne-Jones's mature style at last evolved. Among the other works awaiting him in London was an ambitious altarpiece on the theme of *The Story of Troy*, begun in 1870. This was conceived as a Renaissance polyptych similar to one by Mantegna in the church of St Zeno in Verona, which Burne-Jones had visited in 1862. It contained three main panels, and three predellas, or smaller panels, below; the whole contained in an architectural setting in Renaissance classical style. A large oil sketch of the whole project survives in Birmingham City Art Gallery. Although Burne-Jones was never to complete it, several of the panels were developed later into paintings, notably *The Wheel of Fortune* and a *Feast of Peleus*. Large, unfinished versions of most of the other panels survive, mostly the work of studio assistants. It is undoubtedly significant that Burne-Jones never completed the Troy triptych. In attempting to combine a classical subject with an Italian Renaissance altarpiece, he probably felt in the end that it was too derivative. By the mid 1870s, he had outgrown it, and moved on. Burne-Jones was

Above left: *Self-Caricature by an Easel.*
Right: **Cupid and Psyche**, *1867. Between 1864 and 1868 Burne-Jones made numerous drawings to illustrate Morris's* Earthly Paradise, *including forty-seven finished designs for 'The Story of Cupid and Psyche'. Eventually they were not published, but Burne-Jones made use of them for many years to come, in paintings, watercolours and murals.*

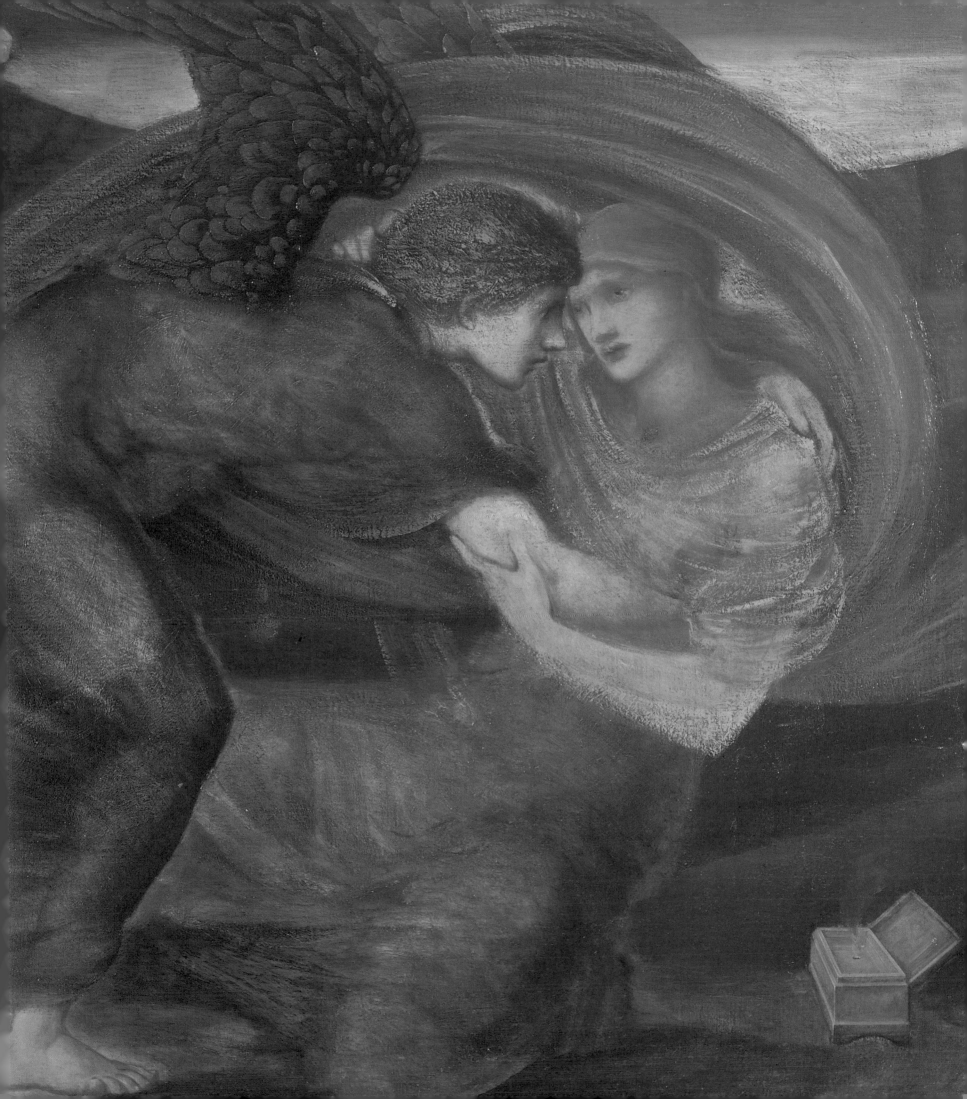

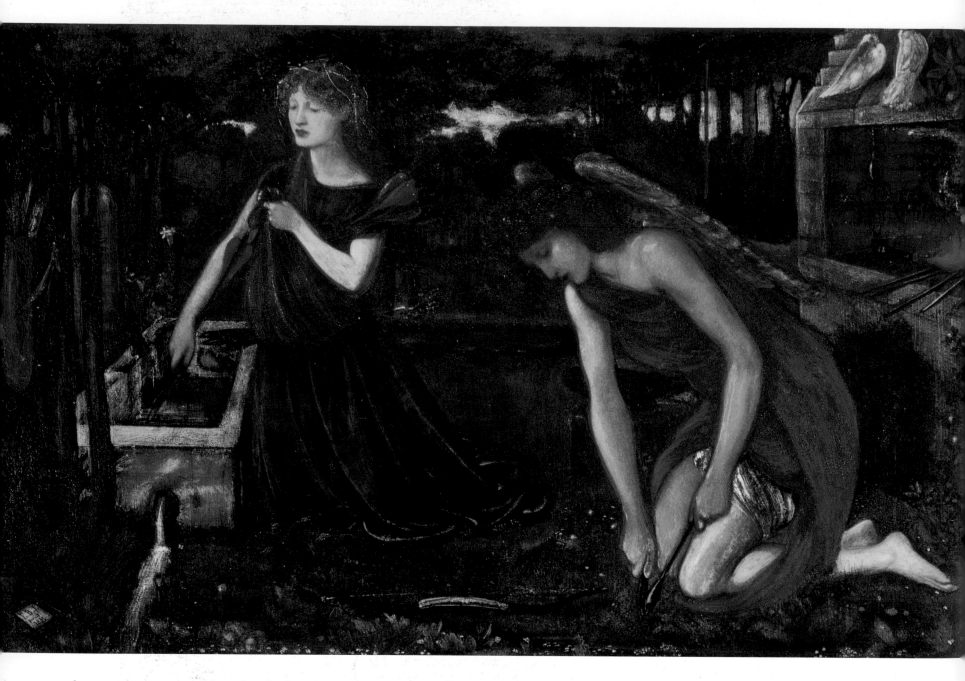

always more successful at developing his own ideas.

Much of the Troy triptych is the work of studio assistants, in particular T. M. Rooke, who painted two of the smaller predellas, *Venus Discordia* and *Venus Concordia*. The central predella, the *Feast of Peleus*, survives in a large unfinished version, which is mostly the work of assistants, and a small, highly finished version by Burne-Jones in Birmingham City Art Gallery. Burne-Jones's method was to make detailed pencil drawings, which would be transferred to canvas by assistants. The underpainting would then be carried out by assistants, so that Burne-Jones could then finish off the overpainting. It must have often happened that Burne-Jones either lost interest at this point, or did not have time to finish the pictures. This explains why there are so many unfinished works, or unfinished versions, in Burne-Jones's œuvre. His idea was to run a kind of Renaissance studio, with him and the assistants working simultaneously on a great many projects. Burne-Jones's output was therefore huge, and historians will be kept busy for many years debating just how much of his work is by assistants.

Burne-Jones's periodic moods of depression and uncertainty were another reason why he left so many pictures and projects incomplete. Like most creative people, he suffered from bouts of lack of confidence. He wrote to Watts, who became a father-figure for him,

about every fifth day I fall into despair as usual. Yesterday it culminated and I walked

about like an exposed impostor feeling as contemptible as the most of them could feel, and if it were not for old pictures that make one forget self for a time I don't know how I should ever get to work again ...

But get to work again he did, and the 1870s were to prove his most productive decade. His mind was literally teeming with new ideas at this period, many of which were to preoccupy him for the rest of his life. His last Italian journeys seem to have finally enabled him to turn the corner and develop his own style at last. Increasing confidence led him to work on a larger scale, and the 1870s were to see the completion of some of his finest paintings. He was also by this time working on other subjects, such as *The Sleeping Beauty*, which became the *Briar Rose* series, *Danae or the Brazen Tower*, *Pan and Psyche*, *Chant d'Amour*, *The Golden Stairs*, *Orpheus*, the *Perseus* series, as well as the *Cupid and Psyche* series for George Howard, which was to be the genesis for many other works. By the 1870s Burne-Jones had found most of his ideas; now he only needed the time to carry them out. By 1877, he was ready for his first, and greatest, public triumph, at the opening exhibition of the Grosvenor Gallery.

Burne-Jones's paintings of the 1870s, his middle period, are distinguished by their richness of colour, strong sense of line and brilliant all-over decorative effect. They are also fairly flat and one-dimensional, which gives them the appearance of beautiful tapestries. Later on Burne-Jones became

Opposite: **Cupid's Forge**. *Another watercolour based on the story of Cupid and Psyche, for Morris's* Earthly Paradise. *This was to be the most important source for Burne-Jones's pictures, resulting in no fewer than thirty-five later pictures, including the* Pygmalion *and* Perseus *series.*

Right: **The Bath of Venus**. *Another picture which owes its origin to the Cupid and Psyche series. Burne-Jones worked on it for a long time, from 1873 to 1888.*

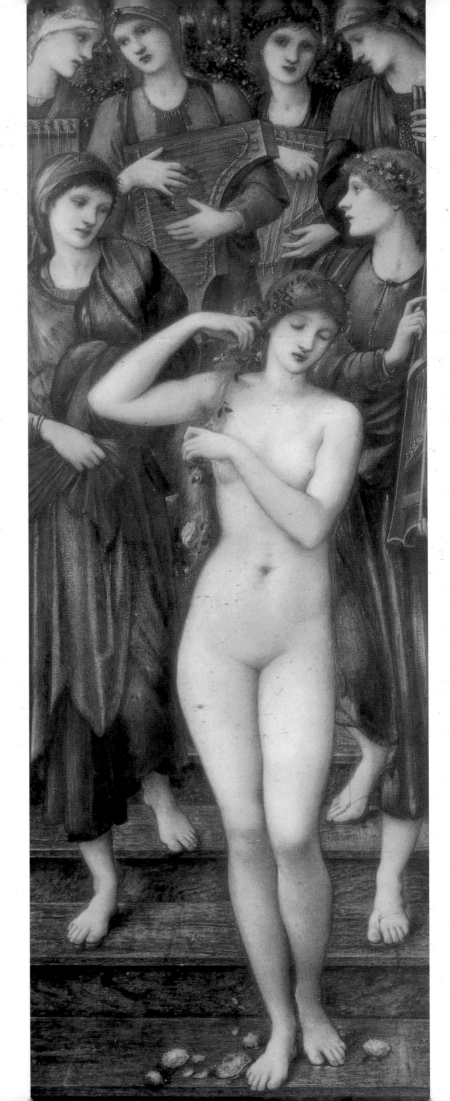

59

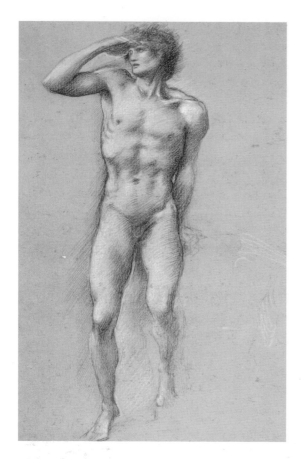

involved in tapestry design, for which his style was ideally suited. The subject of most of these pictures is the power of love, and following his own affair with Maria Zambaco his work develops greater emotional depth. Burne-Jones was not worried by criticisms that his pictures were too flat and lacked perspective. An all-over decorative effect is what he preferred. He wrote,

I love my pictures as a goldsmith does his jewels … I should like every inch of surface so fine that if all but a scrap from one of them were burned or lost, the man who found it might say whatever this may have represented it is a work of art, beautiful in surface and quality of colour.

Laus Veneris is one of the most beautiful of the 1870s works, and in many ways typical of Burne-Jones's mature style (see p. 77). The subject is taken from a poem of the same title by his friend Swinburne, and a watercolour version of the picture dates

from as early as 1861. It shows a queen and her attendants sitting in a tightly enclosed space, the background mainly consisting of a tapestry. The dresses of the figures are a mixture of brilliant colours, reds, blues and greens, and the queen's dress is a hot, shimmering orange. The attitude of the queen is listless, and the atmosphere of the picture vibrates with suppressed emotion. The faces and the dresses of the girls are strongly Italianate and Botticellian. Through a narrow horizontal window we see a group of knights riding by. Their colours, by contrast, are chilly blues and greys. The hothouse atmosphere of the picture is very similar to that of Swinburne's poem.

Above: *'Mermaids in the Deep'. Inscribed on the reverse 'Study from nature at Rottingdean August 1882'. Burne-Jones recalled that at Rottingdean 'I designed many scenes of life under the sea; of mermaids, mermen, and mer-babies…'*
Above left: *Study for* The Call of Perseus. *A nude study for the figure of Perseus in* The Call of Perseus, *with obvious Michelangelesque overtones.*
Opposite: *'St John the Baptist Preaching', 1877. A design for a stained-glass window at Monifieth Church, near Dundee, in Scotland. It was from these drawings that the enlarged cartoon was made, either by studio assistants or by photography.*

Behold, my Venus, my soul's body, lies
With my love laid upon her garment wise,
Feeling my love in all her limbs and hair.
And shed between her eyelids through her eyes

Burne-Jones's figures have a sense of melancholy resignation and passive acceptance of their fate. To Burne-Jones men and women seem to be mere puppets of fortune, unable to escape what fate has decreed for them.

The Mirror of Venus is another of Burne-Jones's great pictures of the 1870s (see p. 65). The subject had its origin in the *Earthly Paradise* illustrations of the mid 1860s, and one version, entitled *Venus's Mirror*, was begun by 1866. After numerous reworkings, and studies in chalk, gouache and oil, the second, larger version in oil was painted between 1873 and 1875. No picture better illustrates Burne-Jones's unique genius for blending together Pre-Raphaelitism and the Italian Renaissance into a new, Aesthetic style. The scene is purely imaginary, and shows Venus and her maidens gazing at their own reflections in a pool of water. The foreground is a carpet of flowers, but the landscape background is arid and rocky. It is not intended as a view of anywhere in particular; rather it is never-never land. These strangely lunar landscapes were to become a recurring feature of Burne-Jones's art, widely imitated by his followers. If anything, they resemble the often barren landscapes in the backgrounds of Italian Renaissance pictures. The mood and the colours of *The Mirror of Venus* are Pre-Raphaelite, but the self-conscious sweetness and elegance of the figures recall the Italian Renaissance, and in particular Botticelli, an artist later to become a cult among fashionable Aesthetes. The conception is purely Aesthetic – a ring of beautiful girls in colourful draperies of red, blue and orange, with the minimum of narrative or historical context. The draperies are pseudo-Classical, and the title is *Venus*, but it could equally well have been *Reflections*. Through the faces of the girls, and their elegant poses and wistful expressions, Burne-Jones conveys that feeling of intense sadness and nostalgia for the past that is the keynote of so many late Pre-Raphaelite pictures. A picture such as *The Mirror of Venus* is intended above all to be beautiful, and to appeal to the poetic imagination of the spectator.

More specifically Classical is *Pan and Psyche*, commissioned in 1872 by George Hamilton, a business associate of William Graham. Burne-Jones had actually begun it in 1869, and completed it by 1874, retouching it finally in 1878. Once again, the source was *The Story of Cupid and Psyche*, one of many designs for Morris's *Earthly Paradise*. Psyche, having lost Cupid, has thrown herself into a river; she is saved, and comforted, by the god Pan. The picture is in many ways reminiscent of *The Death of Procris* by Piero di Cosimo, which Burne-Jones would have known at the National Gallery, which acquired it in 1862. Burne-Jones has transformed it, however, into his own inimitable idiom. He seems to have been particularly fascinated by the story of Cupid and Psyche, for which he made

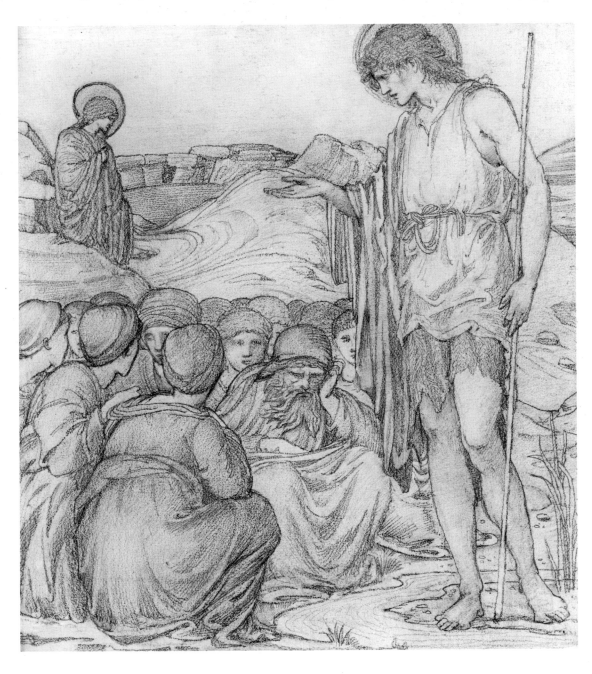

61

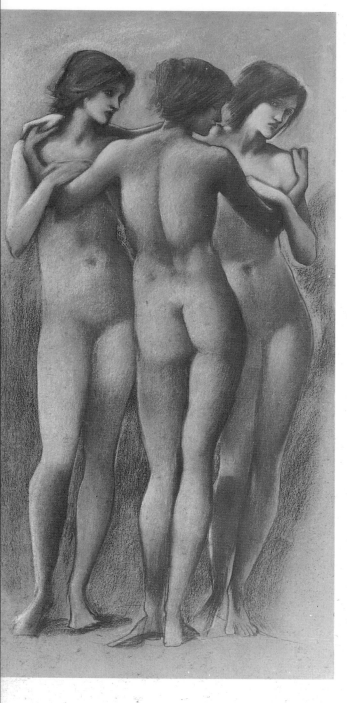

Above: 'The Three Graces'. A study of the Graces in the large oil version of Venus Concordia (Plymouth Art Gallery). This is one of many compositions developed out of the Troy triptych.
Opposite: **Love among the Ruins**, 1894. This is the second oil version of the subject, painted after the first version, a gouache of 1870–73, was badly damaged by Goupil's in Paris. He used two professional models, Gaetano Meo and Bessie Keene, and exhibited this version at the New Gallery in 1894.

forty-seven finished drawings, now in the Ashmolean Museum, Oxford. No doubt the story appealed to him as an allegory of the soul's search for God. The story was popular with many late Victorian artists, particularly J. W. Waterhouse. Burne-Jones later returned to the subject of Pan with *The Garden of Pan* (1886–7). *Pan and Psyche* was shown at the second Grosvenor Gallery exhibition of 1878, where it appeared with *Le Chant d'Amour*, another picture begun in the 1860s, but not finished until the 1870s.

Another remarkable masterpiece of the 1870s is *Merlin and Nimue*, now generally known as *The Beguiling of Merlin*. This and *The Mirror of Venus* were commissioned by F. R. Leyland for his famous Aesthetic interiors at 49 Prince's Gate in London, where Whistler painted the notorious Peacock Room. Both pictures were shown at the celebrated opening exhibition at the Grosvenor Gallery in 1877. Burne-Jones had already painted at least two earlier versions of *Merlin and Nimue*, so he was reverting once again to his favourite Arthurian themes. The source in this case was the medieval French *Romaunce of Merlin*, in which Merlin is lulled to sleep by the enchantress Nimue, in a hawthorn bush in the forest of Broceliande. The subject had also been described by Tennyson in *The Idylls of the King* (1859). This is the scene which Burne-Jones chose to depict, and the result is one of his most arresting compositions. The theme, once again, is the power of love, or enchantment, and consists of two figures, as so often in Burne-Jones's pictures. The standing figure of Nimue is highly Michelangelesque, and presents a strong vertical contrast to the supine, horizontal figure of Merlin, whose eyes glisten as if in a hypnotic trance. The model was the American journalist W. J. Stillman, who later married the Greek beauty and artist, Maria Spartali. The tension is accentuated by the writhing, linear forms of the drapery and the densely contorted background of the hawthorn bush. Burne-Jones has used

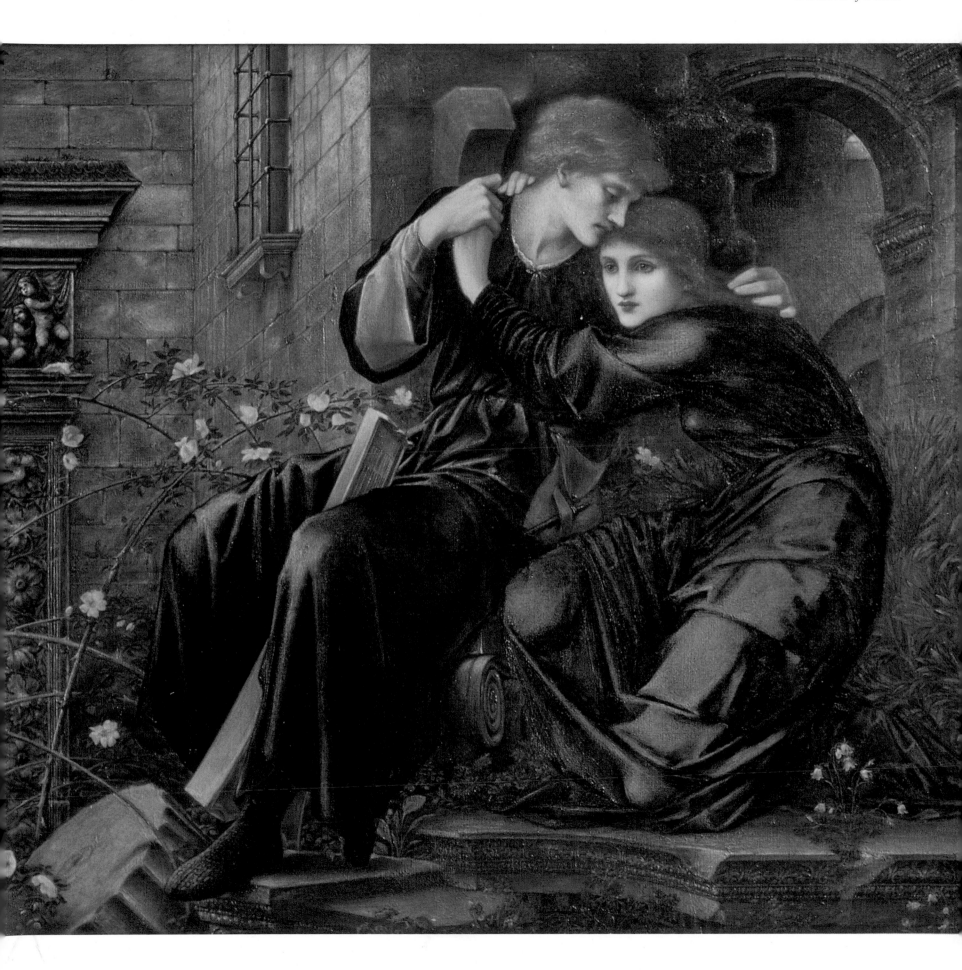

all these elements to create a remarkable tension and drama – one of his finest evocations of the world of medieval romance.

By the 1870s, Burne-Jones was able to interpret any subject – classical, religious, Arthurian or simply make-believe – in his own uniquely personal way. He had learnt to fuse together all the complex elements that went to make up his extraordinary style. *Love among the Ruins*, which he

worked on from 1870 to 1873, is based on a poem of the same title by Browning. In the poem, Browning muses on the decay of a once-great city, now completely overgrown and obliterated. He concludes that the power of love is all that survives, and the last line of the poem is 'Love is best!' Burne-Jones has reinterpreted the poem by depicting a romantic but pensive couple in what seem to be the ruins of a classical city. In the foreground are pieces of a broken column, overgrown by briar roses very similar to those in the *Sleeping Princess*, or *Briar Rose* series, which Burne-Jones had begun to work on in 1871. The doorway to the left is strongly Italianate, as is much of Burne-Jones's architecture. The mood is once again sad and wistful and, combined with the title, suggests a reference to his affair with Maria Zambaco, which was by this time coming to an end. The model for the female figure may well have been Maria Zambaco, but it was repainted later.

Love among the Ruins was one of the very few pictures exhibited by Burne-Jones in the early 1870s. He showed it, together with *The Hesperides*, at the Dudley Gallery in 1873, and it entered the collection of Frederick Craven of Manchester, who bought several works by Burne-Jones at this period. Thereafter, *Love among the Ruins* was often exhibited in England, and in Paris at the Exposition Universelle of 1878, and became one of Burne-Jones's most popular works. Disaster struck in 1893, when it was sent to Paris for exhibition again, to the Goupil Gallery, who were instructed to photograph it for reproduction purposes. Ignoring Burne-Jones's own note on the back, pointing out that the picture was a watercolour, the gallery washed the picture over with white of egg, thereby ruining large areas of it. Later Burne-Jones discovered that white of egg could be removed by using ox-gall, and towards the end of his life restored and substantially repainted the picture. He had, in addition, already started on a full-size replica in oil, which he com-

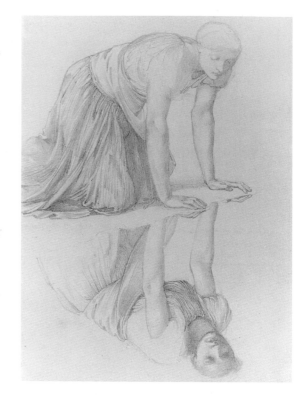

Top and above: *Two studies for* The Mirror of Venus.

Left: '*Saint Cecilia*'. *Saint Cecilia, patron saint of music, was a favourite with Burne-Jones, and he made numerous drawings and watercolours of her, usually holding a small portable organ.*

Opposite: **The Mirror of Venus,** *1873–1877. An oil study for the picture exhibited at the Grosvenor exhibition in 1877. Like* Laus Veneris, *it is based on an illustration for 'The Hill of Venus', a version of the Tannhäuser legend in Morris's* Earthly Paradise. *It was commissioned by F. R. Leyland.*

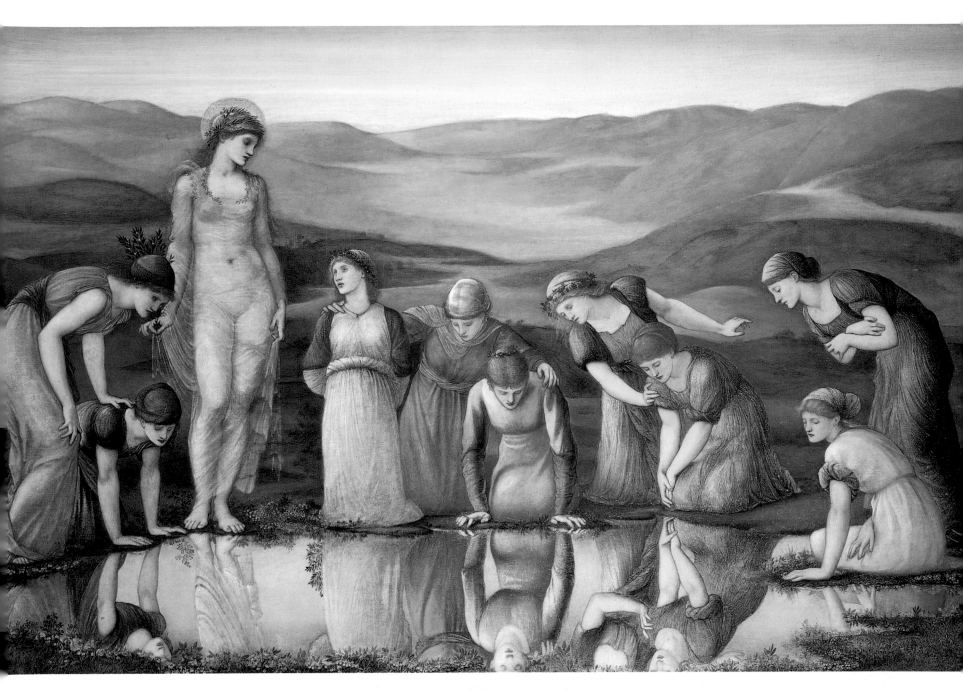

pleted during 1893 and 1894. This is the version which was shown at the New Gallery in 1894, and now hangs at Wightwick Manor, a National Trust property near Wolverhampton. Contemporary critics thought that the oil version, though better painted, lacked the mystery and magic of the earlier 1870–73 gouache. The title, *Love among the Ruins*, sounds typical of G. F. Watts, and it is interesting to compare Burne-Jones's picture with the many versions of Watts's *Love and Death*. Once again,

the comparison demonstrates how completely differently two artists, both belonging to the Aesthetic Movement, could interpret similar subjects.

Also shown at the 1877 Grosvenor exhibition was a set of six pictures entitled *The Days of Creation*. Although the originals are now in a museum in the USA, this set has become widely known through photogravures, usually framed as a set, with emblematic decorations on the frames. Burne-Jones painted a number of religious

subjects, most of which derived from stained-glass designs. *The Days of Creation* started life in 1870 as a cartoon for stained glass for the church at Middleton Cheney in Northamptonshire. It consists of six small lights above a window depicting Shadrach, Meshach and Abednego in the Fiery Furnace. Burne-Jones had also designed Creation windows for Waltham Abbey, and Selsley Church in Gloucestershire. The Creation was also the theme of a series of watercolours he made in 1863 for the

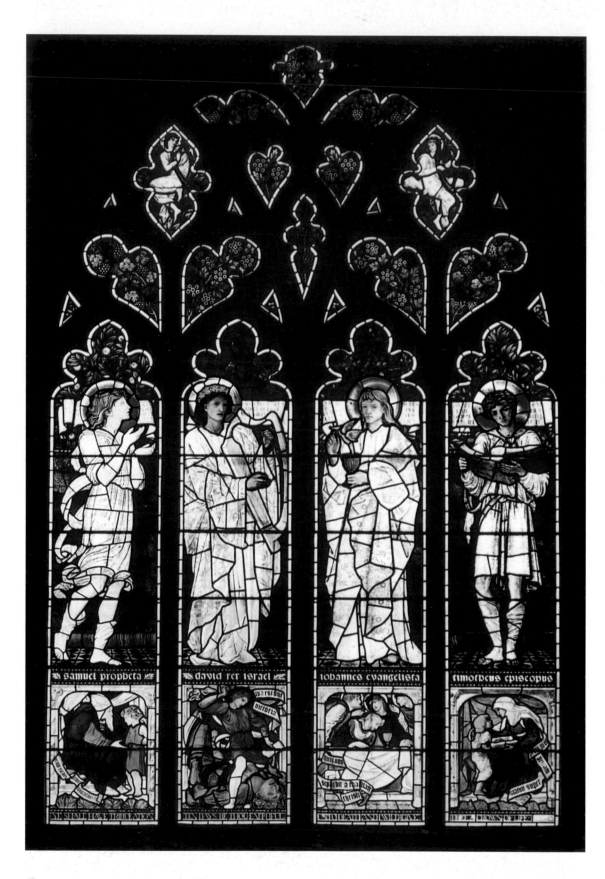

Dalziel Brothers' 'Illustrated Bible Gallery'. Burne-Jones therefore brought considerable experience to this subject, but in the final paintings he made a brilliant innovation. He decided to depict the Creation in a set of six crystal balls, held by angels. The first panel contains one angel, the second two, including the one from the first, and so on, until all seven angels appear in the sixth panel, which contains two new figures. The angels are once again Botticellian types, very similar to the figures in *Laus Veneris* and *The Mirror of Venus*. Some of them were modelled from Morris's daughter Jenny. The backgrounds are a dense mass of wings and flowers which, together with the colourful draperies, make a brilliantly decorative, tapestry-like effect. The Creation scenes inside each crystal ball strike a more mystical note, culminating in the Creation of Adam and Eve. Altogether they are one of Burne-Jones's most striking and original compositions. At the Grosvenor they were shown together in a Renaissance-style altarpiece frame.

During the 1870s, Burne-Jones became increasingly interested in painting series, or cycles, of pictures, with interlinking narratives. 'I want big things to do and vast spaces,' he told his wife. He was commissioned by three patrons – George Howard, Arthur Balfour and R. H. Benson – to carry out decorative schemes. The first commission came from his friend and fellow-artist, George Howard, an aristocrat who was later to become the 9th Earl of Carlisle. He was the owner of Castle Howard in Yorkshire, but preferred Naworth Castle in Cumbria, where both Morris and Burne-Jones were frequent guests. Howard was a professional artist, and part of a group now referred to as 'The Etruscans', who painted landscapes in the Italian Campagna. The leader of the group was an Italian artist, Giovanni Costa, who also became a friend of Burne-Jones, and of Frederic Leighton. George Howard was a valued client of Morris & Co. from the

beginning, and commissioned furniture, carpets and other products for his houses. His London house at 1 Palace Green, in Kensington, was completely refurnished in the Firm's taste. In 1872 he commissioned Morris and Burne-Jones to decorate the dining-room with a series of episodes from the story of Cupid and Psyche. Twelve designs were selected from the *Earthly Paradise* illustrations, that most fertile source of inspiration for Burne-Jones's pictures. First Burne-Jones painted a set of preparatory watercolours, to establish the overall design and the colour scheme. Unfortunately, as so often, he did not find time to paint the murals, so Howard called in Walter Crane to finish the job. In his memoirs, Crane described his part in the completion of the scheme:

> The frieze was to be painted in flat oil colour enriched with raised details gilded somewhat after the manner of Pinturrichio. The canvases – in various stages, some blank, some just commenced, some, in parts, considerably advanced – were all sent to my studio at Beaumont Lodge, and I started to work, having the prints from the woodcuts above mentioned to go by.

Crane worked from both woodcuts for *The Earthly Paradise* and Burne-Jones's watercolours. Morris's contribution was to paint patterned decoration around the murals, and also to inscribe suitable passages from

Right: 'L'Amore che Muove'. The full-size cartoon for the large embroidery designed for Frances Horner. She carried out the embroidery, which is now in the church at Mells, Somerset.

Opposite: **The Vyner Memorial Windows,** *Christ Church, Oxford. Designed by Burne-Jones for Morris & Co. in the 1870s, they clearly show the artist's new aesthetic style, in contrast to the St Frideswide windows in the same chapel.*

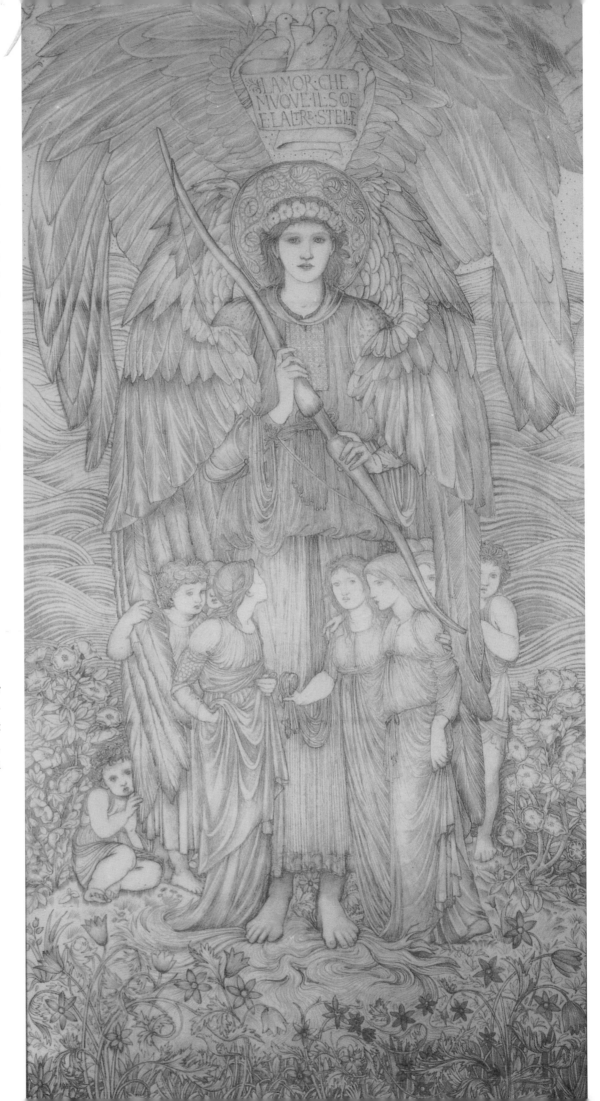

THE GROSVENOR GALLERY – SUCCESS

The Grosvenor Gallery was the brain-child of a Victorian aristocratic amateur, Sir Coutts Lindsay, and his rich and artistic wife, Blanche, whose mother was a Rothschild. Both Sir Coutts and his wife were artists, and both felt that there was a need for an exhibition space in London where young contemporary artists, both English and foreign, might show their work. In 1875, after discussions with a fellow-artist, Charles Hallé, Lindsay decided to build a new gallery from scratch. A site was found on the west side of New Bond Street, more or less opposite to where Sotheby's stands today. The façade, designed by an architect called Sams, was Italianate, with a classical doorway removed from a Palladian church in Venice, recently demolished. Two large galleries were built on at the back, in plain brick.

The interiors, however, were far from plain. Both the entrance hall and the two main galleries were furnished in grandiose, Italianate style, with classical columns and pilasters. The main galleries were lined with a rich, red damask. There were also smaller watercolour and sculpture galleries. Furniture, statuary and carpets were added to the décor, which gave the impression of a grand, private house. Lindsay might well have had in mind Dorchester House on Park Lane, which belonged to his brother-in-law, Robert Holford, and which was also furnished in grand, Italianate style. The Grosvenor Gallery was finished and ready to open by 1877.

Left: *Study of the head of Nimue, 1870, used in* The Beguiling of Merlin
Opposite: **The Beguiling of Merlin**, *1874. Shown at the first Grosvenor Gallery exhibition of 1877, this picture helped to establish Burne-Jones's reputation. The model for Merlin was the American journalist W. J. Stillman. Nimue was modelled by Maria Zambaco.*

During the year or so before the opening the Lindsays began to approach artists and invite them to contribute to the opening exhibition. These invitations were extended both to Royal Academicians and non-Academicians, as Lindsay did not seek a confrontation with the power of the Royal Academy. As a result numerous RAs did exhibit at the Grosvenor, including Alma-Tadema, Leighton, Millais, Poynter and even the then President of the RA, Sir Francis Grant. The Grosvenor was undoubtedly intended as a challenge to the Academy's monopoly, but Lindsay's conciliatory approach was to have one regrettable consequence – Rossetti refused to exhibit. He wrote a letter to *The Times* stating his view that to open the Grosvenor to Academicians was contrary to the whole point of the exercise. In spite of Rossetti's refusal, Burne-Jones decided to exhibit, and wrote to Rossetti:

> As to the Grosvenor Gallery, if you have made up your mind we won't talk about it. I should have liked a fellow-martyr – that's natural – as it is I shall feel very naked against the shafts, and as often as I think of it I repent promising, but it doesn't really matter – the worst will be temporary disgrace.

What was to follow was far from a 'temporary disgrace'. Amongst the other artists the Lindsays persuaded to contribute were Walter Crane, Evelyn de Morgan, George Howard, Holman Hunt, Albert Joseph Moore, Spencer Stanhope, J. M. Strudwick, Tissot, G. F. Watts, Whistler and even Gustave Moreau from Paris. With such a roll-call the Grosvenor could hardly fail. One notable omission was Ford Madox Brown, who took umbrage at not being invited, and then later refused when he was.

After the usual feverish last-minute dramas, the Grosvenor finally opened its doors for its first annual exhibition on 1 May 1877. On the first day, 7,000 people

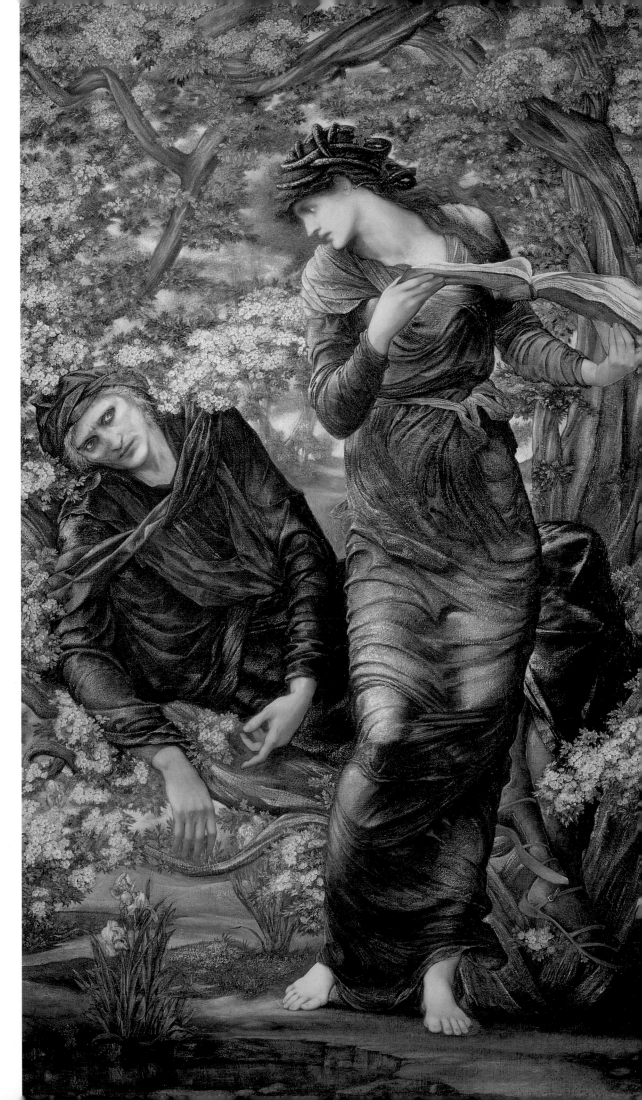

paid the shilling entrance charge. A grand dinner and reception were held on 7 May, attended by the Prince and Princess of Wales. Their presence ensured that the opening of the Grosvenor would be a highly fashionable event. Louise Jopling, a painter and exhibitor at the opening exhibition, wrote in her memoirs that

> The Gallery was opened with great *éclat*. The Prince and Princess of Wales were invited to dine, which they graciously consented to do, and all that London held of talent and distinguished birth were summoned to meet them. We dined in the Restaurant under the Picture Gallery, and afterwards a large reception was held upstairs.

In general, the reaction to the appearance of the galleries was enthusiastic. The painter W. Graham Robertson wrote that

> The general effect of the great rooms was most beautiful and quite unlike the ordinary picture gallery. It suggested the interior of some old Venetian palace ...

The young Oscar Wilde, just sent down from Oxford, appeared in a special suit designed as a cello. Writing for the *Dublin University Magazine*, he declared that the

Left: *The Grosvenor Gallery. Interior of the large West Gallery, 1877. This is the gallery where Burne-Jones's pictures were hung, on red damask walls.*
Below: *Study of the head and hair of Nimue, for* Merlin and Nimue
Opposite: *Study of the head of an Angel, 1879. A study of the head of the Angel in* The Annunciation, *exhibited at the Grosvenor Gallery in 1879, and now in the Lady Lever Art Gallery, Port Sunlight.*

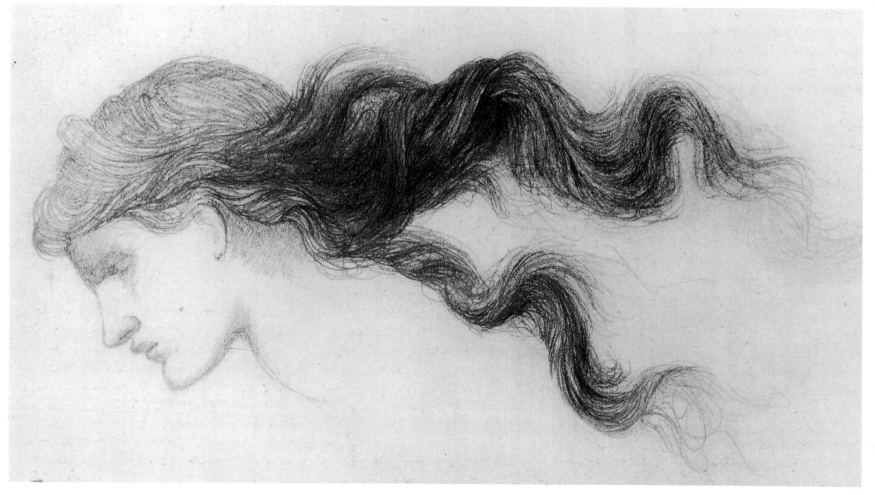

gallery had 'everything in decoration that is lovely to look on, and in harmony with the surrounding works of art'. The only dissenting voice was Ruskin's; he criticized the red damask walls, which he thought overwhelmed the pictures. In this Burne-Jones was to agree with him. Ruskin also wrote his celebrated diatribe against Whistler, which led to the unfortunate Whistler *v.* Ruskin case the following year, in which Burne-Jones was to be reluctantly involved.

One of the principles of the Grosvenor Gallery was that each artist's works should hang together, so that they could be properly appreciated as a group. This was in deliberate contrast to the Royal Academy, where the pictures were hung higgledy-piggledy, from floor to ceiling, with little thought of what pictures might hang next to each other. At the first Grosvenor exhibition, Burne-Jones sent in no fewer than eight works. Among them were some of his finest pictures of the 1870s – *The Mirror of Venus, The Beguiling of Merlin* and *The Days of Creation*. The remainder were single-figure pictures, *Temperantia, Fides, St George, Spes* and *A Sibyl*. They were hung together in a group, in the large west gallery. As Burne-Jones had hardly exhibited his work publicly since 1870, their effect was astounding. It is not too great an exaggeration to say that Burne-Jones became famous overnight. His wife wrote in her *Memorials* that

> from that day he belonged to the world in a sense that he had never done before, for his existence became widely known and his name famous.

The English realized at last that they had a genius in their midst.

The novelist Henry James, normally a caustic critic of English art, was one of the first to recognize Burne-Jones's originality. In his review of the 1877 exhibition, he singled out the pictures of Burne-Jones as 'by far the most interesting things in the Grosvenor Gallery', and concluded thus:

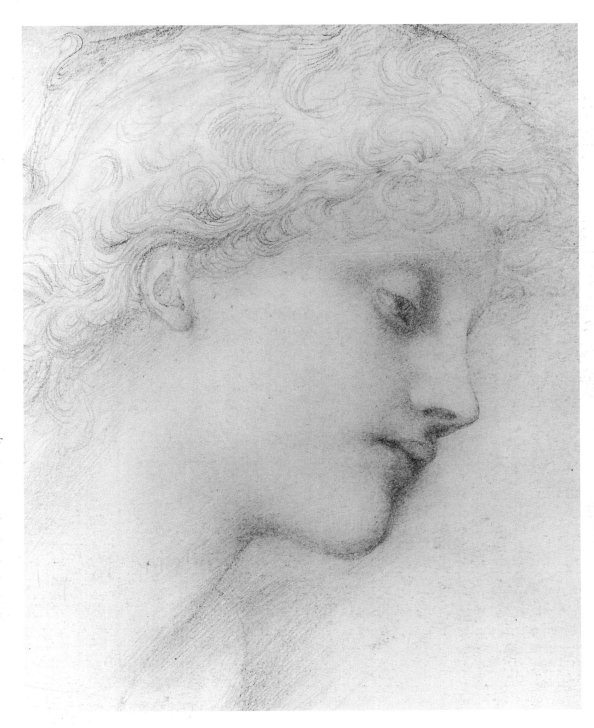

In the palace of art there are many chambers, and that of which Mr Burne-Jones holds the key is a wondrous museum. His imagination, his fertility of invention, his exquisiteness of work, his remarkable gifts as a colourist... all these things constitute a brilliant distinction.

Inevitably, there were some dissenting voices. Ruskin warned that Burne-Jones's work contained 'many elements definitely antagonistic to the general tendencies of public feeling'. He was presumably referring to Burne-Jones's deliberate other-worldliness, his total rejection of the modern world. Some found Burne-Jones's figures too decadent and effeminate. Philistines thought his male figures soppy, and in need of a pint of beer and a game of cricket! The Aesthetic movement was to provide an abundant

soon at work, and George du Maurier in his *Punch* cartoons created Mrs Cimabue Brown, Postlethwaite and a whole world of passionate Aesthetes, brilliantly caricaturing the more ridiculous antics of the PBs. His most famous cartoon showed an Aesthetic couple gazing rapturously at a Chinese vase, and saying, 'Can we live up to it?' The other Aesthetic emblems were the sunflower and the peacock feather. In 1880 Gilbert and Sullivan composed their operetta *Patience*, making fun of the whole 'greenery-yallery Grosvenor-Gallery' craze, and creating that archetypal Aesthetic character, 'Bunthorne, the fleshly poet'. So much had the moral climate changed by the 1880s, that the fleshly school of poetry was now simply regarded as a joke. As so often in England, behind the chortling of the philistines lay a serious artistic purpose. The Grosvenor Gallery, during its fourteen years of existence, was to become an important venue for contemporary art, and a key chapter in the history of English nineteenth-century art. Burne-Jones was to prove its most loyal

supporter, and continued to exhibit there almost every year until 1888.

In the midst of all this, Burne-Jones remained detached. He never expected the triumph at the Grosvenor, and was doubtless bemused by it. He was flattered by the attention of society, but his natural modesty

Left above: *'The Price of Success'. Burne-Jones with a lady visitor to his studio.*
Left below: *'A Bathing Beauty'. Burne-Jones seemed to have a particular horror of fat ladies, who frequently feature in his caricatures, sometimes dressed, sometimes not.*
Below: *Study of Fanny Cornforth. A study for the figure of Venus in* Laus Veneris. *Fanny Cornforth was for a time Rossetti's model, mistress and housekeeper.*
Opposite: **Laus Veneris**, *Completed 1878. The story comes from the medieval legend of Tannhäuser, on which Wagner based his opera. Morris recounted it as 'The Hill of Venus' in* The Earthly Paradise *and Swinburne used it in his poem 'Laus Veneris', published in 1866. This picture was shown at the second Grosvenor exhibition of 1878.*

source of mirth for satirists and cartoonists for many years to come.

Equally, there was much in Burne-Jones which corresponded exactly to the temper of the times and was to lead to his becoming a cult figure for the next decade, especially among young people. The opening of the Grosvenor Gallery began the fashionable phase of the Aesthetic Movement. Women began to cultivate the Burne-Jones look, wearing long, flowing dresses of sage, terracotta and olive-green, curiously embroidered. It became fashionable to be 'intense', and interested in art. Kensington became known as 'Passionate Brompton', where lived the beautiful people of the 1870s and 1880s, known as 'PBs'. The satirists were

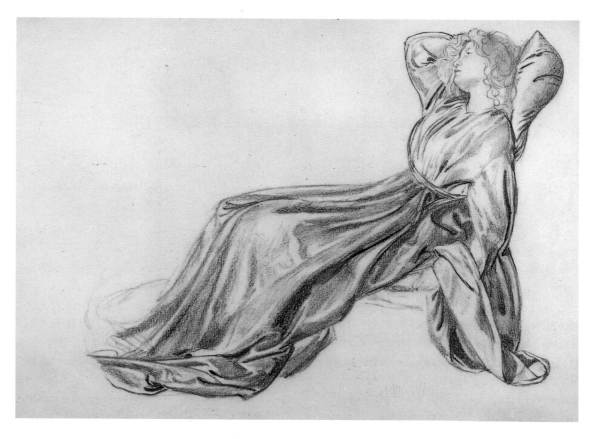

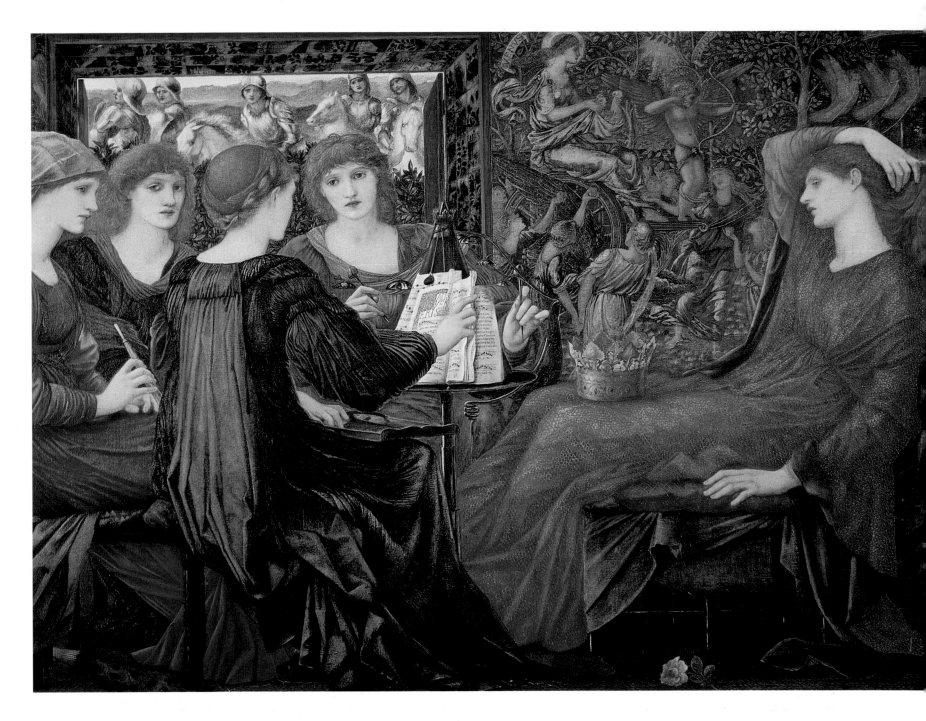

and complete devotion to his art prevented him from becoming spoiled. It became fashionable to visit Burne-Jones's studio, which doubtless distracted him, but he rarely complained, as it was the price of success. It did result in some of his most humorous caricature drawings, especially of fat ladies. Among his close friends, Burne-Jones could be a fascinating and amusing conversationalist, and almost all accounts of him in contemporary letters and diaries

speak of the quiet but delightful charm of his character. Arthur Balfour even declared, 'I have never known a man of equal charm.' Later, T. M. Rooke was to record his conversations in the studio with Burne-Jones, and these were published in 1981. Female confidantes were important to Burne-Jones, especially Frances Graham, later Lady Horner, also Mrs Benson, Mrs Gaskell and Mrs Norton. Many of them sat as models in his pictures. Burne-Jones also had a

remarkable affinity with children, to whom he wrote delightful letters, copiously illustrated with drawings and witty caricatures. His letters to Katie Lewis, the daughter of his friends Sir George and Lady Lewis, in *Letters to Katie* (1925), have now been published also. His many caricatures of himself reveal that he was always haunted by fears of his own inadequacy, and inability to finish things. He avoided reading reviews altogether. His wife recorded that 'two

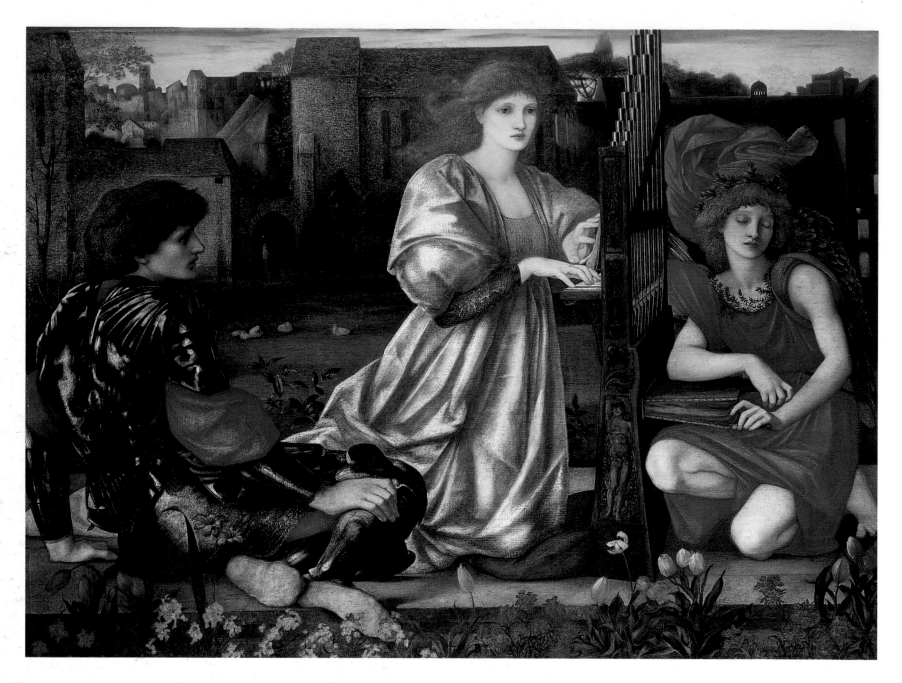

words from a brother-artist were worth them all'. Parodying his own critics, he once said to William de Morgan, the ceramic designer and novelist, 'Yes, I am going to cover that canvas with flagrant violations of perspective and drawing, and crude inharmonious colour.'

When the Grosvenor Gallery opened Burne-Jones was already in his mid forties, and success would not cause a change of course. Although he had become an acknowledged leader of the Aesthetic Movement, he was happy to leave the more

outrageous Aesthetes, such as Oscar Wilde, to jump on the new artistic bandwagon. Success gave him confidence to take on new commissions and projects, and to work on an increasingly large scale. The last twenty years of his life were to see a preoccupation with very large pictures and cycles of pictures, although he considered these a poor substitute for the walls he might have covered if he had lived in fifteenth-century Florence. More studio assistants came and went, notably T. M. Rooke, and John Melhuish Strudwick, both painters in their

Above: **Le Chant d'Amour**, *1868–73. The rich Italianate colours and Giorgionesque mood owe much to the influence of William Graham, who commissioned the picture in 1868. Henry James praised it at the Grosvenor exhibition of 1878, and described it as 'a group of three figures, seated, in a rather unexpected manner, upon the top of a garden wall'.*

Opposite: **Pan and Psyche**, *1869–74, retouched 1878. Yet again, a subject, based on 'The Story of Cupid and Psyche' from Morris's* Earthly Paradise. *The story of Psyche, which is taken from* The Golden Ass *by Apuleius, had great appeal to Burne-Jones, Waterhouse, and other late Victorian artists.*

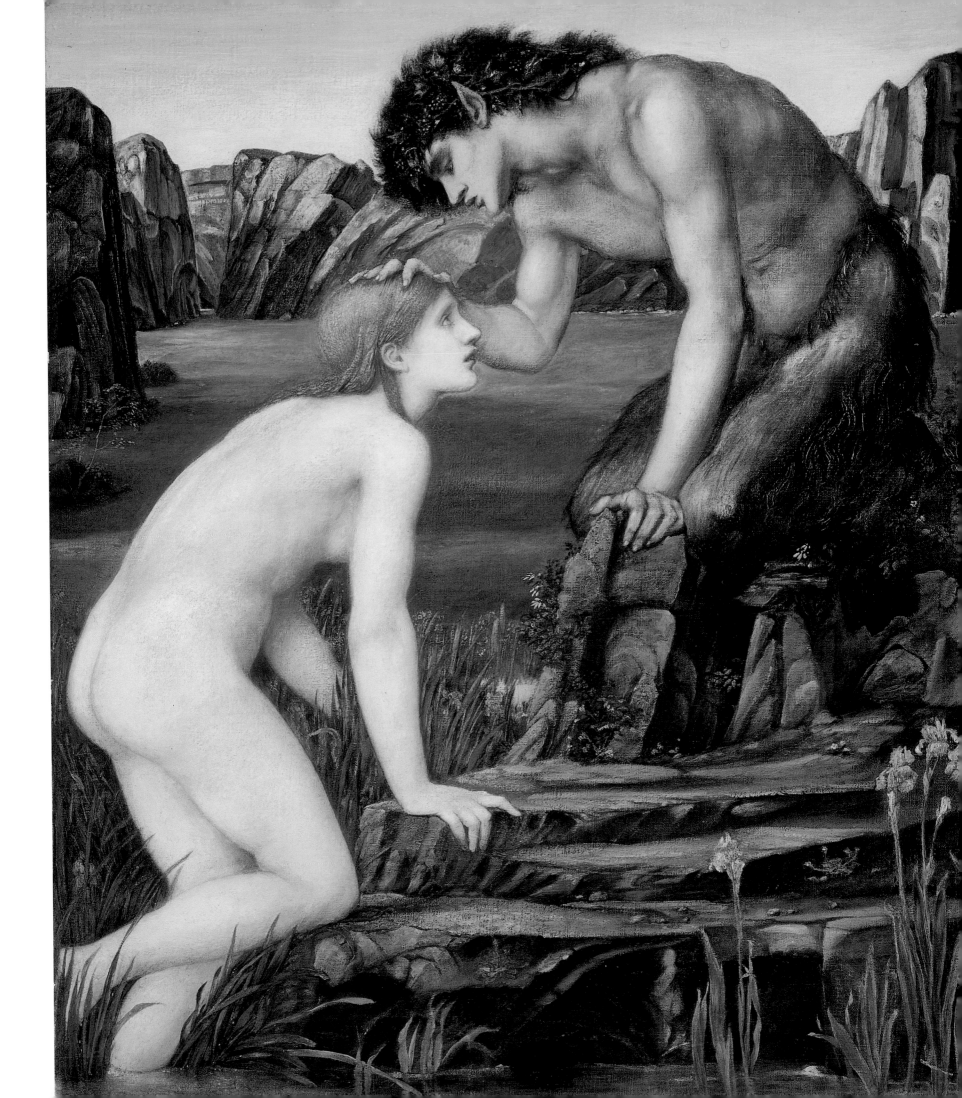

own right who exhibited at the Grosvenor.

Burne-Jones's great success at the Grosvenor was marred by the subsequent Whistler *v.* Ruskin trial, in which he was forced to appear as a witness. By this time Ruskin was becoming increasingly erratic and out of touch with contemporary art. In a review of the Grosvenor in *Fors Clavigera* on 2 July 1877 he accused Whistler of 'cockney impudence', and of asking 'two hundred guineas for flinging a pot of paint in the public's face'. Paradoxically, Whistler was, like Ruskin, a great admirer of Turner, but any reader of Ruskin has to be prepared to put up with such inconsistencies. For Ruskin, and others of the conservative artistic establishment, Whistler and the Aesthetic painters were bringing dangerous French ideas into England and so were bitterly attacked, just as the Impressionists had at first been attacked in the 1860s. The late nineteenth century was to see more or less continuous tension between conservative and progressive tendencies in art. Whistler was touchy and combative, and responded by suing Ruskin for damages of £1,000.

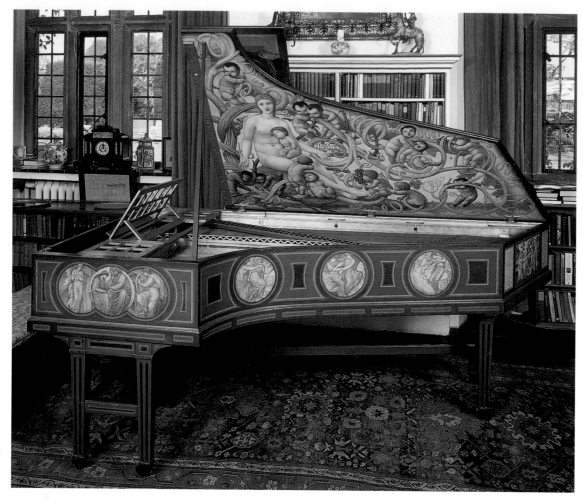

The case was tried in November 1878, and Burne-Jones was called as a witness on behalf of Ruskin, who was unable to attend because of illness. Burne-Jones testified out of loyalty to his old friend, not because he did not admire Whistler's work. In court he admitted that Whistler's work showed genuine artistry, but said that it was unfinished and too expensive. Later he wrote to George Howard,

> I hated going to that abominable trial as you may imagine – never disliked anything so much in my life and moved earth and hell to get out of it ...

To Frances Horner he later wrote that he was right to support Ruskin, who 'had lifted all England by his life and given himself and wasted himself; it would have been a shame not to have been on his side'.

Above: **The Orpheus Piano**, *1879. The only piano to have been both designed and completely decorated by Burne-Jones. His aim was to replace the bulges and curves of the average Victorian grand piano with the simpler lines of the harpsichord. There was so much interest in the piano that Broadwood did produce this model commercially, although without the unique Burne-Jones decoration.*

Left: *Georgiana Burne-Jones playing the piano. The Burne-Joneses were a very musical family, and Burne-Jones encouraged his wife in both her piano playing and her singing. They were given a piano as a wedding present. Burne-Jones decorated it; this led to his lifelong interest in redesigning pianos.*

Opposite: *Study for* Le Chant d'Amour. *A study for the central figure in* Le Chant d'Amour, *commissioned by William Graham. Previous versions included a watercolour of 1865, and a painting on a piano.*

By testifying against Whistler, Burne-Jones seemed to be on the side of the artistic establishment, alongside W. P. Frith, which is one of the more paradoxical consequences of this curious case. Both artists earned the undying hatred of Whistler, who won the case but was awarded a derisory farthing damages. Whistler went bankrupt and had to sell his house in Tite Street, designed for him by E. W. Godwin, and return to the Continent.

Burne-Jones returned to the Grosvenor the following year with an even more impressive group, this time of eleven pictures. It included several of his finest works, such as *Laus Veneris* and *Pan and Psyche*, completed earlier in the decade, with *Le Chant d'Amour*, and one of the *Perseus* series, *Perseus and the Graiae*. *Le Chant d'Amour* is one of his most hauntingly beautiful works, and for many years it has hung in the Metropolitan Museum in New York, a lone representative of the Pre-Raphaelite school. As usual, its origins go back a long way. The title is from an old Breton song known to Georgiana Burne-Jones, and probably sung by her. The first version of the subject was painted on a piano (now in the Victoria and Albert Museum) which was given to the Burne-Joneses as a wedding present. In the mid 1860s, Burne-Jones produced two versions in watercolour, one adding the knight to the left, the second omitting the figure of Love on the right. The final oil version at the Grosvenor was commissioned in 1868 by William Graham and finished in 1877.

William Graham was Burne-Jones's greatest patron, not only a close friend but an important influence on the artist's work. Fifteen years older than Burne-Jones, Graham was a Scot of strict evangelical faith, who made a fortune in business and entered Parliament as Liberal member for Glasgow in 1881. He collected both Old Masters and modern pictures, and particularly loved early Italian painting. Among modern painters, Rossetti and Burne-Jones especially appealed to him. He began to

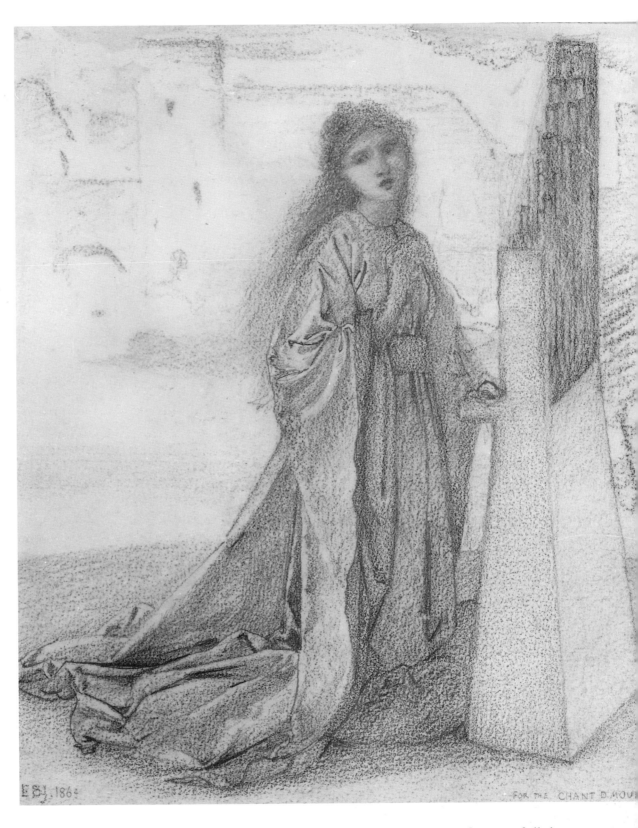

collect Burne-Jones's watercolours in the 1860s, having seen them at the OWS. Later he owned several major works, including *Le Chant d'Amour*, *Laus Veneris*, *The Days of Creation* and *Green Summer*. The strongly Venetian, Giorgionesque flavour of all these pictures certainly owes much to Graham's influence. The theme of music in *Le Chant d'Amour* and *Laus Veneris* reflects the importance of music in the Graham household.

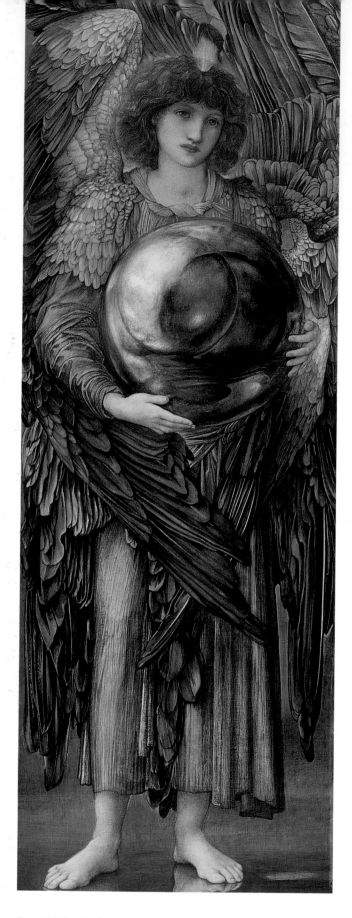

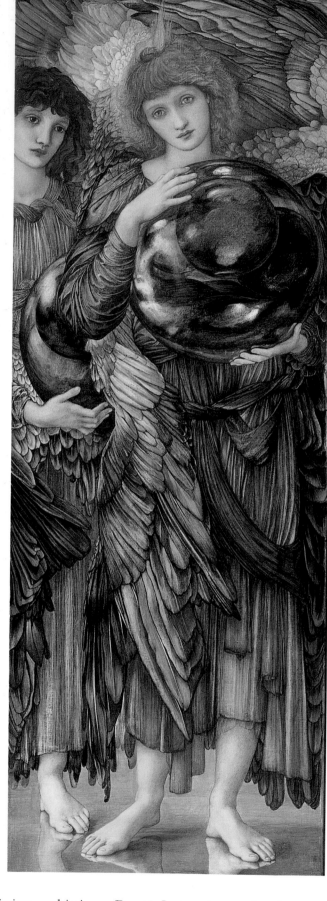

In 1879 Graham was to commission the celebrated *Orpheus* piano, the finest of those decorated by Burne-Jones.

Graham was fond of dropping in on Burne-Jones's studio, where he would dis-

cuss the works in progress, and commission either new works or new versions of existing ones. In spite of his puritanical Scottish background he had a passion for pictures, and once made the romantic gesture of

kissing a Burne-Jones picture that he particularly liked. In 1884 Gladstone made him a Trustee of the National Gallery. Burne-Jones would dine regularly at the Grahams' house in Grosvenor Place, and also con-

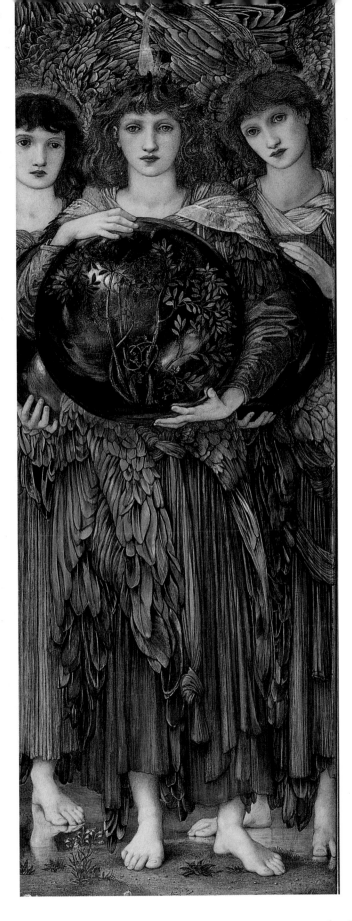

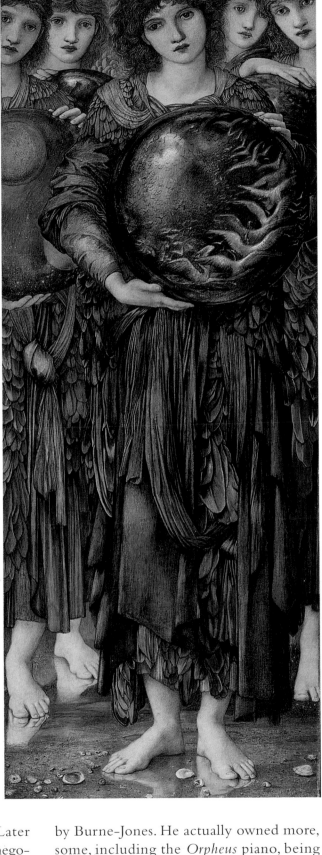

The Days of Creation (6), 1870–76. As so often, Burne-Jones first treated this subject in stained glass, then in illustrations for Dalziel's 'Illustrated Bible Gallery'. To put the creation scenes into crystal balls, held by angels, was a brilliantly inventive stroke.

sulted him over financial matters. Later Graham acted as Burne-Jones's agent, negotiating the sale of *King Cophetua* and the large *Briar Rose* series. After his death in 1885 the sale included thirty-three pictures by Burne-Jones. He actually owned more, some, including the *Orpheus* piano, being retained by his family. Some high prices were achieved, and Burne-Jones's reputation was enhancd. *Le Chant d'Amour* made

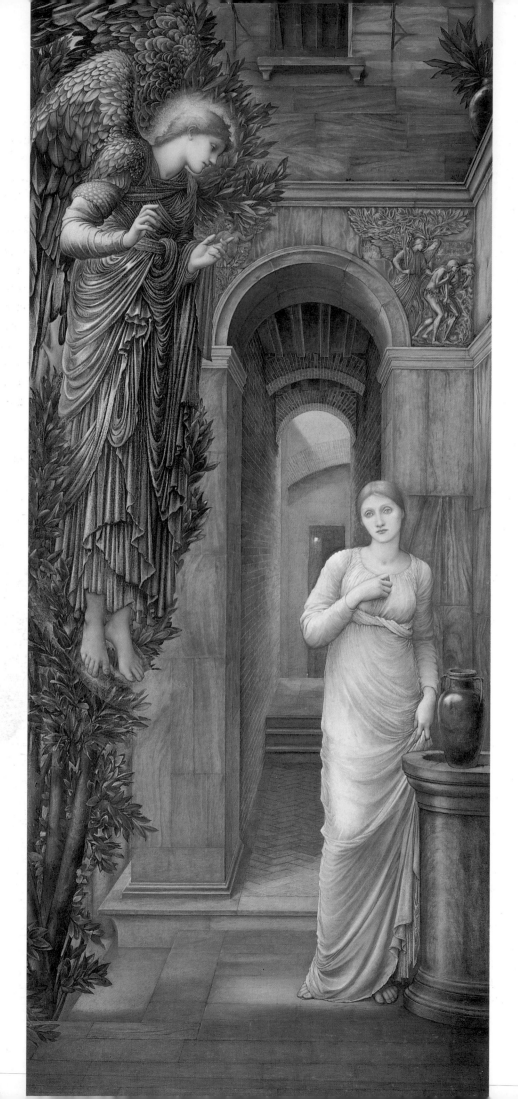

the top price of 3,000 guineas (£3,150).

The other major work shown at the Grosvenor in 1878 was *Perseus and the Graiae*. This was one of the cartoons of the *Perseus* series for Arthur Balfour. Burne-Jones was already at work on a set of ten cartoons in gouache for the series, of which only eight were used in the final versions. The first of the cartoons was *The Call of Perseus*. Once again, the origin of this series was *The Earthly Paradise*, and it tells the story of 'The Doom of King Acrisius', of whom it was prophesied that the king would be killed by his grandson. To prevent this, King Acrisius locked up his only daughter, Danae, in a brazen tower (Burne-Jones later made this a separate subject). However Zeus, disguised as a shower of gold, seduced Danae, and their son was Perseus. King Acrisius abandoned Perseus and his mother at sea in a small boat, but they were washed ashore on an island. Here one of Danae's suitors ordered Perseus to find and kill the Medusa, one of the three Gorgons; from this quest he was not expected to return. However, the other gods lent him weapons, wings and armour, and a goatskin bag to put the Medusa's head in. His first task was to find the Graiae, or Grey Sisters, half-sisters of the Gorgons, who lived in an icy and desolate region. They shared one eye and one tooth between them, and Burne-Jones has shown Perseus stealing the eye and forcing them to tell him where the Gorgons are. The robes of the Graiae are deliberately rendered in a cold grey with hard classical folds, emphasizing the icy realm which they inhabited, one of Burne-Jones's most desolate landscapes. Perseus then goes on to find and behead the Medusa, using a mirror as looking at Medusa's face would turn him to stone. After putting the head in the bag, he flies home, rescuing Andromeda, a princess who has been chained to a rock to appease a sea monster, on the way. He kills the monster and marries Andromeda. These were to form the subject of the other three

Above: 'The Days of Creation' – a study for Adam
Right: Study for Figures in the Pygmalion series
Opposite: **The Annunciation** 1876–79 The largest and most elaborate of Burne-Jones's versions of this subject. The model for the Virgin was Julia Stephen, the mother of Virginia Woolf.

completed pictures of the series: *The Rock of Doom*, finding Andromeda chained to the rock; *The Doom Fulfilled*, killing the dragon; and *The Baleful Head*, showing Andromeda the head of Medusa in the reflection of water in a well. Burne-Jones worked on the series through the 1880s. The completed version of *Perseus and the Graiae* was shown in 1882, but *The Baleful Head* was not displayed until 1887 (see chapter 10).

The other exhibits at the Grosvenor were all single figures – *Night* and *Day*, and an allegorical figure of the moon, entitled *Luna*. There was also a set of four upright pictures of *The Seasons*. These were purchased by F. R. Leyland for his Aesthetic palace at Queen's Gate. He also purchased the figures of *Night* and *Day*, and acquired *Phyllis and Demophöon*, *The Wine of Circe* and *The Mirror of Venus*. Leyland's taste was different from Graham's, and *The Four Seasons* are painted in a more decorative, Classical style. The poses are based on Classical sculpture, and the figures are similar to standing figures by Albert Joseph Moore. *The Seasons* show how Burne-Jones could vary his style to suit the taste of a patron. Leyland was a shipping magnate from Liverpool, a man of considerable taste and refinement and a talented musician. He was never a close friend like William Graham, but he was an equally important patron. He was so pleased with his picture *The Wine of Circe* that he paid an extra £100 over the agreed price.

Burne-Jones had written to Charles Hallé, the manager of the Grosvenor Gallery, about the red damask walls, complaining that the colour was

far too glaring to be tolerable near any delicately coloured picture ... It sucks all the colour out of pictures, and only those painted in grey will stand it.

The offending red damask was removed after the first exhibition and replaced with a plain green cloth. Whistler's biographers also wrote later that 'the sumptuousness of Sir Coutts Lindsay's background was disastrous to the pictures'. In choosing such a heavy Italianate style Lindsay was going against the taste of the time for lighter, simpler, more airy interiors. The Fine Art Society, for example, which opened in 1876 a few doors down in Bond Street, had much plainer interiors designed by E. W. Godwin, Whistler's architect. Whistler himself used deliberately pale and muted colours at his later exhibitions at the Royal Society of British Artists and Dowdeswell's.

The critics were once again divided over Burne-Jones's pictures in 1878. There were the usual complaints that his art was 'morbid' and 'unmanly'. The Victorian horror of decadence was to grow increasingly strident, reaching hysteria levels at the time of the Oscar Wilde trials. The most intelligent comments, once again, were made by Henry James writing in the *Nation*. Writing of *Le Chant d'Amour*, he thought the colours – 'like some mellow Giorgione or some richly-glowing Titian' – to be 'a brilliant success'. Although the picture had some faults, lack of modelling and over-flatness in the figures, James concluded that Burne-Jones's pictures were 'far away the most interesting and remarkable things in the exhibition'. He went on,

No English painter of our day has a tithe of his 'distinction'; his compositions have the great and rare merit that they are pictures. They are conceptions, representations; they have a great ensemble.

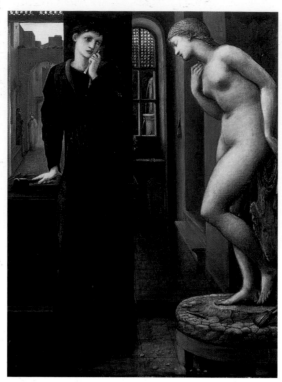
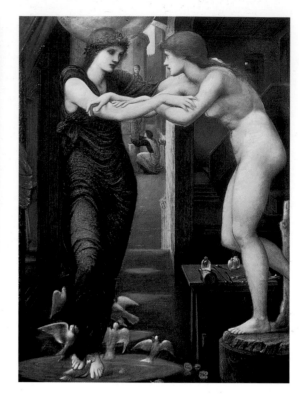

At this date, no other critics were as perceptive as James in seeing the unique imaginative genius of Burne-Jones's vision. Writing about Burne-Jones in another context, James provided one of the best definitions of late Pre-Raphaelite painting and the Aesthetic Movement:

It is the art of culture, of reflection, of intellectual luxury, of aesthetic refinement, of people who look at the world and at life not directly, as it were, and in all its accidental reality, but in the reflection and ornamental portrait of it furnished by literature, by poetry, by history, by erudition.

In 1879 Burne-Jones's exhibits at the Grosvenor were fewer, but no less distinguished: a set of four pictures on the theme of Pygmalion and a large version of *The Annunciation*. The latter is the largest and most monumental of all Burne-Jones's treatments of this subject and was painted between 1876 and 1879. It is tall and upright, following the shape of the many stained-glass windows he had by then designed. The composition is also austere

and vertical, the two figures straight and tall, echoed by the narrow arches in the background. In colour the picture is notably more restrained and monochromatic than either *Laus Veneris* or *Le Chant d'Amour*, shown in the previous year. This marks a shift in Burne-Jones's style towards more monumental, Classical forms and compositions combined with paler, more restrained colours. This trend was to be continued with *The Golden Stairs*, shown in 1880.

The architectural background of *The Annunciation* is very Italianate, and doubtless based on buildings studied in Italy on Burne-Jones's trips of 1871 and 1873. The relief to the right of the arch depicts the Expulsion from Eden, the episode leading to the Fall of Man, thus to be redeemed by the coming of Christ, as announced by the angel of the Annunciation. The model for the head of the Virgin was Julia Stephen, wife of Leslie Stephen, compiler of the *Dictionary of National Biography*, and mother of Virginia Woolf and Vanessa Bell. She was considered a beauty, and was photographed many times by Julia Margaret Cameron.

The Annunciation was purchased by

The Pygmalion series, *1868–70*
Above left: **The Heart Desires**
Above centre: **The Hand Refrains**
Above right: **The Godhead Fires**
Opposite: **The Soul Attains**
The story of Pygmalion, a sculptor on the island of Cyprus, whose sculpture turned into a lovely girl, Galatea. These pictures are Burne-Jones's personal homage to Greek sculpture, yet they are imbued with a feeling of medieval courtly love.

Burne-Jones's close friend and fellow-artist George Howard. During the 1870s Burne-Jones was a frequent guest of the Howards at Naworth Castle in Cumbria, and he designed a set of windows for the local church, St Martin's in Brampton. Howard was also later to commission Burne-Jones's largest picture and *magnum opus*, *The Last Sleep of Arthur in Avalon*. *The Annunciation* remained in Howard's family until his widow's death in 1922, when it was subsequently sold to Lord Leverhulme, founder of the museum and gallery at Port Sunlight.

The *Pygmalion* series was a set of four pictures, entitled *The Heart Desires*, *The Hand Refrains*, *The Godhead Fires* and *The*

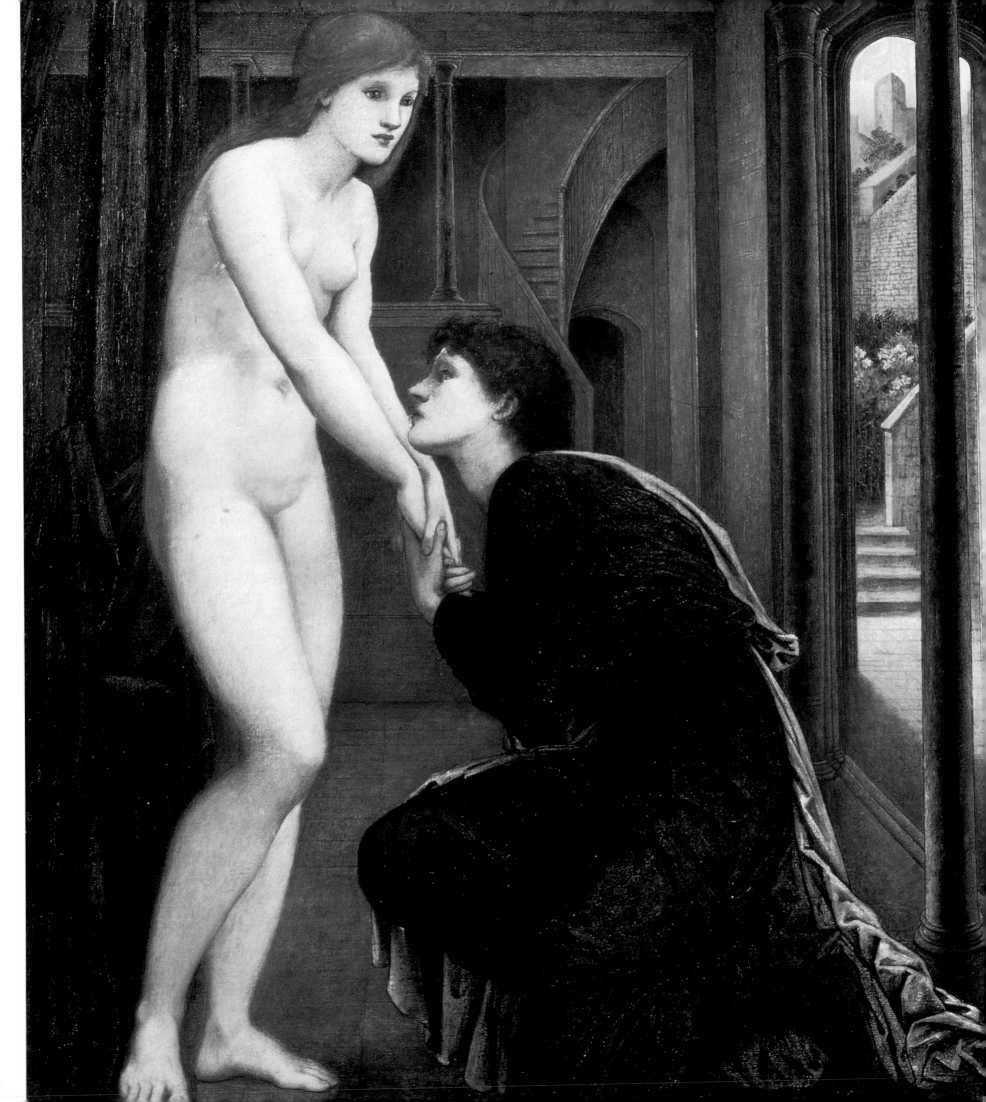

FAME – THE 1880s

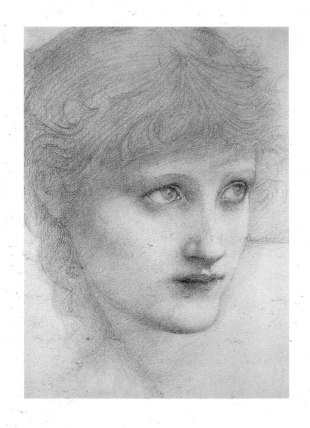

By 1880 Burne-Jones was at the height of his powers and at the height of his fame. For him this was to be a hugely busy decade, working on his two greatest cycles, *Perseus* and *Briar Rose*, as well as his magnum opus, *The Last Sleep of Arthur in Avalon*. He also began and completed numerous other pictures, notably *King Cophetua and the Beggar Maid*. He was in demand as a society portrait painter, began to design tapestries, decorated pianos and designed a large set of mosaics for the American Church in Rome. On top of all this he still found time to design stained glass as well. He and his studio assistants were constantly busy, and now received a stream of distinguished visitors, English and foreign. Burne-Jones had become a celebrity. At the Grosvenor he acquired a whole constellation of disciples and followers, referred to by the *Art Journal* as the 'quasi-classic, semi-mystic school'. They included Walter Crane, Spencer Stanhope and his niece, Evelyn de Morgan, as well as the studio assistants, T. M. Rooke and J. M. Strudwick.

Until 1877 Burne-Jones's portrait work was limited to paintings or drawings of his family or intimate friends. After the Grosvenor Gallery success he was in demand as a portrait painter. It was not a role he relished or desired, but he did

Left: '*St Mary Magdalen*'. *A study for a figure in* The Morning of the Resurrection, *exhibited at the Grosvenor Gallery in 1886.*
Opposite: **Baronne Deslandes**, *1895–6. Baronne Deslandes was an exotic* fin-de-siècle *figure, friend of Oscar Wilde, mistress of Maurice Barrès, said to receive her admirers reclining on a bed of lilies. One of the leading Aesthetic celebrities of her day, she was also an authoress of romances and short stories.*

carry out a number of portrait commissions, mostly of society beauties. He had very defined ideas of what a portrait should be:

> The only expression allowed in great portraiture is the expression of character and moral quality, not anything temporary, fleeting, accidental ... The moment you give what people call expression you destroy the typical character and degrade them into portraits which stand for nothing.

Following this dictum, Burne-Jones liked to paint his sitters in an attitude of complete repose, with their arms at their sides, and no background of any kind. His subjects often have a dreamy, abstracted air, as if their thoughts were far away. The mood is conveyed largely by means of colour. At first he used strong, dark colours but, as his style changed, he moved towards paler and paler tones, until his later portraits became almost ethereal. One or two of his three-quarter-length portraits of society women such as Lady Windsor are a marvellous record of the 'Aesthetic woman'. His portrait of Baronne Deslandes, a Belgian lady, also has considerable style and elegance, in spite of Burne-Jones's great restraint in portraits. He very rarely painted men, though he did draw the Polish pianist, Paderewski. Burne-Jones wrote of him,

> He looks so like Swinburne looked at 20 that I could cry over past things ... I praised Allah for making him and felt myself a poor thing for several hours. Have got over it ...

Burne-Jones's best portraits are of children and young girls. With the young he seemed to have an immediate empathy. The portrait of Amy Gaskell, mysteriously looming out of a dark background, is one of his best female portraits. So is the one of Caroline Fitzgerald, an American girl, who sits in a dark green velvet dress holding an open book. Even more striking is the portrait of

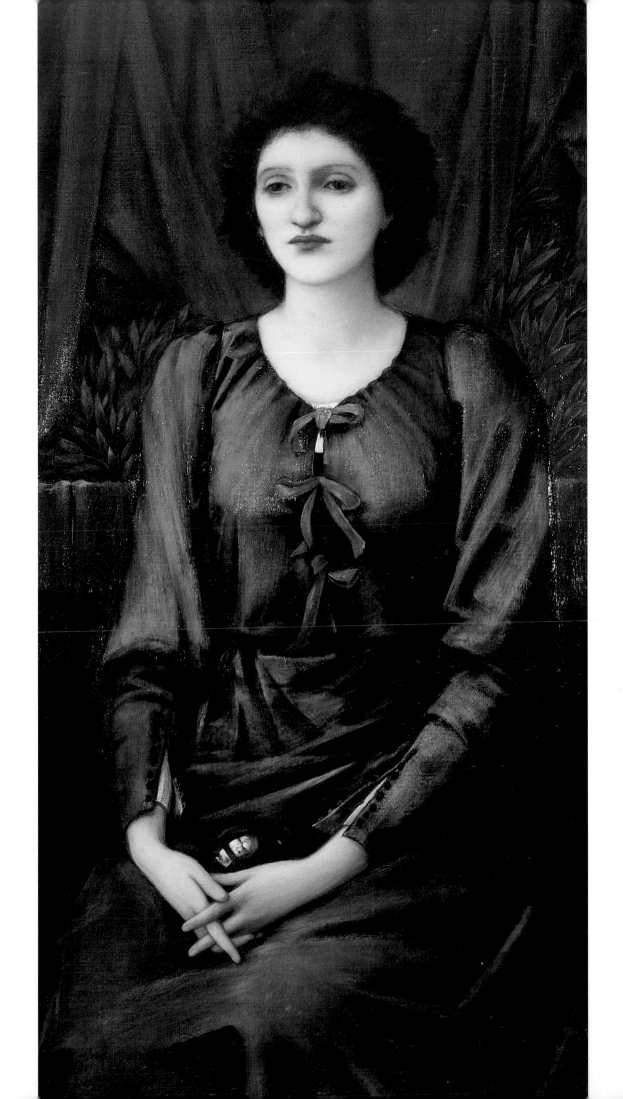

Katie Lewis, the recipient of some of his most charming letters. Katie is shown lying down, a most unusual pose for a Victorian child portrait, completely absorbed in her book, with a little dog curled up at her feet. The colours span the Aesthetic range – dark blues, greens and orange. It is a Romantic, Pre-Raphaelite, Aesthetic image that transcends portraiture, as do all great portraits.

Burne-Jones also painted one or two charming portraits of boys, none more so than of Philip Comyns Carr, the son of the manager of the Grosvenor Gallery, Joseph Comyns Carr. The most sympathetic portraits are those of his own family, in particular the *Portrait of Georgiana*, with their two children Philip and Margaret in the background. He also painted a wonderful *Portrait of Margaret*, with another portrait of her in a convex mirror hanging behind her. As well as oil portraits, Burne-Jones made many beautiful pencil drawings of his friends, which he would often give to them. There are several fine examples of Venetia Benson, the wife of his friend W. A. S. Benson. The brilliant technique of these drawings shows how much Burne-Jones's drawing skills had advanced since the 1860s, and he became one of the finest Victorian draughtsmen. Few English artists have drawn better with the pencil.

As in *The Golden Stairs*, music-making features frequently in his art. Figures play all kinds of ancient instruments: rebecs, psalteries, portable organs and shawms, as well as more modern instruments. Both Burne-Jones and his wife were passionately fond of music, and Burne-Jones encouraged Georgiana in her piano-playing and singing. From very early in their marriage, he had begun to decorate pianos. In 1880 he wrote to Kate Faulkner:

I have been wanting for years to reform pianos, since they are as it were the very altar of homes, and a second hearth to people, and so hideous to behold mostly that with a fiery rosewood piece of ugliness

Above: *'Portrait of a Boy called Francis'. Possibly of the Jekyll family. This is typical of Burne-Jones's many sensitive studies of children.*

Right: **Philip Comyns Carr**, *1883. This is the son of Joseph Comyns Carr, one of the managers of the Grosvenor Gallery, and later the New Gallery, and it was exhibited at the Grosvenor in 1883.*

Opposite: **Amy Gaskell**, *1893. Amy Gaskell was the daughter of one of Burne-Jones's closest friends and confidantes, Mrs Helen Mary Gaskell. It is one of the most beautiful and haunting of all his pictures of young girls.*

it is hardly worthwhile to mend things,
since one such blot would and does destroy
a whole house of beautiful things.

Burne-Jones first decorated a piano he had been given as a wedding present, and also another one for his friend G. P. Boyce. The decorations consisted of painted panels on the front, as these were upright pianos. Burne-Jones also painted similar panels for decorations on organs belonging to George Howard and William Graham. His decoration of a grand piano for William Graham was much more elaborate. Here Burne-

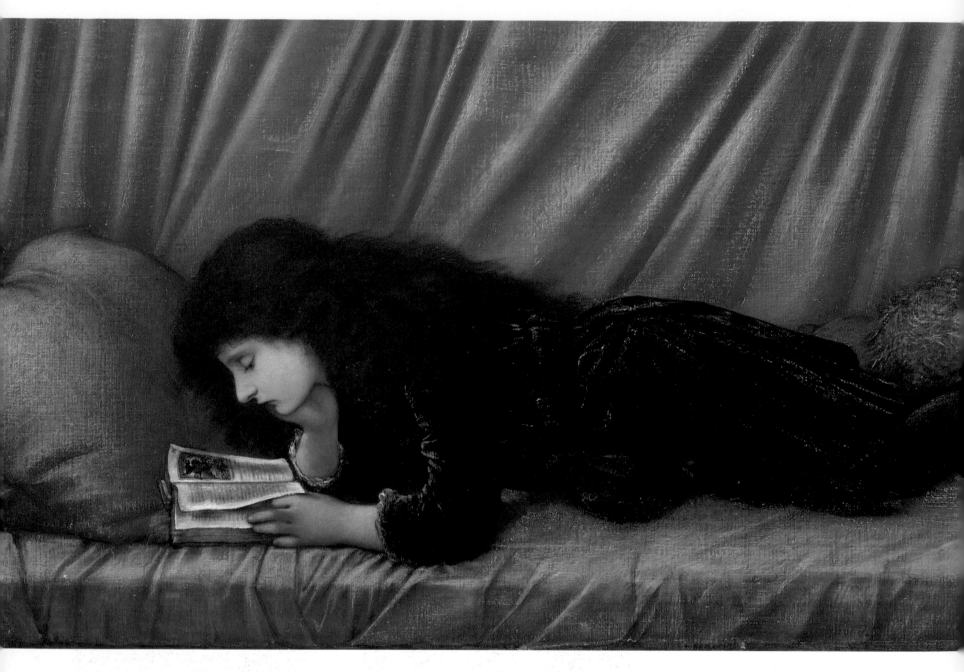

Jones literally covered the entire piano with decoration, including architectural motifs to fill the spaces. The top of the lid is covered with sprays of leaves, a scroll of poetry and a muse inspiring a reclining poet. Inside the lid is a figure of Mother Earth, surrounded by a troop of chubby babies. Here Burne-Jones binds the composition together cleverly, using swirling tendrils of a stylized grapevine, thus overcoming the difficult shape of a piano lid. But the most remarkable feature of the Graham piano is the series of twelve roundels on the side, which tell the story of Orpheus. Painted virtually in monochrome, they are in a tight, linear style, very similar to his *Aeneid* illustrations. Although small, Burne-Jones has packed a tremendous amount of drama and emotion into them. *The Regained Lost*, showing Orpheus clutching at Eurydice's robes as she sinks back into Hades, is full of pathos, and the other scenes are of equal quality.

The only other pianos decorated by Burne-Jones were done in painted gesso, using all-over decoration of foliage and flowers, but no figures. The decoration of these he entrusted to Kate Faulkner, a gesso artist who also worked for Morris & Co. Although not on a par with the *Orpheus* piano the Faulkner pianos are very attractive, and certainly succeed in Burne-Jones's aim of making pianos more beautiful. Burne-Jones worked in gesso on one or two other pieces of furniture, such as *The Garden of the Hesperides* cassone now on loan from Birmingham City Art Gallery, at Wightwick Manor, and a *Pandora's Box*. Burne-Jones occasionally experimented with panels in gesso, but they were not

me. He made sounds that are really and truly (I assure you, and I ought to know) the very sounds that were to be heard in the Sangraal Chapel, I recognized them in a moment and knew he had done it accurately.

Left: **Katie Lewis**, *1886. Katie was the daughter of the celebrated lawyer Sir George Lewis. The picture was exhibited at the Grosvenor Gallery in 1887, but kept by Burne-Jones until 1897, when he gave it to the Lewises. Katie was the recipient of many of Burne-Jones's most delightful illustrated letters, in which he assumed the character of Mr Beak.*
Below: **Portrait of Georgiana** *A haunting portrait of the artist's wife, begun in 1883, but according to Georgiana herself, in the* Memorials, *Burne-Jones worked on it 'for years at intervals, but never finished it to satisfy himself'. In the background are the two children, Philip and Margaret.*
Below right: **Venetia Benson**, *1890. Venetia Benson was wife of the architect and designer W. A. S. Benson and the daughter of the watercolourist Alfred William Hunt. She was therefore among Burne-Jones's closest circle of friends and fellow-artists.*

Burne-Jones did not generally like Wagner's music, but this passage is ample evidence that both artists were concerned with the interpretation of ancient legends in a modern idiom. In this sense, Burne-Jones and Wagner belong to the same cultural epoch, even if they were not consciously influenced by each other's work. Burne-Jones was involved with the Arthurian legends all his working life, and in the 1890s was to design a set of tapestries on the theme of the Holy Grail. It is no accident that the *Perseus* series is now in a German museum. The Germans fully understand the connections between their legends and our own.

Wagner's wife Cosima had been brought to Burne-Jones's studio by George Eliot in 1877. She gave the artist a death-mask of Beethoven, and he made a drawing of her. Wagner himself was too busy to come and, although he and Burne-Jones exchanged notes, they never met. Burne-Jones went to several of Wagner's concerts, and even to a morning rehearsal, 'which was an extraordinary thing for Edward to do', his wife

considered a success, and he did not persevere with this technique.

The whole question of Burne-Jones's musical taste and its relation to his art has not been fully explored. We know from the *Memorials* that he was familiar with the Ring Cycle by Richard Wagner, and also with the Niebelungen legends on which it is based. In 1884 Burne-Jones went to hear *Parsifal* at the Albert Hall and wrote of it:

I heard Wagner's *Parsifal* the other day – I nearly forgave him – he knew how to win

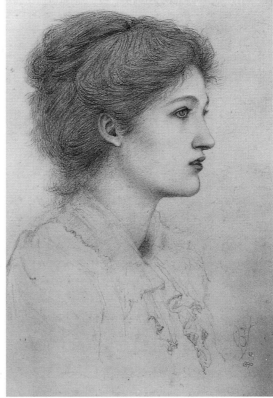

wrote, but regrettably friendship between artist and composer never matured. At the rehearsal Burne-Jones spotted an attractive girl, and wanted to draw her for the *Perseus* series. An introduction was effected, and this is how he came to meet the architect W. A. S. Benson and his wife Venetia.

In 1881, Burne-Jones did not exhibit at the Grosvenor, but his successes enabled him to acquire a house by the sea in Sussex. This was at Rottingdean, then an unspoilt village at the foot of the Sussex Downs. He soon found it a good place to rest, recuperate and work away from London and the studio. He also found the landscape inspiring, especially the sharp outlines of the Downs as they swept to the sea. The village was little more than a cluster of cottages around the church, with a windmill on the hills above. Even more inspiring was the sea, which helped Burne-Jones to imagine distant lands, or the mysterious underwater world. Mermaids began to feature in his work, and he painted *The Depths of the Sea*

in 1886. Also in 1882 at Rottingdean he began *The Flower Book*, one of his most original and personal creations.

In 1881 Burne-Jones received one of the biggest commissions of his career, to design mosaics for the American Church in Rome. This was a Protestant, Episcopal church, built for the American residents in Rome who wanted their own place of worship. The architect was G. E. Street, an old friend of Morris & Co., who designed it in Venetian gothic style. Burne-Jones was commissioned to design mosaics for the apse and the choir. Here was an opportunity for him to cover the large spaces he wanted. However, the commission in the end caused him more distress than pleasure. He had to supervise the work at arm's length and never visited the church, and he had endless problems with the Italian firm making the mosaics. At one point the money ran out, and the whole scheme remained dormant for several years. Stylistically Burne-Jones tried to emulate the Byzantine mosaics he had seen in Venice and Ravenna. Above the apse he designed a Christ in Majesty in typical Byzantine style, with archangels either side, angels in the firmament below, and saints below them on earth. Above the arches of the choir he designed two semi-circular spandrels; one an Annunciation set in a rocky landscape, the other a bloodless Crucifixion, entitled *The Tree of Life*, attended by Adam and Eve and their children. The result is a gentler, more Victorian vision of Christianity, long on salvation, short on hell and damnation. Compared to Byzantine mosaics, Burne-Jones's have a greater feeling of perspective, and also a far greater range of colours.

The Compagnia di Venezia-Murano, the Italian firm making the mosaics, caused endless trouble. Morris and Burne-Jones spent several of their Sundays sorting out the tesserae (pieces of mosaic) and arranging the colour scheme. When the first trial angel arrived, however, the firm had completely failed to follow his instructions.

Left: **Portrait of William Graham.** *Graham was Burne-Jones's most devoted patron, friend and adviser. Burne-Jones became a close friend to the whole family, especially to his daughter Frances Graham, later Lady Horner.*

Below: *Study of an Angel. A study for one of the figures in the mosaics in the American Church in Rome.*

Opposite: **The Crucifixion,** *1880s. A design for one section of the mosaics in the American Church in Rome. This is really an allegorical Crucifixion, and depicts Christ as part of the Tree of Life, attended by Adam and Eve and their two children.*

In a rare outburst of anger, Burne-Jones wrote to T. M. Rooke, who was luckily in Venice at that moment:

> O Rookie – scold them, pitch into them, bully them, curse and refrain not – otherwise I must, late as it is, give it all up. You see they don't copy my outline, they don't keep to my colours told them, so what the devil can I do?

The whole project was deeply frustrating, but fortunately Burne-Jones had met the manager of the firm, Signor Castellani and, by writing personally to him, was able to sort out many of the problems. All this went on for many years, and the project was still unfinished at Burne-Jones's death in 1898. It was eventually completed by T. M. Rooke. Although it fell short of the masterpiece that Burne-Jones wanted, passages of it are effective, especially the spandrel of *The Tree of Life*, designed in 1892. This is a strong and impressive design, and fills the space well. Burne-Jones made many drawings, studies and gouaches for the whole scheme, and most of these have survived. The figures of standing archangels are especially impressive. One of these was Lucifer, but he was not included in the mosaics. He was to have been shown leading a procession of his followers down to hell, but this was converted instead into a painting, *The Fall of Lucifer,* completed in 1894. Several of the figures of saints executed after Burne-Jones's death are portraits – Burne-Jones is St John Chrysostom, his wife St Barbara, his daughter Margaret St Dorothea.

During the 1880s Burne-Jones designed

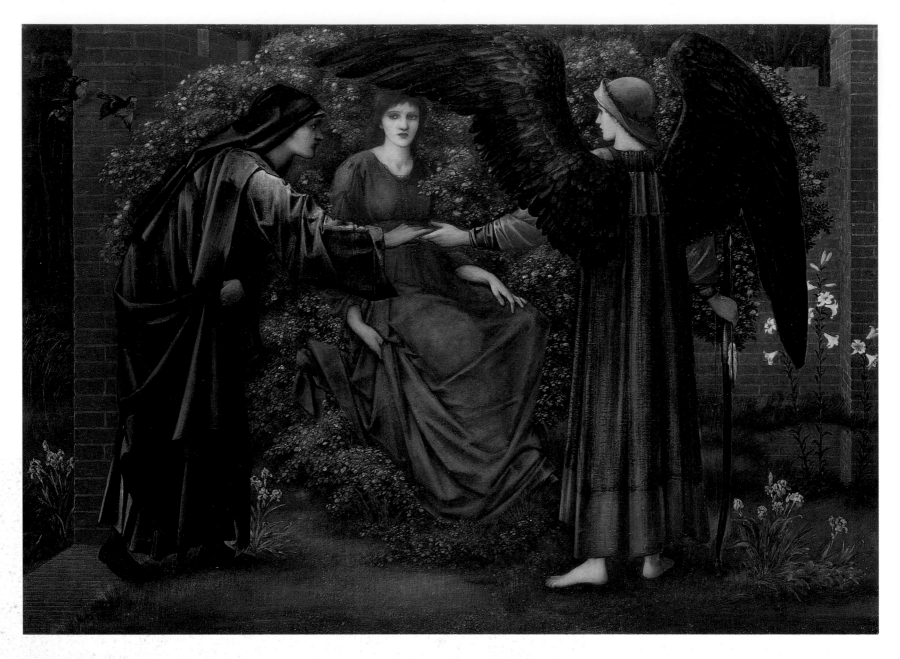

fewer windows, but received commissions from churches as far afield as Boston and Biarritz. By this time Burne-Jones had adopted the habit of carrying a single design across a series of windows, as in the *Resurrection* window at All Hallows, Allerton, in Lancashire. His figures became simpler, without the Michelangelesque contrapposto of his 1870s work, but the leading on the glass becomes more dramatic. This use of deliberately angular leading is a feature of his later stained glass, and anticipates the Expressionist glass designs of the twentieth century.

In 1882 came an event that gave great sorrow to both Morris and Burne-Jones – the death of Rossetti. He was only fifty-four but, since the Buchanan affair of the early 1870s, he had become increasingly eccentric and reclusive, cutting himself off from his old friends. The 1870s was the period of his obsession with Jane Morris, of whom he made innumerable drawings and studies, and whom he used as a model for many of his greatest pictures. At the end, he became addicted to chloral, which clouded his mind, and eventually ruined his health. For Burne-Jones, the loss of his early

Above: **The Heart of the Rose**, *1889. One of a set of three pictures illustrating Chaucer's 'The Romaunt of the Rose'. The others are* The Pilgrim at the Gate of Idleness *and* Love and the Pilgrim. *All have their origins in the set of tapestries designed for Sir Lowthian Bell at Rounton Grange, Northallerton.*

Opposite: **The Pilgrim at the Gate of Idleness**, *1874–84. Another of the three pictures illustrating Chaucer's 'Romaunt of the Rose', designed for Sir Lowthian Bell at Rounton Grange, Northallerton, originating in the tapestry designs mentioned above.*

mentor and hero was a great blow. He could not face the funeral, but he never forgot Rossetti, thought and spoke about him often and always remembered the anniversary of his death.

In 1883–4 Morris became increasingly interested in Socialism, and he joined the Social Democratic Federation. Like Ruskin before him, Morris had decided that the only way to change public taste was to change society. He had become disillusioned that the Firm's products were only purchased by the rich. Burne-Jones was saddened by his friend's decision. He himself was completely apolitical, although his views were those of a Victorian liberal. 'Morris was before all things a poet and an artist,' he maintained. Out of loyalty, he supported Morris and his work with the Socialists, but secretly he wished he would give it up, and return to poetry and art. In the 1890s, he did.

Morris's involvement in politics meant that he had less and less time for the Firm. Responsibility increasingly fell upon his main assistant, John Henry Dearle, who was a willing follower, but lacked the creative talent and refinement of Morris. Burne-Jones tolerated Dearle, but far preferred to work with Morris. The Firm moved to Merton Abbey, near Wimbledon, in 1881, and during the 1880s and 1890s Burne-Jones designed most of the Firm's works, culminating in the great *Holy Grail* series of the 1890s. Tapestry was an important part of Burne-Jones's output. Thanks to him, Morris tapestries are some of the finest of all English tapestries. They certainly have no equal in the nineteenth century.

At first, the tapestries tended to be single figures, surrounded by flowers and foliage, usually with a border. *Flora*, designed in 1885 and now in the Common Room of Exeter College, Oxford, is typical of these. For other tapestries, Burne-Jones typically recycled some of his stained-glass designs, such as *St Agnes*, *St Cecilia*, *St George* and *Peace*. As he became more confident, and

the tapestry weavers more skilful, they began to produce larger, more complex compositions, involving several figures. The first of these was *The Adoration of the Kings*, woven for the chapel at Exeter College. 'It will be a blaze of colour and look like a carol,' wrote Burne-Jones. The figures are typical of Burne-Jones's religious style, and are set amidst a rich profusion of flowers, designed by J. H. Dearle. Because Morris and Burne-Jones were alumni of Exeter College, it was sold to them at a reduced price. But it proved to be the most popular of all Merton Abbey's tapestries, and at least ten versions were woven between 1890 and 1904, each with different borders. Also very popular for church decoration were *Angeli Laudantes* and *Angeli Ministrantes*, both first designed as church windows for Salisbury Cathedral. They were not made into tapestries until 1894, but proved successful, and were repeated, with variations.

Burne-Jones's method of designing tapestry was similar to that of stained glass. First he made preliminary drawings, both of the figures and the design. Then he produced a finished design, which would be enlarged to the right size by studio assistants. Later he began to use photography for this stage in the process, enlarging the photograph to the size he wanted. This sometimes meant producing photographs 6 or 8 feet wide, or larger. Burne-Jones then worked over these, using them as the final cartoon. As usual with Burne-Jones, there was considerable interplay between his tapestries and his paintings. *The Passing of Venus*, originally conceived as a painting, was adapted into a design for a large tapestry. The painting of *The Pilgrim at the Gate of Idleness* began life as an embroidery panel in the *Romaunt of the Rose* series at Rounton Grange. *Launcelot at the Chapel of the Holy Grail* was at first a painting (1883),

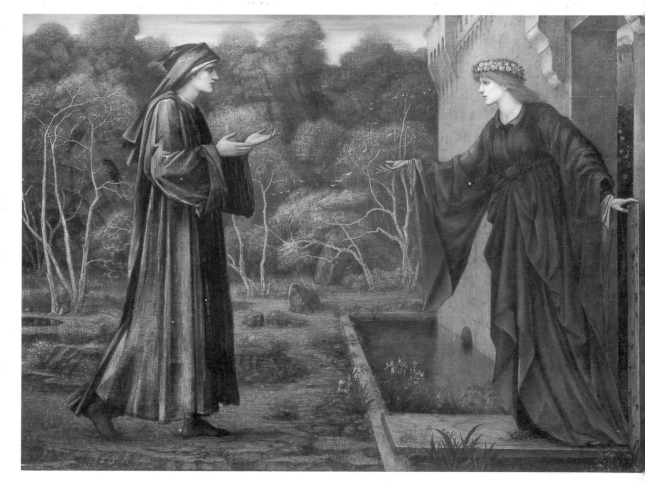

then a tapestry in the *Holy Grail* series, then a memorial window to Tennyson.

In 1883 and 1884 Burne-Jones was back once again at the Grosvenor Gallery. In 1883 he showed the portrait of Philip Comyns Carr, *The Wheel of Fortune* and *The Hours*. *The Wheel of Fortune* had its origin in the unfinished Troy triptych, where it was one of the smaller panels between the lower predellas. Burne-Jones made various studies in pencil and gouache before completing the final versions, of which there are at least three. It must have been one of Burne-Jones's favourite compositions, and it is certainly one of his best. It is also one of his most Italianate pictures; the figures are highly Michelangelesque, and the figure of the king on the wheel has echoes of a

picture by Annibale Carracci in the Pitti Palace, Florence, entitled *Christ in Glory*. Michelangelo's unfinished picture, *The Deposition*, now in the National Gallery in London, shows just how much his style influenced that of Burne-Jones in the 1870s and 1880s. *The Hours* is a simpler composition of six seated figures facing the spectator. He began the composition as early as 1865, but the picture was not started until 1870. It is therefore much more Venetian in style and colouring, similar to *Love among the Ruins* and *The Mirror of Venus*. It is strongly Botticellian, and the mood and colouring belong to Burne-Jones's work of the 1870s, even though he did not exhibit it until 1882. This long gestation period is however typical of him; it often took ten or twenty years to complete a picture.

In 1884, Burne-Jones exhibited one of his most famous pictures, *King Cophetua and the Beggar Maid*. This too has a long history. It is based on a traditional ballad, and also a poem by Tennyson, 'The Beggar Maid', about a king who falls in love with a beautiful beggar maid and marries her:

> *So sweet a face, such angel grace,*
> *In all that land have never been;*
> *Cophetua sware a royal oath;*
> *'This beggar maid shall be my queen.'*

Burne-Jones started planning the composition about 1874, but did not begin the picture until 1881. The composition and the architectural setting are once again strongly Italianate, and there are similarities with Mantegna's *Madonna della Vittoria* in the Louvre, in which a knight kneels before the Madonna. There are also elements taken from the work of the Venetian painter, Carlo Crivelli, notably the rich colours, the elaborate architecture, the choristers leaning over the balustrade above, and the Turkey carpet beside them. Burne-Jones made many studies for the armour, although it is not intended to look realistic. Burne-Jones

Above: *Study for* King Cophetua and the Beggar Maid, *showing the crown made by W. A. S. Benson.*

Left: *Study for the Slave in* The Wheel of Fortune. *After Burne-Jones's third trip to Italy in 1871, the influence of Michelangelo on his work was at its height. The Wheel of Fortune was one of many pictures to emerge from the Troy triptych; he made several versions.*

Opposite: **King Cophetua and the Beggar Maid**, *1884. While working on this picture, in 1883, Burne-Jones wrote to a friend that he hoped '… to put on the Beggar Maid a sufficiently beggarly coat, that will not look too unappetizing to King Cophetua – that I hope has been achieved, so that she will look as if she deserved to have it made of cloth of gold set with pearls. I hope the king kept the old one and looked at it now and then.'*

did not want his figures to belong to any particular time and place, rather to the world of the imagination; to be, as he put it, 'a reflection of a reflection of something purely imaginary'. For this reason, the king's

crown was specially designed by his friend W. A. S. Benson. Burne-Jones did not believe in realism; for him the only reality was the reality of the imagination. For the same reason he liked his pictures to be glazed. He thought the glass provided a layer of 'ethereal varnish'. One of the boys leaning over the balcony was modelled by Philip Comyns Carr. Burne-Jones toiled long and hard to finish *King Cophetua* over the winter of 1883–4. 'I torment myself every day,' he wrote, 'I never learn a bit how to paint ...' On 23 April 1884, he wrote to Mrs Percy Wyndham, whose house Clouds had been built by Philip Webb,

This very hour I have ended work on my picture. I am very tired of it – I can see nothing more in it. I have stared it out of all countenance and it has no word for me. It is like a child that one watches without ceasing till it grows up and lo! it is a stranger.

Burne-Jones's labours were not in vain, and *King Cophetua* was to be his greatest success of the 1880s. The critics for once were unanimous at the Grosvenor, and even the conservative *Art Journal* hailed it as 'the picture of the year'. *The Times* went further, declaring it 'not only the finest work that Mr Burne-Jones has ever painted, but one of the finest pictures ever painted by an Englishman.' It was also a great success in Paris, where it was shown at the Exposition Universelle in 1889. Burne-Jones was awarded the the Légion d'Honneur. After this, Burne-Jones exhibited regularly in Paris until 1896, and his pictures became something of a cult in intellectual circles, particularly amongst the Symbolist group of writers and painters.

King Cophetua was bought by the Earl of Wharncliffe, a wealthy Yorkshire landowner who had already commissioned Poynter to paint four large pictures for his billiard room. Regrettably, these have all disappeared. Poynter was Burne-Jones's brother-in-law, as he was married to Georgiana's

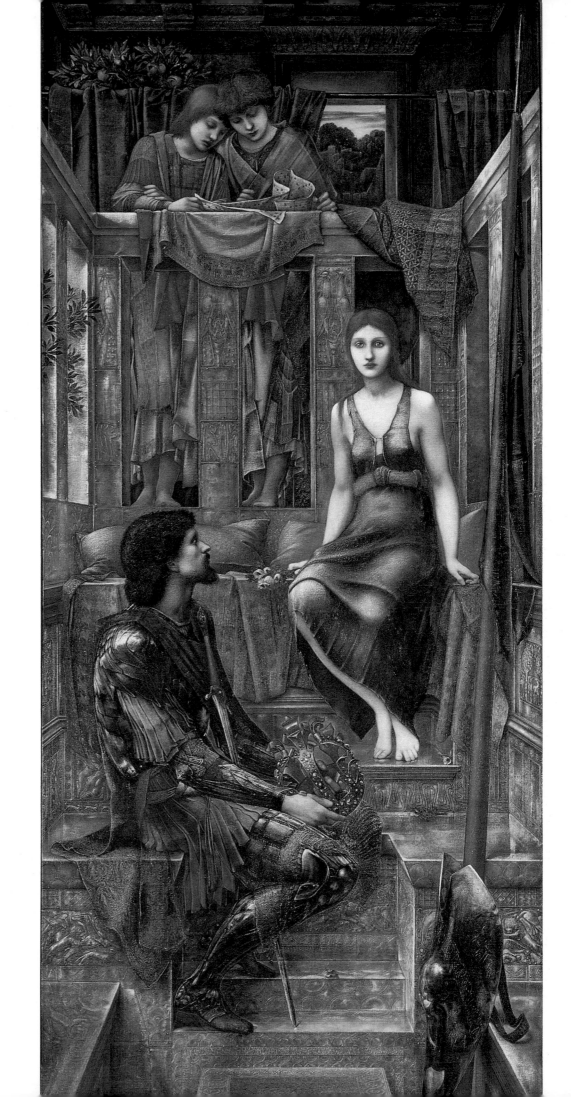

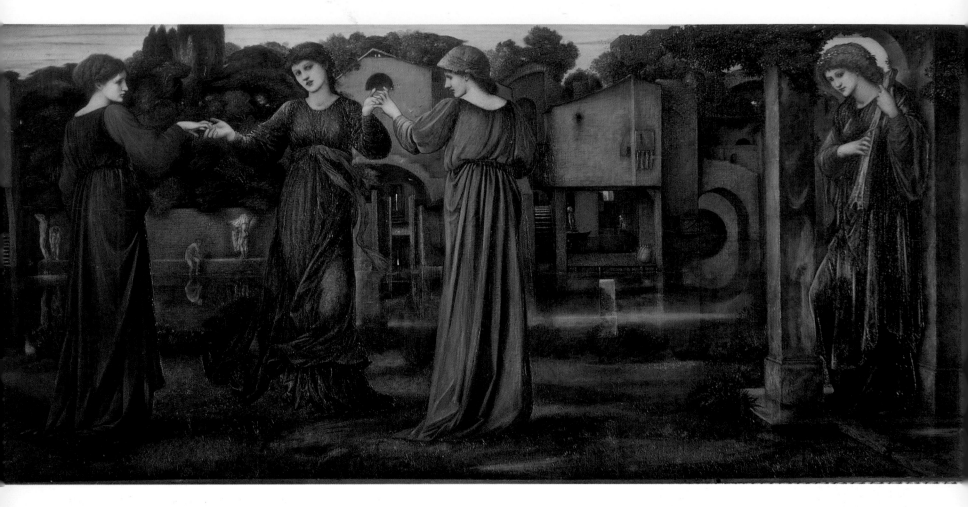

sister Agnes (Aggie). (The MacDonald sisters all made remarkable marriages – another married John Kipling, the father of Rudyard Kipling, and the fourth became the wife of Alfred Baldwin, father of Stanley Baldwin, the future Prime Minister.) The sale of *King Cophetua* was negotiated by the ever-supportive William Graham, who himself bought a large-scale pastel cartoon of it. There are at least two small gouache versions, and many studies. In 1900 the picture was bought by the Tate Gallery, and Lady Burne-Jones wrote that she was very glad because 'this picture contained more of Edward's distinctive qualities than any other that he did'. It is not only a great picture, but it sums up the ideals of Burne-Jones and his circle – chivalry, beauty, poverty, romance and the quest for the perfect love.

In 1885 Burne-Jones once again did not show anything at the Grosvenor. He wrote to a friend to explain:

I have begun so many and finished none – and just for once I thought how delightful it would be to have a foretaste of Paradise and be at peace. And it is peace – no dear friend now can come and say, 'Did you see what the *Observer* says of you?'

In June of the same year, Burne-Jones received the unexpected news that he had been elected as an Associate of the Royal Academy. He had been proposed by Briton Riviere, whom he did not know. The President of the RA, Frederic Leighton, had been trying for several years to persuade Burne-Jones to exhibit there, and wrote to him about the election:

Dear Ned, an event has just occurred which has filled me with the deepest satisfaction and with real joy. A spontaneous act of justice has been done at Burlington House – the largest meeting of members that I ever saw has by a majority elected you an Associate of the Royal Academy … It is a pure tribute to your genius and therefore a true rejoicing to your affectionate old friend Fred Leighton.

Burne-Jones and his wife were thrown into a turmoil of indecision, and cast about among their friends for advice. Watts urged him to accept, Morris to refuse. At last Burne-Jones wrote to the faithful William Graham, then seriously ill and out of London. Graham advised him to accept, 'whilst maintaining your old independence'. So, reluctantly, Burne-Jones wrote to accept the honour. He could now put the letters ARA after his name. Burne-Jones was only to exhibit one picture there, *The Depths of the Sea*, in 1886. He wrote to Mrs Horner of Mells (Frances Graham), 'it will be lost entirely in the Academy – but here it looks like a dream well enough.'

William Graham died a month after Burne-Jones's election to the Academy. Georgiana wrote that 'no one could supply his place to us'. For both of them it was a great loss; they missed not only his support and encouragement, but his sage advice on business matters. Burne-Jones was so unworldly that it was not until the late 1860s that he could be persuaded to open a bank account. His other great patron F. R.

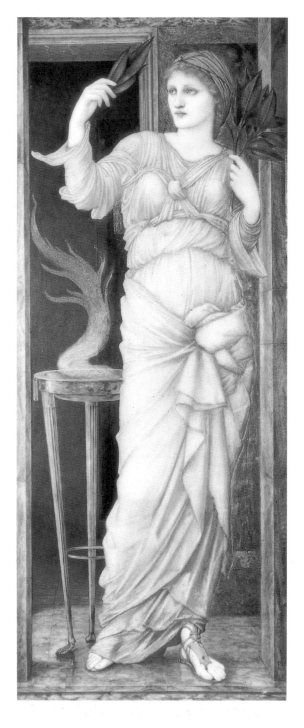

Leyland showed him how to write out a cheque, and he was greatly incensed that this should be described as 'drawing'.

In 1885 Burne-Jones also accepted the Presidency of the Society of Artists in his home town, Birmingham. Provided he should not give any lectures or make speeches, Burne-Jones agreed to visit the local Art School and School of Design. This he much enjoyed, and he wrote afterwards to his host, Mr Kenrick, about his hopes for the city:

> And Birmingham shall be a famous city of white stone, full of brave architecture, carved and painted – politics quite needless since the fight has been won (the fighters portrayed in marble placidly sleeping)[,] advertisements penal, and the newspapers, if needed at all, in strict rhyme and metre.

In his life, and his art, Burne-Jones liked to be completely out of touch with the real world. But he never succeeded; contemporary events pressed in upon him, and his letters are full of impassioned comments on the issues of the day. It was an expression of Burne-Jones's own special sense of beauty, perceptively described by David Cecil as 'the characteristic sense of a highly cultured, refined spirit, living a sheltered life at the end of a long tradition of civilization'.

1886 and 1887 were the last two years in which Burne-Jones exhibited at the Grosvenor. In 1886 he showed three pictures, *Flamma Vestalis*, *The Morning of the Resurrection* and *Sibylla Delphica*. The best-known of these is *Flamma Vestalis*, of which an etching was made. Burne-Jones described it as 'a little like Margaret'. The title, and the flaming torch embroidered on the girl's sleeve, indicate that she is one of the Vestal Virgins of Rome, whose duty was to tend the sacred flame of the Goddess Vesta. Margaret was to marry J. W. Mackail, a scholar and civil servant, two years later in 1888. Burne-Jones combined Christian allegory by showing the Vestal Virgin hold-

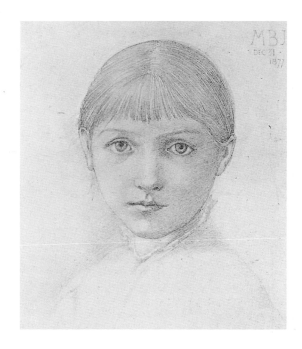

Opposite: **The Mill,** *1882. Another Symbolist work by Burne-Jones, evoking the nostalgic mood of a summer evening, but without any specific subject. The picture was bought by Constantine Ionides, and the three girls, or three graces as they were known among their friends, were his daughter Aglaia Coronio, their friend Maria Spartali and cousin Maria Zambaco.*
Above: **Margaret Burne-Jones,** *1877. A portrait of Burne-Jones's beloved daughter Margaret, aged 12. From a young age, she read to her father while he worked in the studio, and she modelled for numerous pictures.*
Left: **Sibylla Delphica,** *1886. Exhibited at the Grosvenor Gallery in 1886, this very Michelangelesque sibyl shows Burne-Jones's classical style of the 1880s developing.*

ing a rosary, leading one critic to think she was a nun. The headdress is similar to that worn by the figure of Fortune in *The Wheel of Fortune*, and both are related to the figures of Sibyls on the ceiling of the Sistine Chapel, by Michelangelo. The *Sibylla Delphica*, also shown at the Grosvenor in 1886, like the *Cumean Sibyl* shown in 1877, derives from the windows of Jesus College Chapel, Cambridge. *The Morning of the Resurrection*, a lunette-shaped picture, likewise owes much to stained-glass work, but it is one of Burne-Jones's most austere and

gallery in 1883, the first London gallery to do so. With a young Italian called Sebastian de Ferranti, he set up a generating plant next to the galleries, which was soon supplying electricity to the surrounding area. Winter exhibitions were held, sometimes with great success, notably the Millais Exhibition in 1885–6. But none of this was enough. In 1884 Lindsay appointed a jeweller, one Joseph Pyke, as manager, who let out some of the rooms, sometimes for parties, and turned the restaurant into a public eating-house with an orchestra. He also put advertisements and billboards on

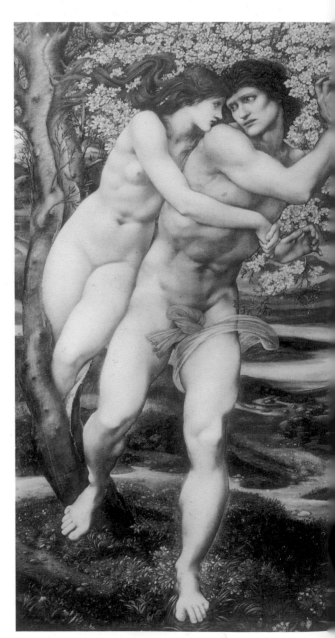

impressive religious works. In the left-hand corner, he painted the words 'In Memoriam L.L. Easter 1886', a tribute to Laura Tennant, Lady Lyttelton, a close friend and occasional model, who had recently died very young. Burne-Jones later designed a memorial tablet to her.

In 1887, in what was to be his last appearance at the Grosvenor, he exhibited five pictures, *The Garden of Pan*, *The Baleful Head*, two portraits and a memorial tablet. *The Garden of Pan* fulfilled Burne-Jones's long-held ambition to paint the beginning of the world. It is a large landscape with a boy piping to two naked figures, full of Burne-Jones's typically Puckish humour. It is also strongly Italianate, with echoes of both Piero di Cosimo and Dosso Dossi. *The Baleful Head* was the last in the finished *Perseus* set, which he was working on throughout the 1880s, for 'the patient and kind Arthur Balfour'. Balfour certainly needed large reserves of patience and kindness, as the series was still unfinished at Burne-Jones's death. Perversely, he worked on the three last episodes first, those involving the story of Perseus and Andromeda. *The Baleful Head*, a magnificently colourful

Above: Drawing on the envelope of a Letter to Katie Lewis. The date stamp is 1883.

Right: **The Tree of Forgiveness** *A later version in oil of the watercolour* Phyllis and Demophön, *painted in 1870. This time Burne-Jones has added discreet drapery, thus avoiding the furore caused by the watercolour version at the Old Watercolour Society (see p. 34).*

Opposite: **The Garden of Pan** *1886–7 Burne-Jones wrote of* The Garden of Pan *that it had 'no satire in it, but is meant to be a little foolish and to delight in foolishness — and is a reaction from the dazzle of London wit and wisdom'.*

and beautiful picture, shows Perseus holding the head of the Medusa above a well so that Andromeda can look at its reflection.

The Portrait of Katie, also shown in 1887, was the portrait of Katie Lewis, painted 1882, but worked on again later. 1887 was Burne-Jones's last year at the Grosvenor, where a crisis had been building up over recent years. The problems were mainly financial, and stemmed from the Lindsays' separation in 1882. Coutts Lindsay was not a good businessman, and gradually began to lose interest. One of his better initiatives was to introduce electric lighting in the

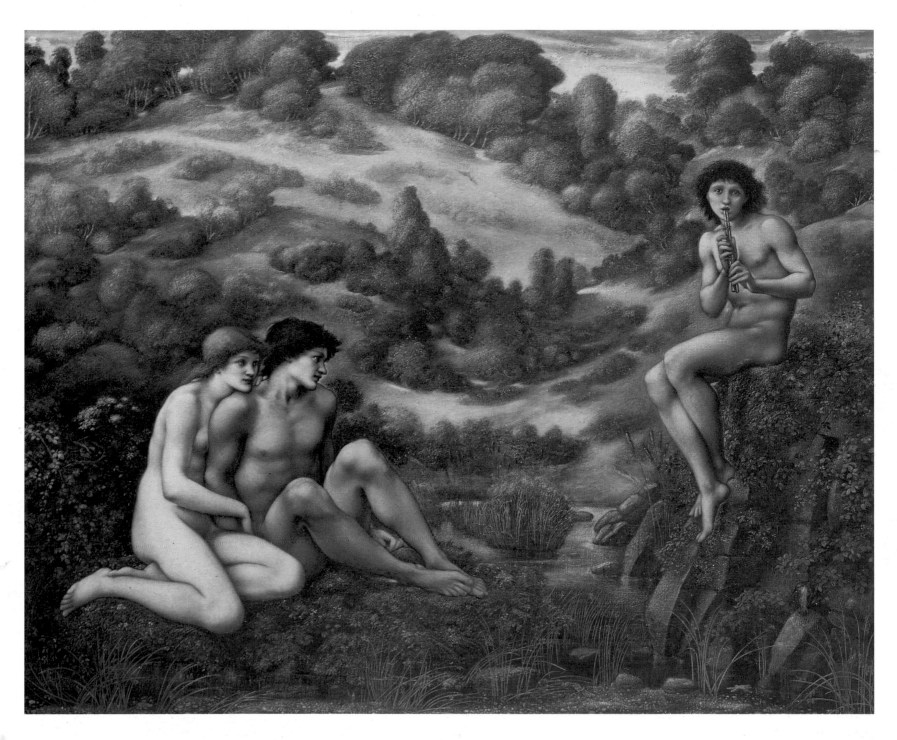

the street front of the building. All this was anathema to Hallé and Comyns Carr, and to many of the Grosvenor artists. In October 1887, Burne-Jones wrote to Hallé voicing his concerns:

I am troubled and anxious more than I can say by the way in which it seems to me the Gallery has been gradually slipping from its position ... to that of a room which can be

hired for evening parties ... steadily and surely the Gallery is losing caste: club rooms, concert rooms, and the rest, were not in the plan, and must and will degrade it.

Burne-Jones also wrote to Coutts Lindsay, pointing out that the gallery 'has begun a downward course'. Unless matters changed, he warned that 'I for one would have to withdraw, with pain and reluctance

– feeling miserable at the breakdown of so handsome an undertaking as it was.' In November, Hallé and Comyns Carr resigned, explaining their reasons in a letter to *The Times*. They quickly found other premises in Regent Street, which they called the New Gallery. Their first exhibition was held in May 1888, and Burne-Jones transferred his allegiance. This was a body-blow from which the Grosvenor

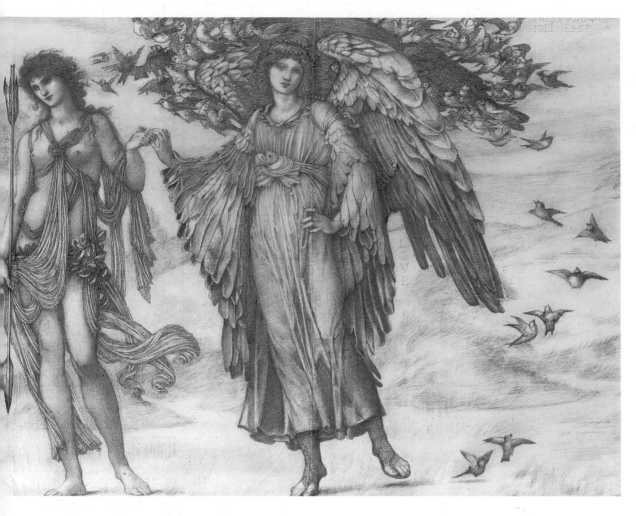

in the increasingly severe style of Burne-Jones's later years. Danae's robes are hard and sculptural, as if cut from stone, but it is relieved by some beautiful flowers in the foreground. The architecture is once again Italianate, but stony and threatening, as if to suggest a prison. Through the doorway, Danae watches her father's soldiers building the tower in which she is to be confined. The picture was bought soon after its completion by Glasgow City Art Gallery.

The Rock of Doom and *The Doom Fulfilled* are the sixth and seventh pictures in the *Perseus* series, coming before *The Baleful Head*, shown at the Grosvenor in 1887. This meant that Burne-Jones had completed four of the series. He was still working on *The Call of Perseus*, *The Arming of Perseus* (numbers one and two), *The Finding of the Medusa* and *The Escape of Perseus* (numbers four and five). None of these was ever completely finished. *The Rock of Doom* shows Perseus discovering Andromeda chained to

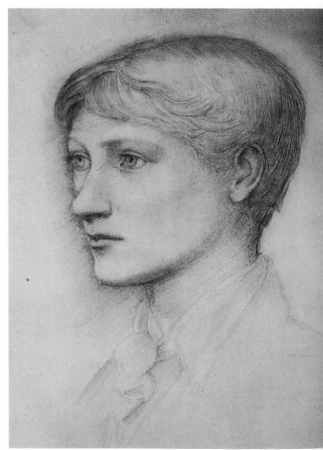

never recovered. It limped on for a further two years, but finally closed its doors in 1890. It was a sad end, but the fourteen years of the Grosvenor remain one of the key episodes of Victorian art, redefining perceptions about art and its purpose for the late nineteenth century. It was the focal point of the Aesthetic Movement. But for Burne-Jones, it was time to move on. He served on the committee of the New Gallery, which was to be his chief exhibiting forum for the rest of his life. His retrospective exhibition was held there in 1894, and a memorial exhibition in 1898.

Burne-Jones sent three important pictures to the first New Gallery exhibition, *Danae or the Brazen Tower*, and two more of the *Perseus* pictures, *The Rock of Doom* and *The Doom Fulfilled*. *Danae* goes back to the 'Cupid and Psyche' illustrations for *The Earthly Paradise*, and Burne-Jones made at

Above: **The Garden of Idleness: Love and Beauty**, *1870s. A design for the series of tapestries, based on Chaucer's 'Romaunt of the Rose', commissioned by Sir Lowthian Bell for Rounton Grange, Northallerton. The tapestries are now in the William Morris Museum, Walthamstow.*
Right: **Portrait of Philip Burne-Jones** *(1861–1926). A sensitive portrait of the Burne-Jones's only son, who himself became an artist and portrait painter.*
Opposite: **Danae or the Brazen Tower**, *1888. Another picture whose origin goes back to Burne-Jones's illustrations for* The Earthly Paradise. *This one was exhibited at the New Gallery in 1888, but there are at least three earlier versions, including one exhibited at the Grosvenor in 1882. Maria Spartali posed for the head of Danae.*

least four versions, in 1866, 1869, 1872, and finally the large version completed in 1888. In size, shape and style it is very similar to the large *Annunciation* of 1879. It is painted

a rock; *The Doom Fulfilled* Perseus killing the Dragon. Both of these are among Burne-Jones's finest compositions, particularly the writhing, convoluted coils of the dragon, which have a sinister and menacing quality more akin to European Symbolism.

Although incomplete, the *Perseus* series taken as a whole represents an absolutely unique vision of classical myth, conveyed with greater imaginative power than any other Victorian painter could command. It is Burne-Jones's greatest cycle, but sadly much less well known than the *Briar Rose* series, because the pictures have spent much of their life out of England, and now belong to a German museum. The cartoons all hang in one room in Southampton Art Gallery, and they too have been unaccountably neglected. They have an even more unearthly, ghostly feeling, mainly because of their raw, unfinished appearance, and the lack of backgrounds. *The Escape of Perseus* is the most electrifying of them all; the weird composition of flying figures and their black wings is truly nightmarish, and quite unique in Victorian art (see chapter 10).

The New Gallery opening was adjudged a success, that Burne-Jones's pictures doubtless contributed to. He wrote to a friend:

> I have seen no newspapers, only people tell me the gallery is successful, and I am pleased. The public who said it couldn't succeed, and the press who said it wouldn't, and society who said it shouldn't, all wrong – all wrong as usual, as they always are …

In 1889 he sent nothing to the New Gallery, except a few drawings and studies. 'So this year I rest,' he wrote, 'not from work, but from advertising my work, and I feel clean and happy and comfortable in consequence.' Burne-Jones rarely rested; he was a relentless worker, which is why his output was so huge. If he did not exhibit, it is because he had more important projects in hand. He was finishing the best-known and best-loved of his cycles, the *Briar Rose*.

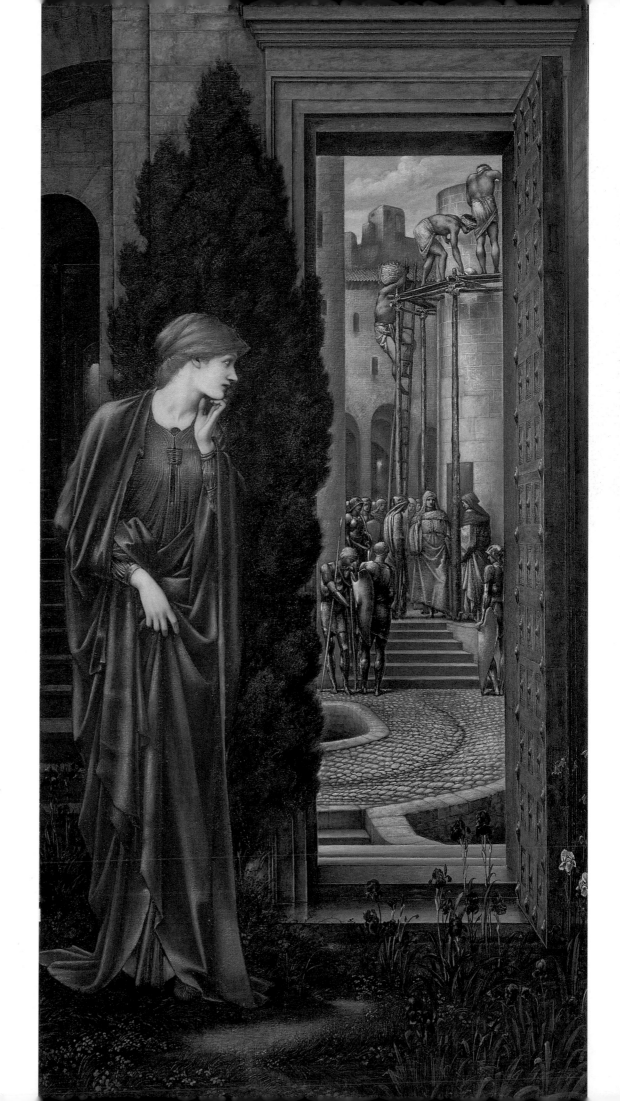

BRIAR ROSE
THE 1890s

Burne-Jones's biggest concern in the 1890s was to finish the *Briar Rose* series. He had a premonition that he would die before his fifty-seventh birthday, and he therefore hurried to complete it during 1889. It was not finally completed until 1890, when T. Agnew and Sons of Old Bond Street bought the set of four pictures for £15,000, and exhibited them in their gallery in April of that year. This was Burne-Jones's biggest triumph since *King Cophetua*, and in many ways the climax of his whole career. The *Briar Rose* had occupied him for nearly thirty years, and is one of his greatest achievements. The set was purchased by Alexander Henderson, a rich financier and railway-builder, who became the 1st Lord Faringdon. The pictures have hung ever since in the saloon of his house in Oxfordshire, Buscot Park, now the property of the National Trust.

The story of the *Briar Rose* series is long and complex and spans most of Burne-Jones's career. It was inspired by the fairy story of 'The Sleeping Princess', recounted in the seventeenth century by Charles Perrault in his *Contes du Temps Passé*. This was later rewritten by the Brothers Grimm and, more importantly for Burne-Jones, by Tennyson in his poem 'The Day Dream' of 1842. This poem was also included in the Moxon Tennyson of 1857, with illustrations by Rossetti; it was seeing this book that led to the meeting of Rossetti and Burne-Jones. When

Left: *A study for the Sleeping Princess in the* Briar Rose *series. The model was Burne-Jones's daughter Margaret. Burne-Jones deliberately ended the story with the Princess still asleep.*
Opposite: **The Briar Rose – 1. The Briar Wood**, *1870–1890. Burne-Jones wrote to his friend Lady Leighton Warren, 'I wonder if in your land there grow stems of wild rose such as I have to paint in my four pictures of the Sleeping Palace – and if deep in some tangle there is a hoary, aged monarch of the tangle, thick as a wrist and with long, horrible spikes…'*

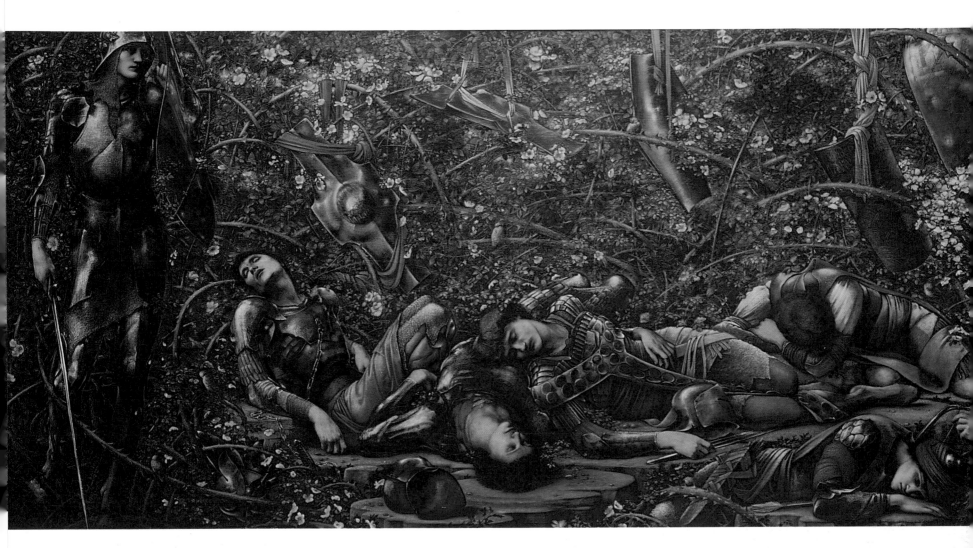

Burne-Jones came to paint the *Briar Rose*, it was the languorous mood of Tennyson's poem he was trying to capture.

In the 1860s Burne-Jones became interested in several fairy stories, including 'The Sleeping Beauty', 'Cinderella' and 'Bluebeard'. Several of these were the subject of sets of tiles which he designed for Morris in the very early days of the Firm. *The Sleeping Beauty* was one of these sets, and one was purchased by Birket Foster for his house, The Hill, at Witley in Surrey. This is now in the Victoria and Albert Museum. Another tile, *The Prince Entering the Briar Wood,* is in the William Morris Gallery. The style is quaint and primitive, owing much to German illustrators Burne-Jones was studying at the time.

By 1869 Burne-Jones was considering a set of paintings on the subject. In that year he painted a large oil study of the first scene, *The Prince Entering the Briar Wood*; this was left incomplete, and was eventually included in his studio sale at Christie's in 1898. In 1871 he painted a small gouache of *The Sleeping Beauty*, showing the Princess asleep amid roses. This was painted for the dealer Murray Marks and is now in Manchester City Art Gallery. By 1872, he had done a set of three oils for William Graham. These are approximately 24 x 50 inches, and are now in the Museo de Arte in Ponce, Puerto Rico. They are generally referred to as the small *Briar Rose* set; the subjects are *The Prince Entering the Briar Wood, The King and his Courtiers Asleep* and *The Sleeping Princess,* awaiting the kiss from the Prince that will wake her and bring the castle back to life. These pictures are richly coloured and Venetian in feeling, and typical of the taste of William Graham. The compositions are similar to the tiles, but the poses of the sleeping knights are more complex and contorted, probably due to Burne-Jones's admiration for Michelangelo at this period. The technique is looser and more sketchy than the final set, and typical of Burne-Jones's style in the early 1870s.

By the 1880s Burne-Jones was working on a much larger set, roughly 48 by 100 inches, and had introduced a new subject. This was *The Garden Court*, showing servant girls who have fallen asleep at a loom and drawing water. No doubt Burne-Jones was already visualizing the pictures on four sides of one room. This was the set sold to Agnew's in 1890, now at Buscot Park.

In the autumn of 1884 Burne-Jones began working on the first scene, *The Prince Entering the Briar Wood*. He wrote to his

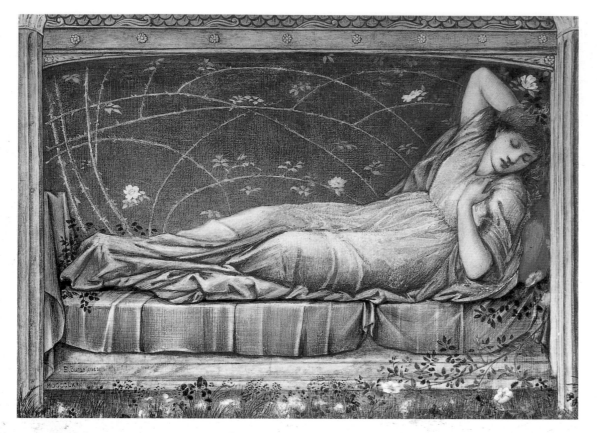

Left: **The Sleeping Beauty**, *1871. This gouache on vellum, commissioned by the dealer Murray Marks, was Burne-Jones's first portrayal of the Sleeping Beauty, later to become the final picture of the Briar Rose series.*

Below: **The Briar Rose 3. The Garden Court**, *1890. This was the new, fourth subject, not included in the first set of three. It depicts servant girls who have fallen asleep at a loom, and drawing water from a well.*

Opposite: **The Briar Rose 4. The Rose Bower**, *1890. Burne-Jones, typically, wanted to end the story with the Princess asleep, rather than show her awakened by the Prince's kiss. He preferred to stay with his 'beautiful romantic dream'. The model for the Princess was his daughter Margaret; he wanted her to remain forever young too. She married J. W. Mackail in 1888, and Burne-Jones gave her a large oil sketch of this picture.*

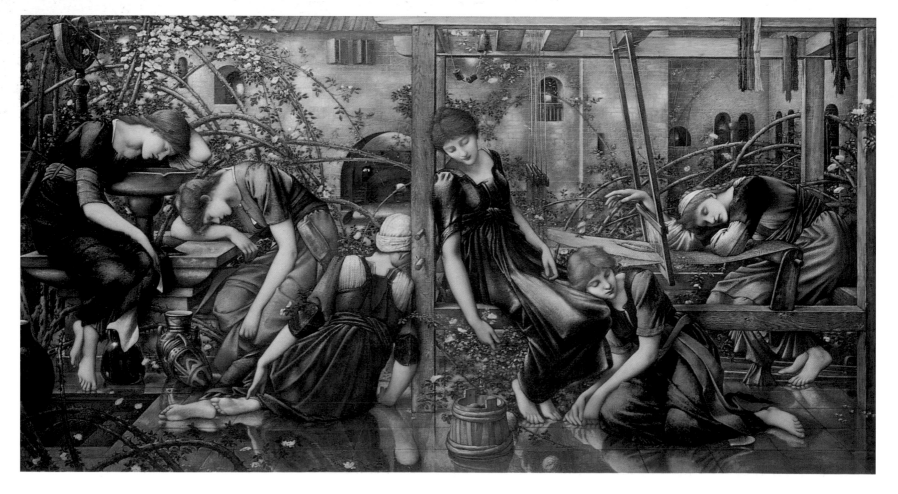

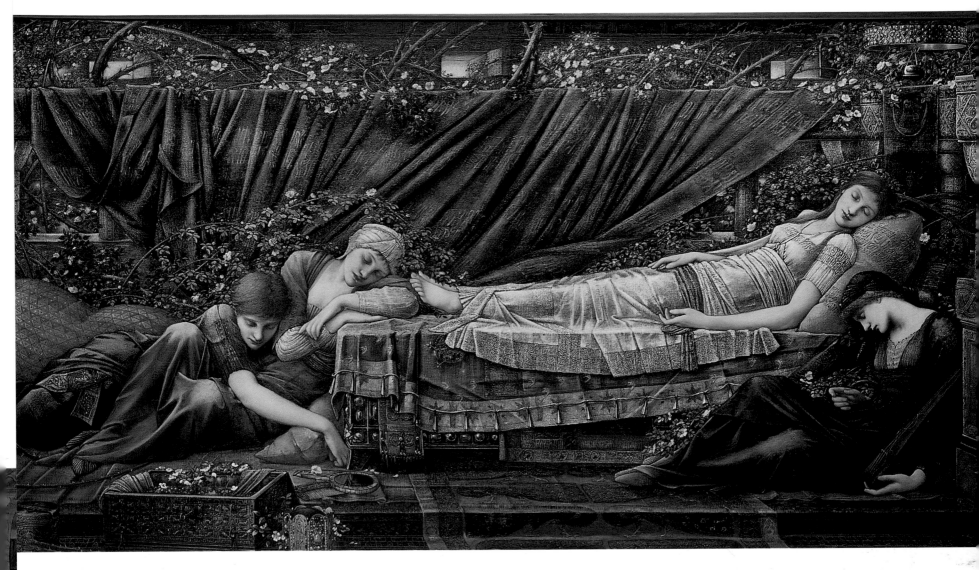

I want it to stop with the Princess asleep, and to tell no more, to leave all the afterwards to the invention and imagination of people, and to tell them no more.

This remark underlines Burne-Jones's passionate belief in the imagination, his imagination, his own private dream world. The *Briar Rose* is the purest expression of that dream world, the intense desire that so possessed the Victorians to escape the times in which they lived. Burne-Jones wanted the Sleeping Princess to dream on; he too wanted to dream on and hope that the nineteenth century would go away. This was Burne-Jones's 'beautiful romantic dream'.

When the four pictures were installed in the saloon at Buscot Park, Alexander Henderson invited Burne-Jones to come and see them, and commissioned him to fill in the gaps with small decorative panels. In these Burne-Jones painted more briar roses, thus making the pictures into a harmonious whole. He also designed a complete framework for the whole set, in rich Italianate style. Underneath each picture were inscribed poems by Morris, rather weak compared to those of Tennyson. And there the series is, complete and untouched, one of the greatest cycles ever painted by an Englishman, and an essential place of pilgrimage for anyone interested in Burne-Jones and the Pre-Raphaelites.

To make matters even more complex, towards the end of his life Burne-Jones completed more large versions of three of the pictures. In the 1890s he tried to complete many of the unfinished studies littering his studio. Morris had said to him one day, 'The best way of lengthening out the rest of our days now, old chap, is to finish off old things.' So he painted another version of *The Garden Court* (1893, now in the Bristol Art Gallery), *The Council Chamber* (1892, Bancroft Collection, Wilmington, Delaware), and *The Rose Bower* (1894, Municipal Gallery of Modern Art, Dublin). The only subject he did not repeat again was the first. So it is literally true that the *Briar Rose* preoccupied Burne-Jones almost the whole of his working life.

He did not die in his fifty-seventh year, as he had feared, but the 1890s were to be his final decade. Once the *Briar Rose* series

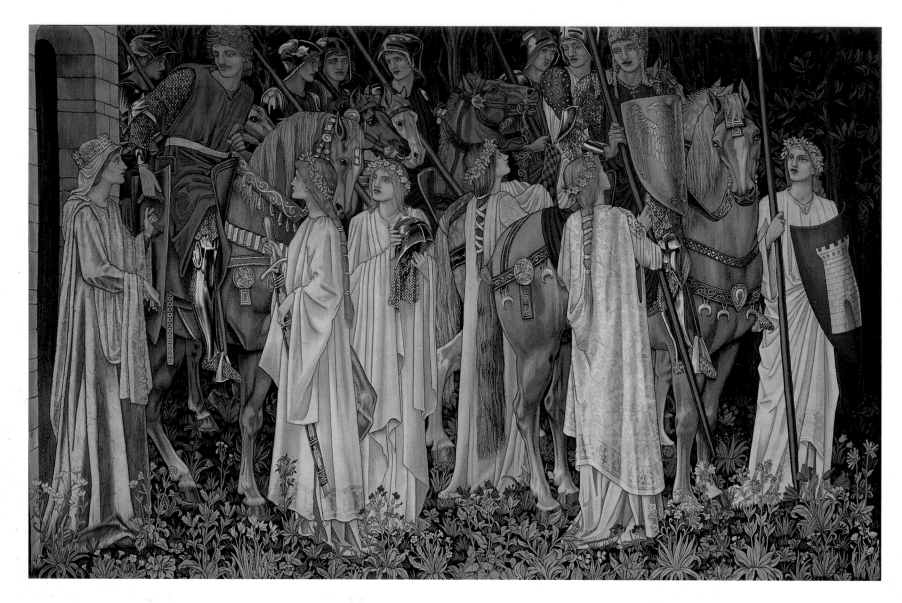

museum – indeed when the book is done, if we live to finish it, it will be like a pocket cathedral – so full of design and I think Morris the greatest master of ornament in the world – and to have the highest taste in all things.

The tone of the letter is typical of Burne-Jones's whimsical style. 'Pocket cathedral' is a memorable phrase, and well describes the *Chaucer*. It was published in 1895, only a year before Morris's death, a fitting memorial to one of England's greatest designers.

Another project in which Morris and Burne-Jones were to collaborate in the 1890s was the *Holy Grail* tapestries. This was another return to a favourite theme of their

youth, Malory's *Morte d'Arthur*. Morris & Co. had received a commission from the Australian mining millionaire, W. K. d'Arcy, to furnish his house, Stanmore Hall, just outside London in Middlesex. It had a large dining-room, and Morris persuaded him to cover its walls with tapestry. It was to consist of five large panels, a smaller panel of a ship, and a decorative dado panel of verdure with knights' shields hanging from trees. Morris asked Burne-Jones to produce cartoons, and five subjects were decided on:

The Knights of the Round Table
Summoned to the Quest by a Strange
 Damsel
The Arming and Departure of the Knights

Above: **2. The Departure of the Knights.** *On the left, Guinevere hands a shield to Sir Lancelot. The other knights, recognizable by their shields, include Sir Gawaine, Sir Hector, Sir Bors, Sir Perceval and Sir Galahad. Burne-Jones thought this the most successful of the* Grail *tapestries.*

Opposite top: **3. The Attainment.** *The Vision of the Holy Grail to Sir Galahad, Sir Bors and Sir Perceval. Only three knights are permitted to sail to the island of Sarras, and see the Holy Grail. Sir Gawaine and Sir Lancelot have fallen by the wayside. Sir Bors and Sir Perceval are to the left, their way barred by angels holding spears; only Sir Galahad is permitted to approach the chapel door.*

Opposite below: **4. Verdure with Deer and Shields.** *This tapestry hung below* The Departure of the Knights *at Stanmore Hall.*

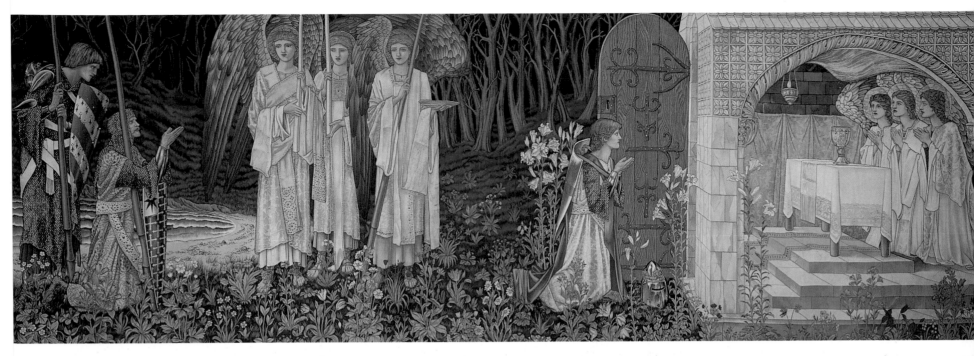

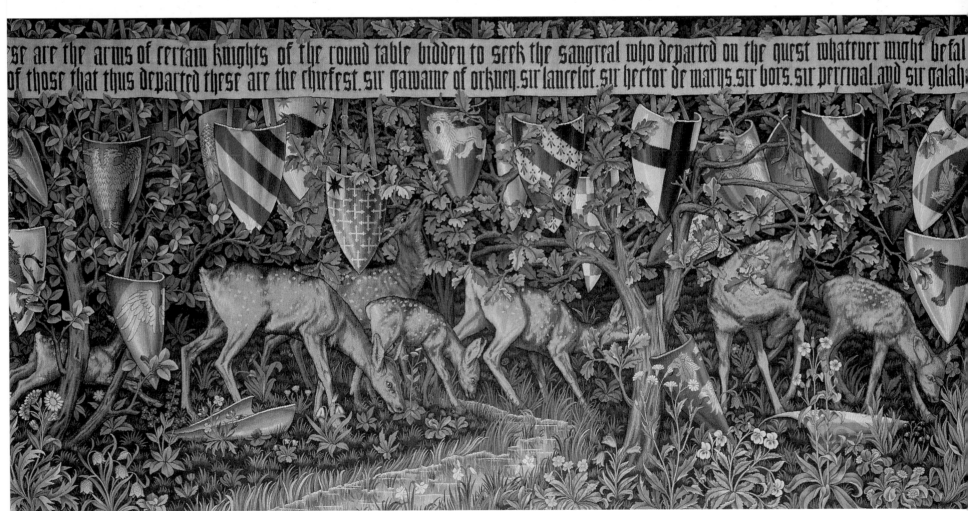

...se are the arms of certain knights of the round table bidden to seek the sangreal who departed on the quest whatever might befal... ...of those that thus departed these are the chiefest. sir gawaine of orkney. sir lancelot. sir hector de marys. sir bors. sir percival. and sir galah...

1895, with Irving in the title-role, Ellen Terry as Guinevere, and Forbes Robertson as Launcelot. In the end, Burne-Jones was disappointed; the play did not live up to his expectations. It did not correspond with his vision of King Arthur, and he confided to his friend Mrs Gaskell:

The armour is good – they have taken pains with it – made in Paris and well understood

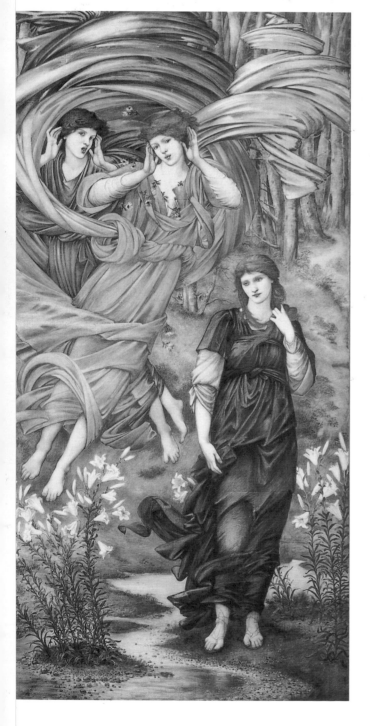

– I wish we were not barbarians here. The dresses were well enough if the actors had known how to wear them – one scene I made very pretty – of the wood in maytime – that has gone to nothing – fir trees which I hate instead of beeches and birches which I love – why? – never mind.

The architecture will do – and the furniture – but mostly the armour is good – and Perceval looked the one romantic thing in it.

Merlin I designed carefully – they have set aside my designs and made him filthy and horrible – like a witch in Macbeth – from his voice I suspect him of being one of the witches – I hate the stage, don't tell – but I do – don't tell but I do don't tell...

Morgan Le Fay is simply dreadful, you remember she is half divine in the ancient story – here they are scandal mongery gossips … the banners with the chalice on them looks nice.

The reality of trying to turn King Arthur into a commercial play was clearly dispiriting for Burne-Jones. Perhaps fittingly, his sets were completely destroyed in a fire, so now all that survives are some notes and brief description he made in a sketchbook, and a photograph of one of the sets in the Theatre Museum.

Burne-Jones continued to support the New Gallery, and in 1891 showed two large pictures, *The Star of Bethlehem* and *Sponsa da Libano*. *The Star of Bethlehem* was a large version in gouache of the tapestry he had designed for Morris & Co., *The Adoration of the Kings*. He worked hard on this during 1890, and wrote:

a tiring thing it is, physically, to do, up my steps and down, and from right to left. I have journeyed as many miles already as ever the kings travelled. I have had a very happy month of autumn, living mostly in suburbs of Sarras …

an ironic reference to his beloved *Morte d'Arthur*. Sarras was the magical isle to

Above: *Study of Melchior in* The Adoration of the Kings. *Melchior was one of the kings in* The Adoration of the Kings *tapestry, and in* The Star of Bethlehem, *a large gouache of the same subject. Burne-Jones made many studies of armour, chain mail and weapons.*

Left: **Sponsa da Libano**, *1891. At first a design for embroidery for the Royal School of Needlework. Burne-Jones liked it so much, he reworked it as a very large watercolour, more than ten feet by five.*

Opposite: **The Adoration of the Kings**, *1887–90. The first large tapestry produced by Morris & Co., woven in 1890 for the Chapel of Exeter College, Oxford. It proved to be a very popular tapestry, and about ten were eventually made. Burne-Jones also produced a large gouache of this subject, entitled* The Star of Bethlehem, *for Birmingham City Art Gallery.*

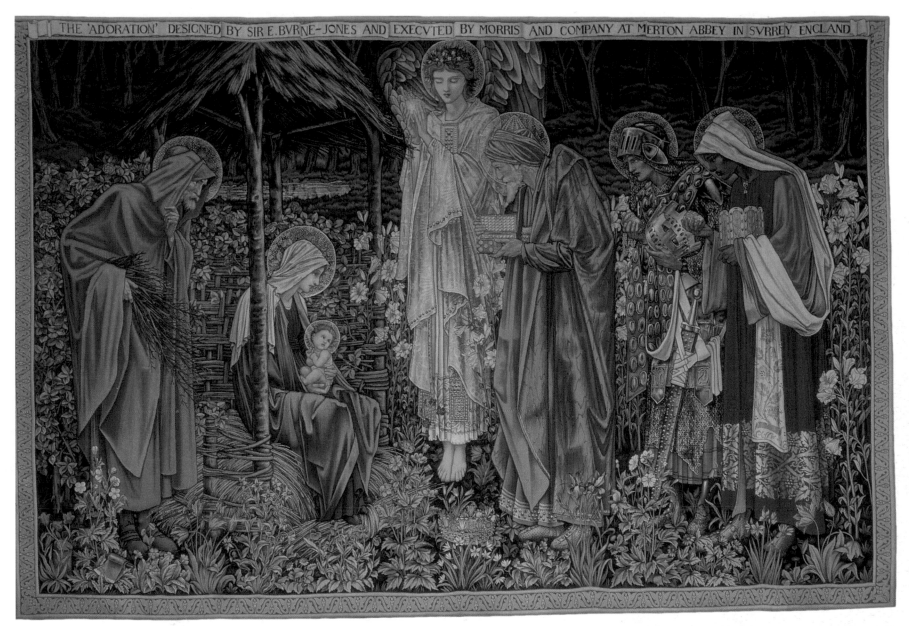

THE 'ADORATION' DESIGNED BY SIR E. BVRNE-JONES AND EXECVTED BY MORRIS AND COMPANY AT MERTON ABBEY IN SVRREY ENGLAND

which the three knights travelled in search of the Holy Grail. While he was working on *The Star of Bethlehem*, a girl was bold enough to ask if he believed in it. 'It is too beautiful not to be true,' he replied, typically. The picture was purchased by his friend Mr Kenrick and given to the newly opened Birmingham City Art Gallery.

Sponsa da Libano started life as a design for embroidery for the Royal School of Needlework, part of a set illustrating *The Song of Solomon*. In 1891 Burne-Jones recast it as a large watercolour, more than 10 x 5 feet. It is a striking composition of female figures representing Winds and Zephyrs, full

of swirling and flowing movement. Like so much of Burne-Jones's late work, it anticipates developments in Europe, particularly Symbolism and Art Nouveau. Burne-Jones wrote to his friend Lady Rayleigh that the model for one of the Zephyrs was:

a little Houndsditch Jewess … self-possessed, mature and worldly, and only about twelve years old. When I said to her 'Think of nothing and feel silly and look wild and blow with your lips,' she threw off Houndsditch in a moment, and thousands of years rolled off her and she might have been born in Lebanon ...'

Also in 1891, Burne-Jones took up an old subject begun in the 1870s, *The Sirens*. It had been commissioned by F. R. Leyland, and Burne-Jones wrote of it:

It is a sort of Siren-land – I don't know when or where – not Greek Sirens, but any Sirens anywhere, that lure on men to destruction. There will be a shore full of them, looking out from rocks and crannies in the rocks at a boat full of armed men, and the time will be sunset. The men shall look at the women and the women at the men, but what happens afterwards is more than I care to tell.

THE DOORS OF HELL

Leyland visited Burne-Jones to discuss the designs, but died in January 1892. Burne-Jones continued to work on *The Sirens*, but never finished it. So now he had lost both his greatest patrons. There were to be many deaths in the 1890s, as one by one Burne-Jones's friends and contemporaries disappeared. In 1890 it was Newman; in 1892, Tennyson. This was the sunset of the Victorian age.

Burne-Jones must have felt old when the New Gallery mounted a retrospective show of his work in the winter of 1892–3. As might be expected, he dreaded it:

> It is the kind of thing that should never be done till a man is dead … I dreaded it exceedingly. I feel a little as if a line was drawn across my life now, and that the future won't be quite the same thing I meant it to be …

To another correspondent he wrote,

> … I had to go to the New Gallery to look at ancient work of mine – and I dreaded it and came back deeply disheartened about myself and feeling to the chilled marrow of me that it had been a poor futile life … I wonder if I shall live to do the thing I want – there isn't much time left. I think I had no equipment but longing – that I had, but nothing else.

As usual, his old friend Morris came to cheer him up:

> This morning brought fresh life to me – for all the week my head had been low in the dust – and he talked of high things till I forgot my abasement.

He received a long letter full of praise from his old friend, the *Punch* cartoonist and now successful novelist George du Maurier.

> I think your special glamour, the gift you always had among others of so strangely impressing the imagination and ever after

Above: *Sir Edward Burne-Jones by Barbara Leighton. He is in front of* The Star of Bethlehem.
Left: *'William Morris at his Loom'*
Below left: *'The Doors of Hell' A drawing made for Burne-Jones's grand-daughter Angela, in a sketchbook he had given to Margaret on her marriage.*
Opposite: **The Sirens.** *Begun in the 1870s, worked on in 1891, and shown to F. R. Leyland just before his death in 1892, ultimately never finished. Burne-Jones intended it to be 'Siren-land … not Greek sirens, but any sirens anywhere …' He made a model of the boat to work from.*

haunting the memory, was almost as fully developed then … as in the later work of greater scope where you had reached your full mastery of execution and draughtsman-ship and design …'

This greatly cheered Burne-Jones, who wrote in reply,

> I shall put it among my phylacteries. My phylacteries are a few very special happyfy-ing letters, like yours, which I can take out and read when I feel particularly worthless to myself, and they serve to drive away demons and night goblins.

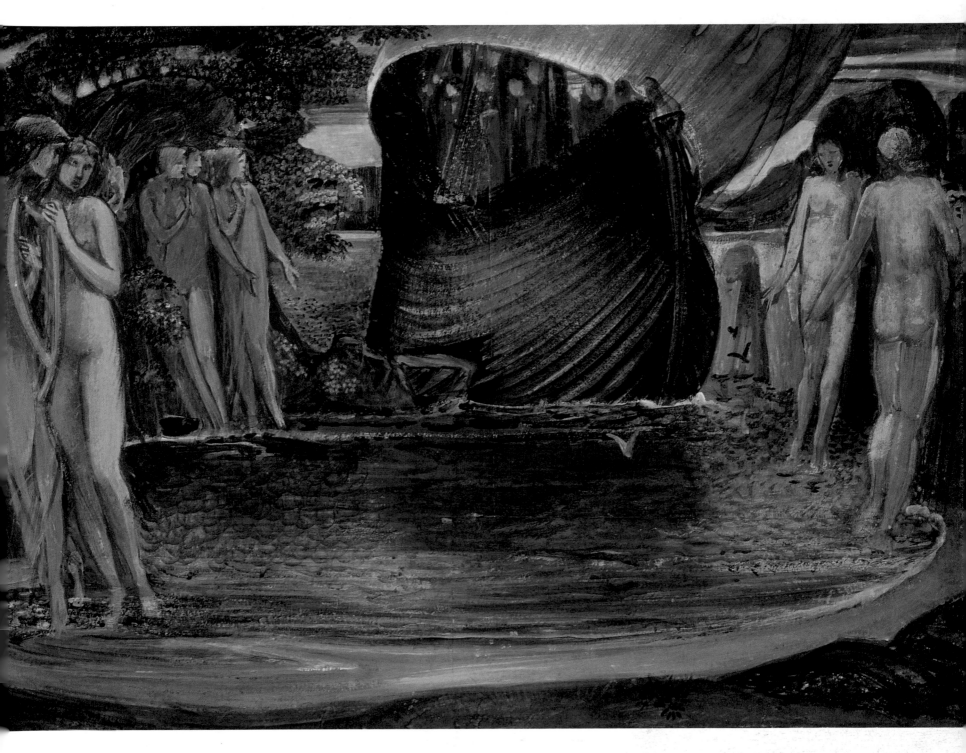

The day before writing this Burne-Jones performed another duty that he had long dreaded. He wrote to Leighton resigning his Associateship of the Royal Academy. He had only exhibited there once and felt there was no point in going on with it. Leighton, of course, was deeply disappointed, but the two men remained good friends. To Alma-Tadema Burne-Jones wrote in lighter vein:

You see, dear friend, I am particularly made by nature not to like Academies. I went to one when I was a little boy, and didn't like it then, and thought I was free for ever when I grew up, when suddenly one day I had to go to an Academy again – and now I've run away.

Although his great friend and mentor G.

F. Watts belonged to the Academy, and exhibited there regularly, Burne-Jones simply could not do it. His creativity depended on complete freedom and independence, especially from any kind of official art establishment. The Grosvenor Gallery and the New Gallery suited him well, as they were both small, independent organizations; the Academy was not for him. So after 1893, he

was free once again to retreat into his own private world of the imagination, through that golden gate of his dreams. On the death of his great hero, John Henry Newman, he wrote, 'to make one's life a great poem is the height of art'. In 1894, Gladstone made him a baronet. It seemed that the more Burne-Jones tried to escape the real world, the more the world wanted to drag him back. Whether he liked it or not, he had become part of the artistic establishment.

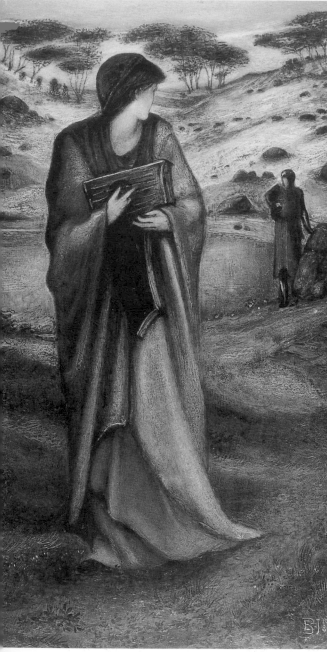

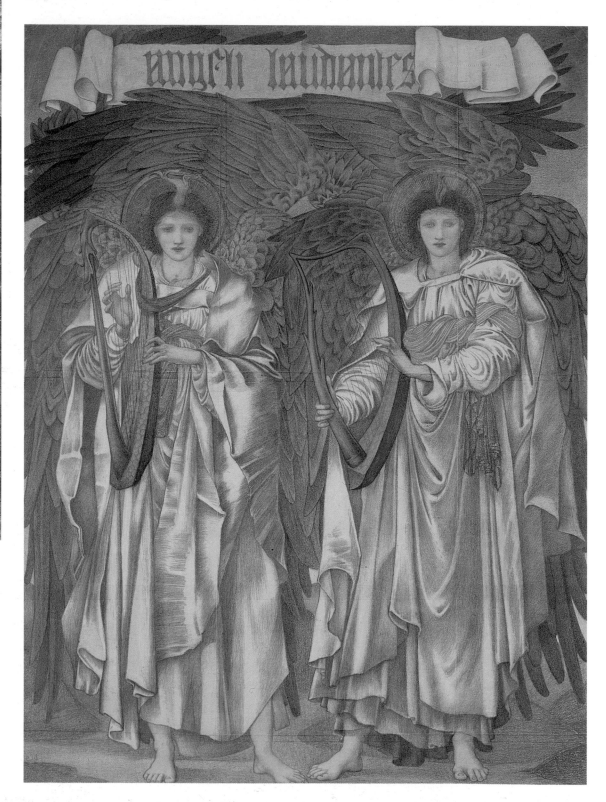

Above: **Merlin and Nimue.** *One of Burne-Jones's favourite subjects from the* Morte d'Arthur, *of which he made numerous versions, this one dating from the 1880s.*

Right and opposite: **Angeli Laudantes,** *1878. This, and its pendant,* Angeli Ministrantes, *were first used as designs for stained-glass windows in Salisbury Cathedral. Later they were turned into tapestries.*

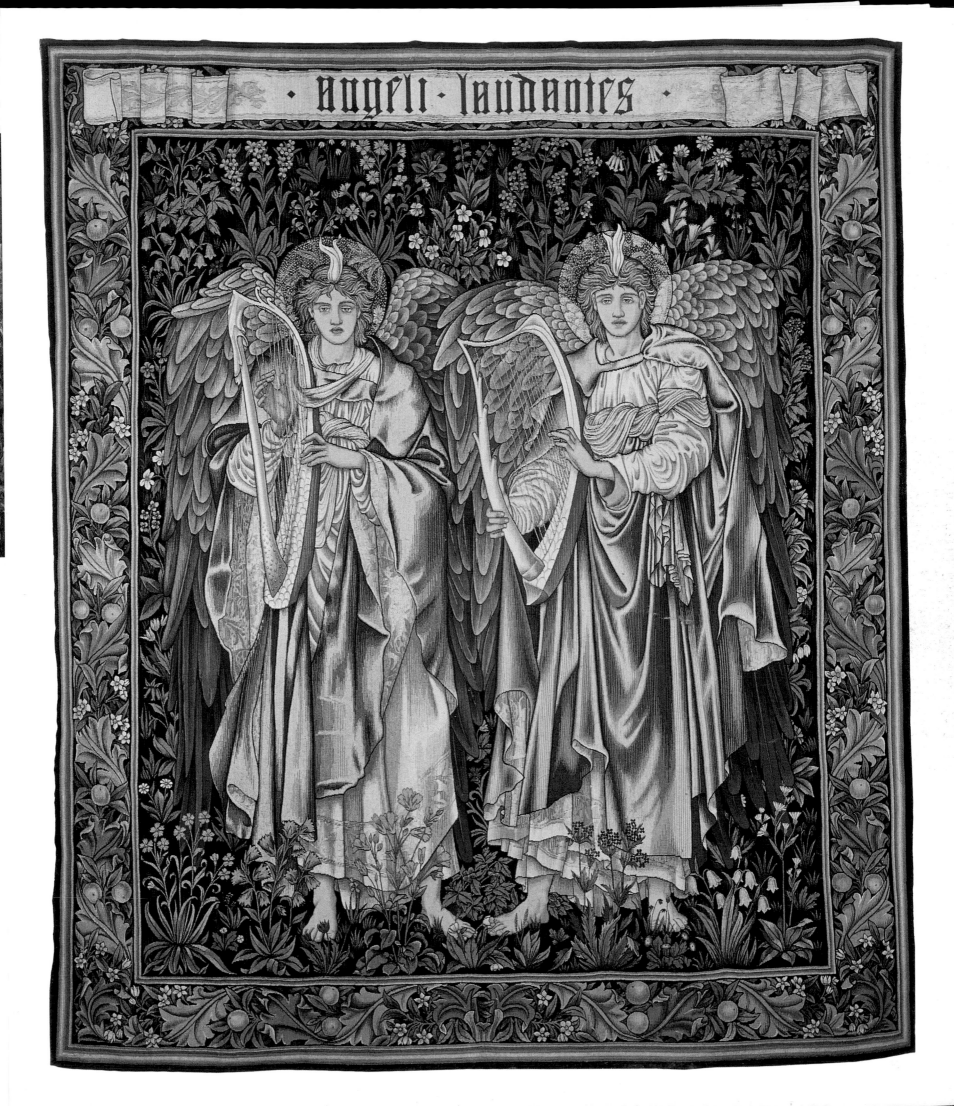

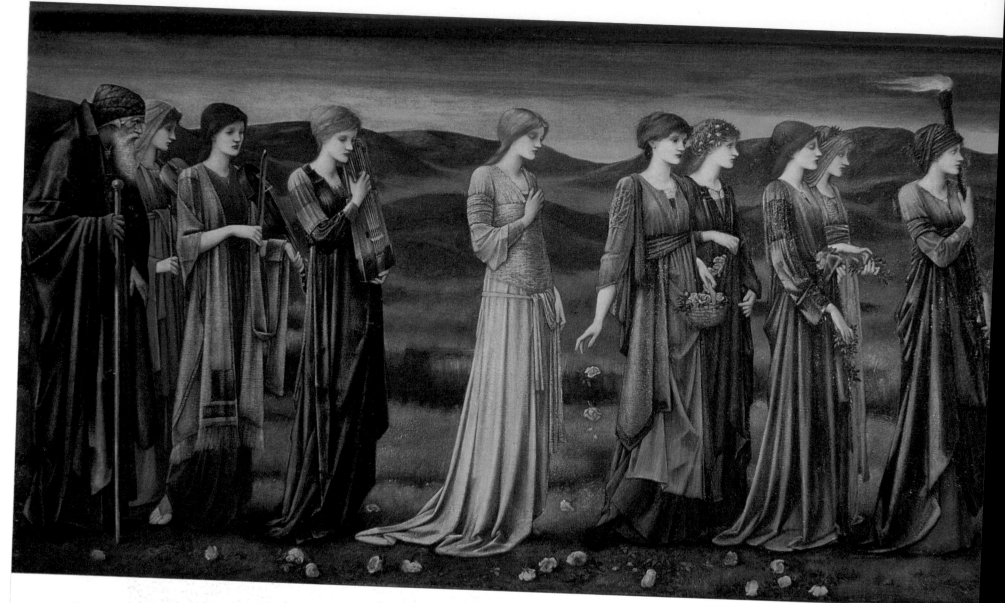

Burne-Jones had met Khnopff in London, and *Memories* was exhibited there in 1890, so there was some possible reciprocal influence. The similarity, however, is one of mood; Burne-Jones's composition dates back nearly thirty years, to the 1860s. Also, Khnopff's picture shows girls in modern dress holding tennis racquets.

Burne-Jones sent four pictures to the New Gallery in 1895. Another was *The Fall of Lucifer*. This was an unused subject from his mosaic designs for the American Church in Rome. It shows Lucifer leading his knights in a winding procession out of Heaven and down to Hell. Typically, Burne-Jones has portrayed Lucifer not as the in-carnation of evil, but as a handsome knight, whose vanity and pride have brought about his fall. As with *The Wedding of Psyche*, there is no sense of violent movement, rather a slow, stately procession. Once again, the faces of Lucifer and his knights are expressionless; they move as if hypnotized. Round the edge Burne-Jones set a wide gold border with a Latin inscription. The picture did not sell, and remained in the studio. Burne-Jones said to Rooke that 'people didn't know how to take it because they thought it was different to my usual things'.

1896 was to be a bad year for deaths; it carried off both Leighton and Millais, who became President of the Royal Academy for

Above: **The Wedding of Psyche**, *1894–5.*
A very late painting, based on the 'Cupid and Psyche' story, the series painted for George Howard in the 1870s. This picture was shown at the New Gallery in 1895, and is a fine example of his late style; 'pictured abstractions', Henry James called them.

Opposite: **The Fall of Lucifer**, *1894.*
This design originated with the mosaics for the American Church in Rome. It was unused, but Burne-Jones turned it into a picture in 1894, and exhibited it at the New Gallery. The figure of Lucifer is very similar to the St George, finished in 1898.

only a few months. Then, in October, came the death that Burne-Jones dreaded most – that of William Morris. They had known since the beginning of the year that his health was failing. Burne-Jones noticed at one of their Sunday breakfasts,

> Morris began leaning his forehead on his hand, as he does so often now. It is a thing I have never seen him do before in all the years that I have known him.

His condition deteriorated rapidly, and he died peacefully on 3 October. Burne-Jones wrote, 'I am alone now, quite, quite.' He had lost not only his greatest friend, but his greatest artistic collaborator, his partner and his inspiration. 'The things that in thought are most of me, most dear and necessary,' he wrote, 'are dear and necessary to no one except Morris only.'

Like everyone who attended it, Burne-Jones was deeply moved by the funeral, which took place in the tiny churchyard at Kelmscott. The simple coffin was carried to the church by a horse and cart, garlanded with willows and country flowers. A few days later, Burne-Jones wrote:

> The burial was as sweet and touching as those others were foolish – and the little waggon with its floor of moss and willow branches broke one's heart it was so beautiful – and of course there were no kings there – the king was being buried and there were no others left.

Observers wrote of Burne-Jones looking tall, grey-haired, and 'like St George'. He and Georgiana consoled themselves by reading Gilchrist's *Life of Blake*, because they felt Blake and Morris resembled each other 'in their splendid simplicity above all'.

At the time of Morris's death, Burne-Jones was working on two windows for St Cuthbert's Church in Newcastle. The subjects were *David Lamenting* and *David Consoled*. The mood of both windows is

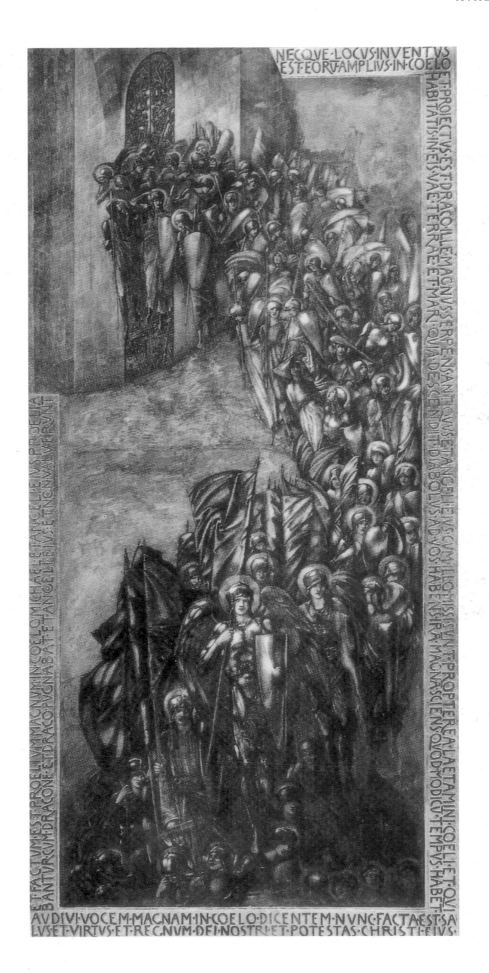

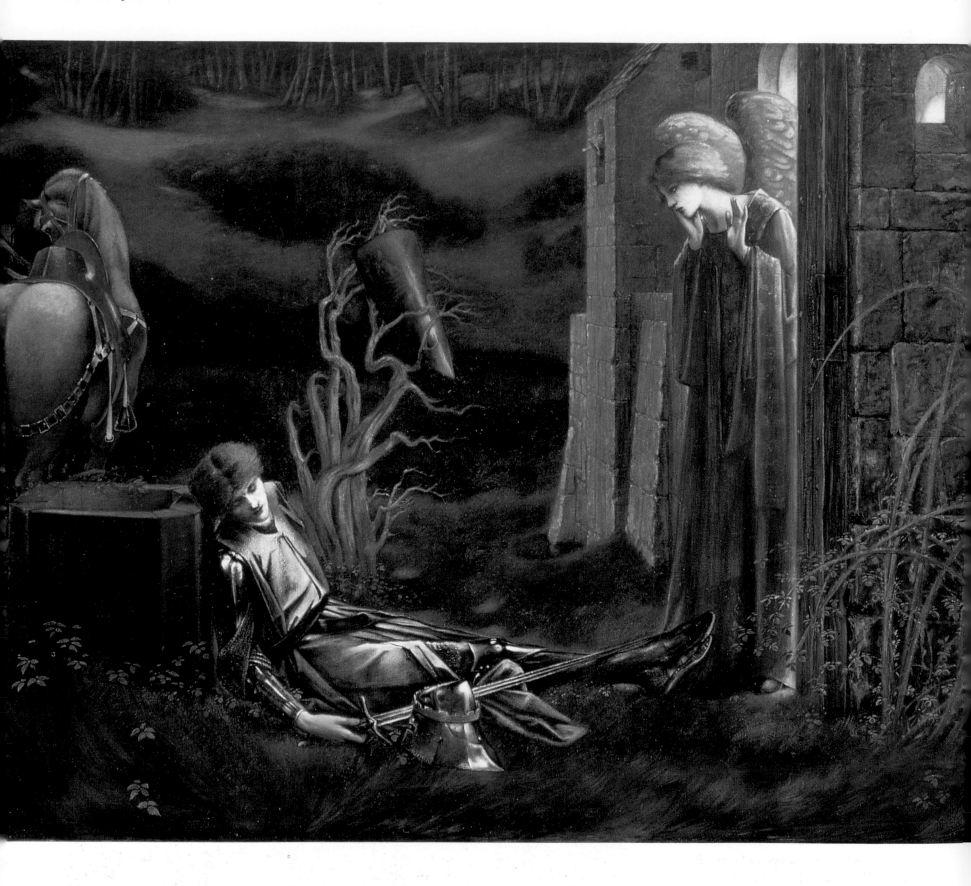

intensely emotional, and Burne-Jones seems to have instilled into them some of his feelings of loss over Morris's death. A friend remarked, 'How strange that there should have been those to do now.' 'I picked them out,' replied Burne-Jones. Also in 1896, he finished the cartoons for what is generally considered his finest window, *The Last Judgement* in St Philip's Cathedral, Birmingham. This is a classical building, and Burne-Jones's window is a single arched shape, with none of the usual gothic mullions or tracery. The design is monumentally simple, with the people below, the angel blowing a trumpet, and Christ in Glory, with angels above. The colours are brilliant, with dazzling reds and yellows. Another great window of these late years was *The Nativity*, designed for the Gladstone family at Hawarden in Flintshire, to commemorate the great man. This is a four-set window, across which Burne-Jones has spread the whole design. He supervised the colours himself, at Merton Abbey, and it is one of his most delicate and successful designs. By this time Burne-Jones had completely mastered stained-glass design. His designs are clear and the narratives simple; the windows are held together by strong, linear rhythms, and by his very subtle sense of colour. After his death, Morris & Co.'s glass immediately declined, but they went on using his designs until the Firm's closure in 1940.

Burne-Jones's reaction to Morris's death was to throw himself feverishly into yet

Opposite: **The Dream of Launcelot at the Chapel of the Holy Grail**, *1896. Launcelot is told by the angel that he will never achieve the Grail because of his adultery with Guinevere. This was the subject of one of the* Holy Grail *tapestries,* The Failure of Sir Launcelot, *and of one of Rossetti's murals in the Oxford Union. Burne-Jones himself had sat to Rossetti for his figure of Launcelot.*
Right: **The Last Judgement**, *1896. One of the greatest of Burne-Jones's late windows. It is the last in a set of four, designed for St Philip's Cathedral, Birmingham.*

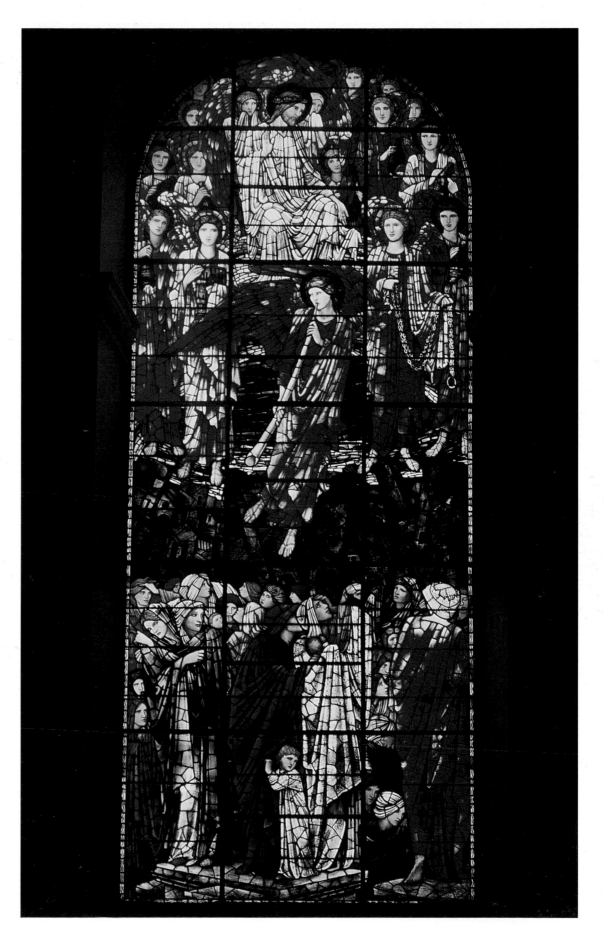

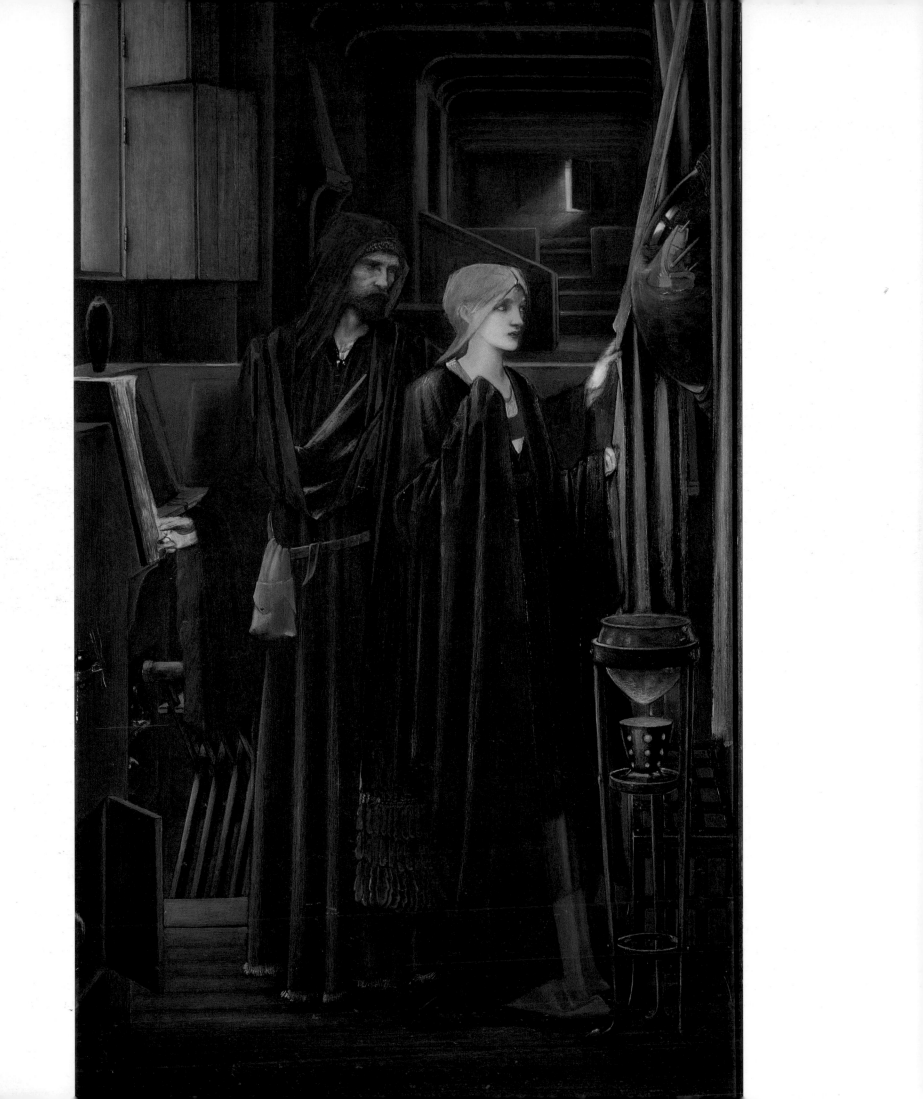

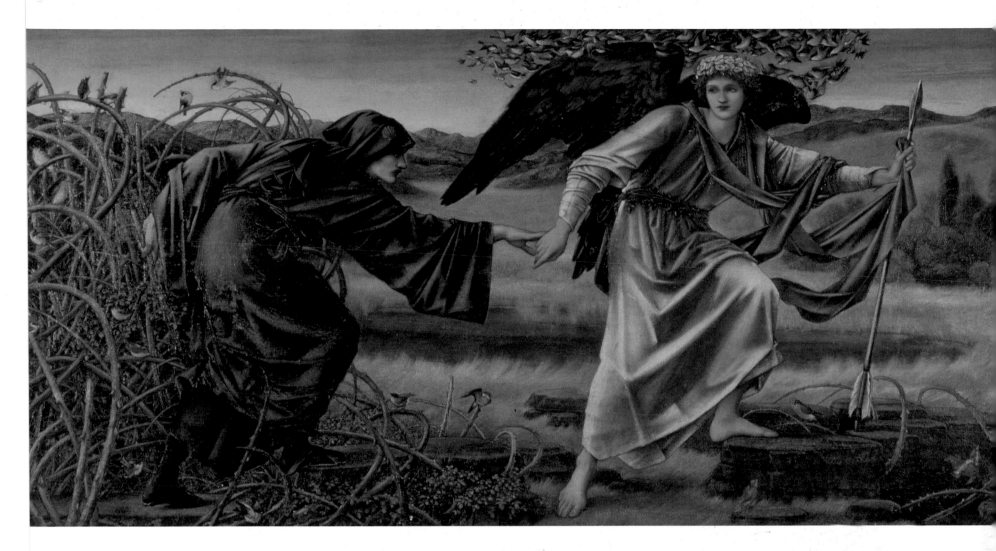

Opposite: **The Wizard** *1896–8 An unfinished picture, and thought to be a self-portrait of the old wizard himself, conjuring up dreams in his own artistic laboratory. Burne-Jones intended it to be his homage to Van Eyck's Arnolfini portrait.*

Above: **Love and the Pilgrim,** *1896–7. We know from Rooke's conversations that Burne-Jones agonized endlessly over* Love and the Pilgrim *during 1895–6. He had particular trouble with the robins around the head of Love, and eventually declared 'Damn the robins – we'll have 'em out'. But they stayed in. 'Damn the thorns,' he also said, 'they're much worse than the robins.'*

more work. He set about completing what was to be one of his last major pictures, *Love and the Pilgrim*, and dedicated it to his friend Swinburne. At the New Gallery in 1896, he showed two pictures, *Aurora* and *The Dream of Launcelot. Aurora*, an allegori-

cal figure with a river and buildings, was the more popular of the two, but Burne-Jones preferred the *Launcelot.* It was large and dark, showing Launcelot asleep outside the Chapel of the Holy Grail, which he may not enter. Rossetti had painted the subject years ago as one of the Oxford Union murals, and Burne-Jones's picture is a recollection of it. According to Georgiana 'the two compositions have much in common'. Burne-Jones had already treated the subject in one of the *Holy Grail* tapestries. The *Times* critic observed of the exhibition that

there is little else in the Gallery that in any way suggests Sir Edward Burne-Jones or his influence; a curious contrast with the days, not so many years ago, when here or at the Grosvenor one used to see his followers and Rossetti's on every wall.

Burne-Jones was still immensely respected, but the art of the 1890s was moving in other directions. He knew this, but it made him more determined than ever to follow his own path. He disliked most modern art; visiting the National Gallery, he contrasted the pictures there – 'it was song after song – the pictures all sang ...' whereas at a modern exhibition it was 'bellow upon bellow, scream upon scream'. The decadence of the 1890s also appalled him, particularly Aubrey Beardsley's lurid illustrations to his beloved *Morte d'Arthur.* Paradoxically, Beardsley had been both an admirer and a friend of Burne-Jones, who had helped and encouraged him at the outset of his career. Burne-Jones had a good sense of humour and he would probably have enjoyed *Monty Python and the Holy Grail*; but Beardsley he could not stand. To

that I have begun, if I might live and clear it all away, and dedicate the last years to that tale – if only I might.

To this end, the picture was moved yet again, this time to 9 St Paul's Studios in Hammersmith. Here he was able to work on it uninterruptedly, and reported to Rooke, 'Do you know I think this picture is beginning to go a little. Just a little, little bit it's beginning to advance.' So absorbed was he that he would write letters from the studio, headed simply 'Avalon'. To his wife he wrote, 'I am at Avalon – not yet in Avalon.' Dream and reality had become one. This was his own quest for the Holy Grail. So identified had he become with King Arthur that he generally slept in the same pose as Arthur in the picture. Of course, the figure of King Arthur is Burne-Jones himself, defiantly dreaming to the end. *The Last Sleep of Edward Burne-Jones* could well have been the title; art and life, life and death, had all become one.

At last, Burne-Jones felt happy with the composition, and was able to concentrate on the details. He decided to change some of the rocks into grassy mounds, and darken the water. 'I shan't want any small brushes today,' he said to Rooke, 'only thumpers and whackers.' He decided to fill the whole foreground of the picture with a carpet of flowers. Much of this work was done together with Rooke. All through the summer of 1898 the studio was full of irises, columbines and forget-me-nots, and Georgiana noted that Burne-Jones was at last happy with his work; 'a very pleasant effect was coming over the picture'.

Finally, in early June, the flowers were all finished. Among his many visitors to the studio was his old friend Charles Edward Hallé, painter and co-founder of the Grosvenor Gallery. Hallé stayed to dinner, and afterwards he and Burne-Jones talked for a long time. 'It was like a summing up of his whole life,' Hallé wrote, 'and as we sat in the dusk, his white face and the solemnity of his voice gave me a feeling of awe.'

On 16 June Burne-Jones spent most of the day working on *Avalon*. In the afternoon, visitors called, one of whom asked if

Above: **The Battle of Flodden** *1882 A design for a bronze relief, commissioned by George Howard. Burne-Jones wrote in his work-list for 1882 'Designed a panel of Flodden Battle, to be worked out by Boehm.'*
Left: *Edward Burne-Jones with his grandchildren, Denis and Angela.*

he did not get tired of working. 'No, never,' he replied, 'I only get tired when I am doing nothing.' He said of old friends,

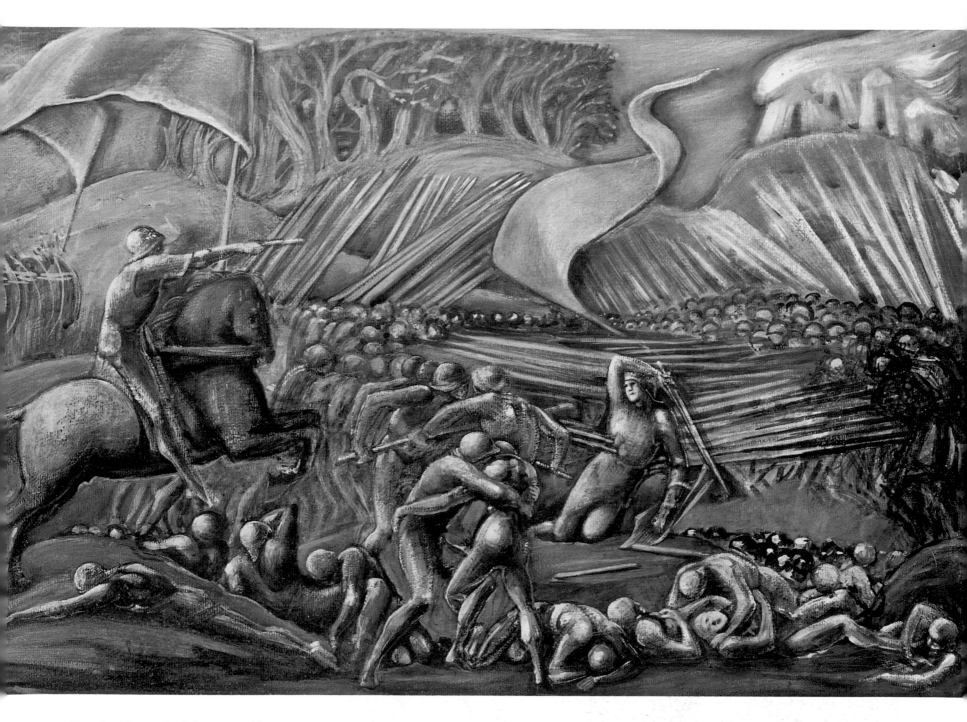

How I wish people did not get old. How I wish they could live new lives ...Yes, I should like to paint and paint for seventeen thousand years ...Why seventeen? Why not seventy thousand years?

By the next day, he was dead.

He spent his last evening alone with Georgiana. On the final page of the *Memorials* she wrote:

A speaking-tube connected Edward's room with mine, and in the night he called me and I went to him. Full and round as ever was the voice in which he spoke, splendid was his strength and courage against mortal pain, but a stronger than he was there, and the first severe shock of *angina pectoris* took his life.

Like Morris, Burne-Jones did not want pomp and circumstance at his funeral. He was cremated, and his ashes interred in the churchyard at Rottingdean, near windows designed by him and Morris. He and Georgiana had chosen the spot long before, as it was visible from the windows of North End House, just across from the village green. On 23 June, a memorial service was held in Westminster Abbey, the first ever held there for an artist. That winter, a memorial exhibition was held at the New Gallery. There was to be no major exhibition of his work again until 1975.

CHAPTER TEN

BURNE-JONES AND HIS INFLUENCE

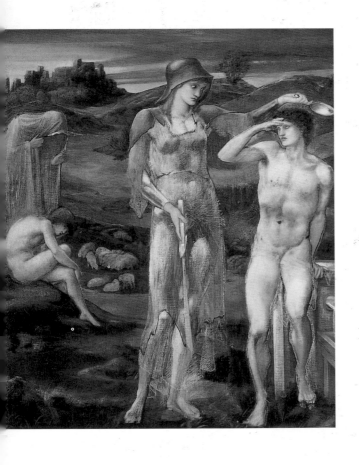

Inevitably, Burne-Jones's pictures were to suffer from the strong reaction against Victorian art, and particularly the Pre-Raphaelites, in the twentieth century. Even in the 1890s, he knew his star was on the wane. 'The rage for me is over for the time,' he said to Rooke. 'I must be prepared for public weariness about me ... I've had a good innings.' Although Burne-Jones was always helpful to younger artists, such as Beardsley, he disliked most of the new art of the 1890s. Impressionism he found too mundane and uninspiring, and in any case, he was never interested in landscape as a subject. Looking at a pretty picture of Surrey countryside, he remarked, 'I want to see hell in a landscape.' He particularly disliked the English Impressionists, such as Sickert and Steer, as they painted nothing but 'landscape and whores', rejected all literary sources, and admired Spanish painting, rather than his beloved

Left: **The Call of Perseus.** *The first of the Perseus series, in which Minerva gives Perseus a mirror in which he can look upon the Medusa.* Opposite: **Perseus and the Graiae,** *1892. Perseus, before setting out to kill the Medusa, seeks out the Graiae, or Grey Sisters, half-sisters of the Gorgons. They share one eye and one tooth between them; Perseus snatches the eye and forces them to tell him the way to the cave of the sea-nymphs, who will arm him for his quest.*

Italians. Sargent he thought a detestable painter: 'An age that makes Sargent its ideal painter what can one say of it?' Burne-Jones's influence may have been on the wane in the 1890s, but he was still an enormously respected figure, both in England, and on the Continent. He was such a towering figure that you had to be for him or against him. Even before his success at the Grosvenor, he was

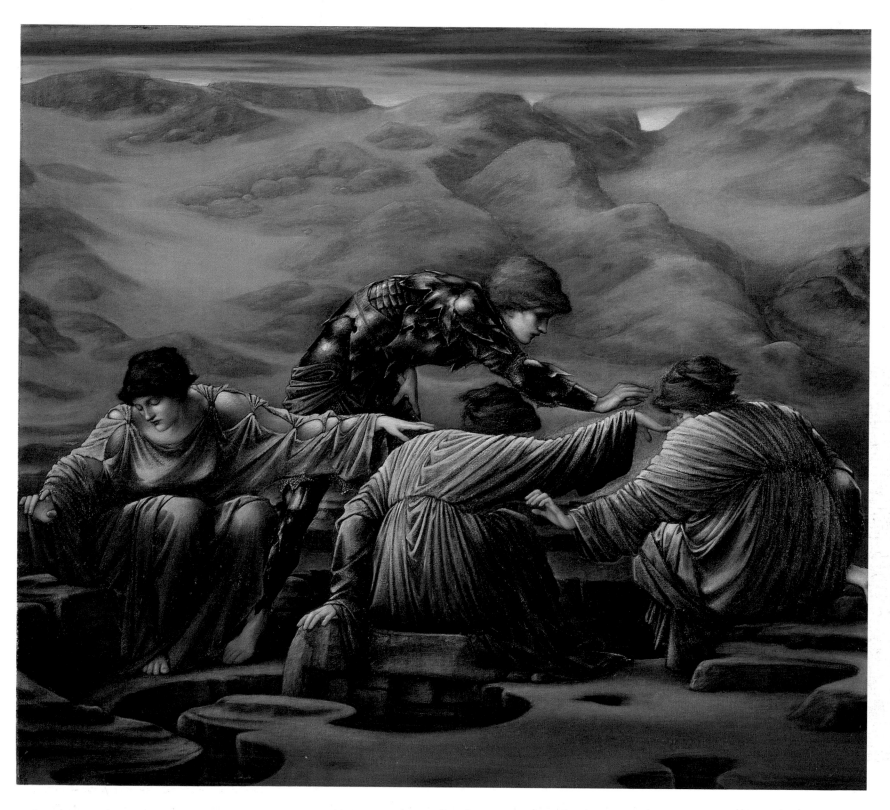

influencing younger artists, such as Simeon Solomon, Henry Holiday and Albert Joseph Moore. After the Grosvenor triumph of 1877, he attracted a whole galaxy of followers and imitators, including the three studio assistants – Fairfax Murray, T. M. Rooke and J. M. Strudwick. Other followers at the Grosvenor included C.E. Hallé, Spencer Stanhope and his niece, Evelyn de Morgan, Henry Holiday, Walter Crane and Thomas Armstrong. Casting the net wider, there are a large number of late Victorian artists in whose work the influence of Burne-Jones can be detected, in terms of both style and Romantic subject-matter, such as J. W. Waterhouse, Herbert Draper, Frank Dicksee, E. R. Frampton, J. D. Batten, Byam Shaw, Eleanor Fortescue-Brickdale, T.

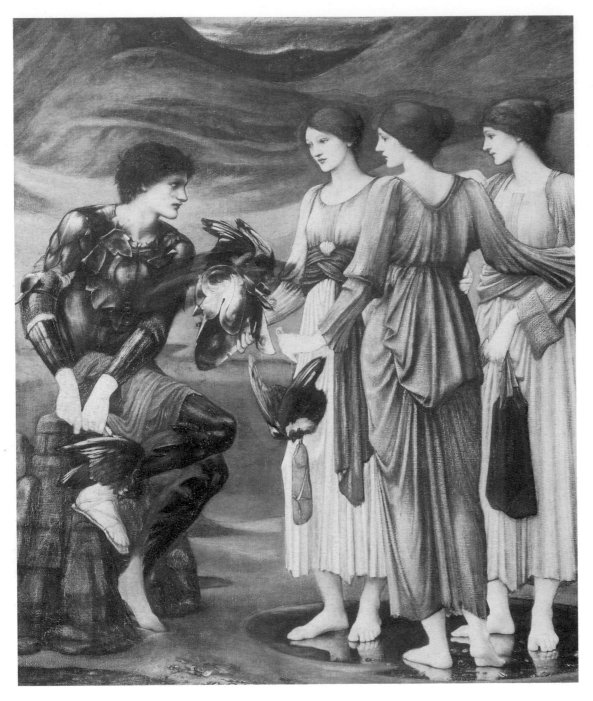

guished, even in the 1920s and 1930s. Frank Cadogan Cowper, for example, went on doggedly painting knights, damsels and *belles dames sans merci* into the 1920s, and beyond. Pre-Raphaelite influence is also detectable in the early work of Paul Nash and Stanley Spencer.

Burne-Jones was also President of the Royal Society of Birmingham Artists, and his influence can be detected in the work of many Birmingham artists, such as Sidney Harold Meteyard and Kate Bunce. J. E. Southall, and other members of the Tempera Society, such as Arthur Gaskin, Charles Gere and Henry Payne, kept alive the twin Pre-Raphaelite ideals of romantic and poetic subjects, allied to skilled and meticulous craftsmanship.

The Kelmscott *Chaucer* had an enduring influence on both book design and book illustration well into the twentieth century, notably on the work of Charles Ricketts, Aubrey Beardsley, Jessie M. King, Cayley Robinson and Walter Crane. Designers such as Emery Walker and Cobden Sanderson carried on the Kelmscott tradition of high-quality, private press books, with beautiful bindings and illustration. The stained-glass designs of Morris and Burne-Jones had an immense influence in both the nineteenth and twentieth centuries, especially on other designers, such as Henry Holiday, Walter Crane and Louis B. Davis. In the 1880s and 1890s Morris & Co. influenced many of the designers working for the Century Guild, notably A. H. Mackmurdo, its founder, and Selwyn Image, who designed stained-glass windows for Heaton, Butler and Bayne. Alfred Gilbert, the sculptor, was also a great admirer of Burne-Jones, particularly *King Cophetua*. Gilbert's flowing, linear style owes much to Burne-Jones, as well as his choice of subjects, such as Perseus, Icarus and St George. On Gilbert's tomb of the Duke of Clarence, in St George's Chapel, the figure of St George appropriately is a portrait of Burne-Jones.

This brief survey gives some idea of the

Above: **The Arming of Perseus.** *The sea-nymphs give Perseus a helmet, which renders him invisible, the winged sandals of Hermes, and a goatskin pouch for the head of the Medusa. This is the third of the series, after* Perseus and the Graiae.

Opposite: **The Finding of the Medusa.** *The fourth picture of the series, after* The Arming of Perseus. *Perseus has found the Medusa, and approaches to kill her with the aid of his magic mirror. Her two Gorgon sisters crouch in terror.*

C. Gotch, H. M. Rheam, E. R. Hughes, Gerald Moira, W. Graham Robertson, Robert Anning Bell, Charles Shannon, and others too minor to mention. It is beyond the scope of this book to examine all these influences in detail, but those wishing to do so can read John Christian's excellent catalogue of the 'Last Romantics' exhibition, held at the Barbican Art Gallery in 1989. This exhibition made it clear that the Pre-Raphaelite flame was never totally extin-

range of Burne-Jones's influence in England. Even more interesting, and not yet fully charted, is the extent of his influence in Europe, and his place in the Symbolist Movement. So far there has been a collection of essays, *Pre-Raphaelite Art and its European Context*, edited by Susan Casteras and Alicia Faxon (1996), and the 1997 exhibition at the Tate Gallery 'The Age of Rossetti, Burne-Jones and Watts – Symbolism in Britain 1860–1910'. There is still much more work to be done in this area. The blinkered view that Pre-Raphaelitism was a purely English phenomenon is certainly out of date; it now needs to be seen in a wider European context. The recent spate of exhibitions devoted to Symbolism demonstrates that the political harmonization of Europe will be followed by cultural harmonization. English art historians have so far been slow to grasp this, out of a combination of cultural insularity, ignorance and insecurity. We have for so long been used to thinking of the English School in the nineteenth century as following the French, that it has come as a shock to realize that Rossetti, Burne-Jones and Watts were actually forerunners of European Symbolism. The influence of Pre-Raphaelitism and the Aesthetic Movement can be detected not only in the work of the Symbolists, but also in other European movements, such as Art Nouveau and Jugendstil. Symbolism, therefore, provides another interesting perspective on the Pre-Raphaelites.

During Burne-Jones's lifetime, his pictures were exhibited in many European cities. He was awarded honours in Paris in 1889, Munich in 1890, Antwerp in 1894, Dresden in 1895 and Munich again in 1897. The city where his work was best known was undoubtedly Paris. In 1878, *The Beguiling of Merlin* was shown there, at the Exposition Universelle. The French critic, Robert de la Sizeranne, author of a book about English art, wrote that 'It was an attraction to the critics, but not to the public. The painter seemed to dwell so far

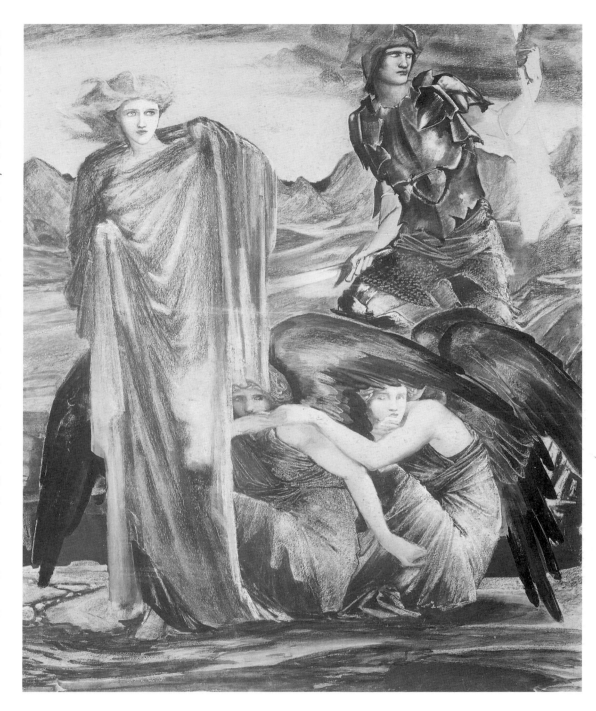

from our art and our life.' In 1882 Burne-Jones and Leighton were invited to exhibit at an international exhibition of contemporary art.

In 1889, *King Cophetua and the Beggar Maid* was exhibited in Paris, this time with much greater success. It was admired by both public and critics alike, and Burne-Jones was awarded the Légion d'Honneur. Among those who admired it was the Belgian Symbolist painter, Fernand Khnopff.

He wrote a detailed description of the picture, describing it as 'incredibly sumptuous'; the two main figures as 'isolated in their absorbed reverie'. Although there is no mention of Khnopff in the *Memorials*, he and Burne-Jones must have corresponded, and possibly met. In 1896 Khnopff gave Burne-Jones a drawing of a woman's head, which he inscribed 'To Sir Edward Burne-Jones from Fernand Khnopff'; Burne-Jones in return gave him a chalk drawing, also of a

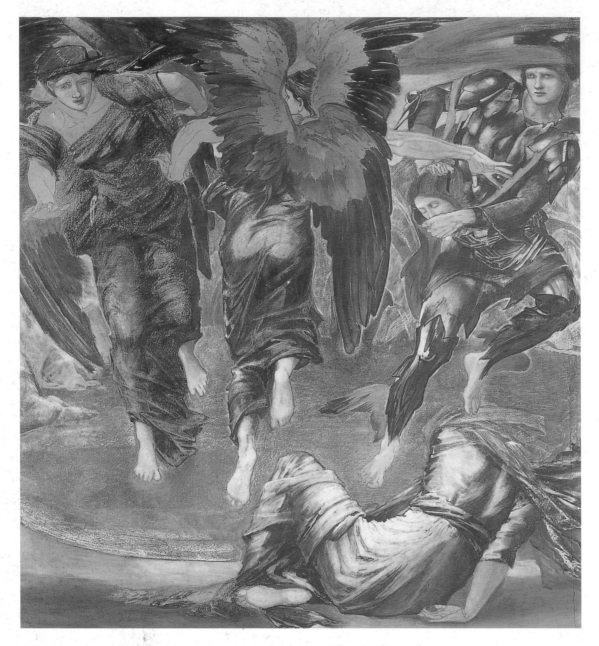

Above: **The Death of Medusa.** *Perseus has killed the Medusa, and escapes into the night with her head, which he is putting into the pouch. The two sisters circle wildly in the air, above the decapitated body of the Medusa. This was the fifth picture of the series.*

Opposite: **The Rock of Doom**, *1885–8. Perseus has escaped with the head of the Medusa, and comes to the town of Joppa, where he finds Andromeda chained to a rock. She is to be sacrificed to a sea-monster to pacify the gods, whom her mother, Cassiopeia, has offended.*

woman's head. Between the work of Burne-Jones and Khnopff there is an undoubted affinity, especially the pensive female figures of Khnopff, who stare hypnotically into space. One of these Khnopff entitled 'I lock my door upon myself', taken from the poem by Christina Rossetti.

Another artist who admired *King Cophetua* was the French painter, Puvis de Chavannes, who invited Burne-Jones to exhibit at the Champ de Mars in 1891. He sent a version of *The Wheel of Fortune*, loaned by Arthur Balfour, together with some drawings. Superficially, there is not much

similarity between the work of Burne-Jones and Puvis de Chavannes. Puvis was a painter of large, monumental pictures of peasant life, and also large allegorical murals. He was, at least, a figurative painter working in the European tradition, thus Burne-Jones felt a community of ideas between them. The artist with whom Burne-Jones should have felt far greater affinity was Gustave Moreau. Tantalizingly, there is no mention of him at all in the *Memorials*, even though he exhibited a picture at the first Grosvenor Gallery of 1877. Moreau was born in 1826 and, like both Burne-Jones and Watts, travelled in Italy. In 1864 his picture of *Oedipus and the Sphinx* caused a stir at the Paris Salon. Thereafter he pursued his own highly idiosyncratic path, eschewing Impressionism, painting figurative pictures of biblical and mythological subjects. His figures are androgynous, like those of Burne-Jones, and he developed something of a bachelor obsession with destructive females, especially Salomés and Sphinxes. No doubt Burne-Jones would have disliked the cruelty and decadence of these pictures, nor would he have liked Moreau's rather loose and murky technique. None the less, Burne-Jones and Moreau were almost exact contemporaries (both died in 1898), and belong to the same cultural phase. Stylistically and emotionally, their work may be very different, but their range of subjects is very similar. They are simply two different ends of the Symbolist spectrum.

Symbolism, like Pre-Raphaelitism, is not easy to define, as it was as much a state of mind as an actual artistic movement. What both share is a strongly literary background. Symbolism began in France as a loose association of writers and artists, who sought to promote a more literary, spiritual and mystical form of art, in opposition to Impressionism and Realism. The term was first used by a French poet and critic, Jean Moréas, writing in *Le Figaro* in 1886 about the decadent poets. Among the French writers involved with the movement were

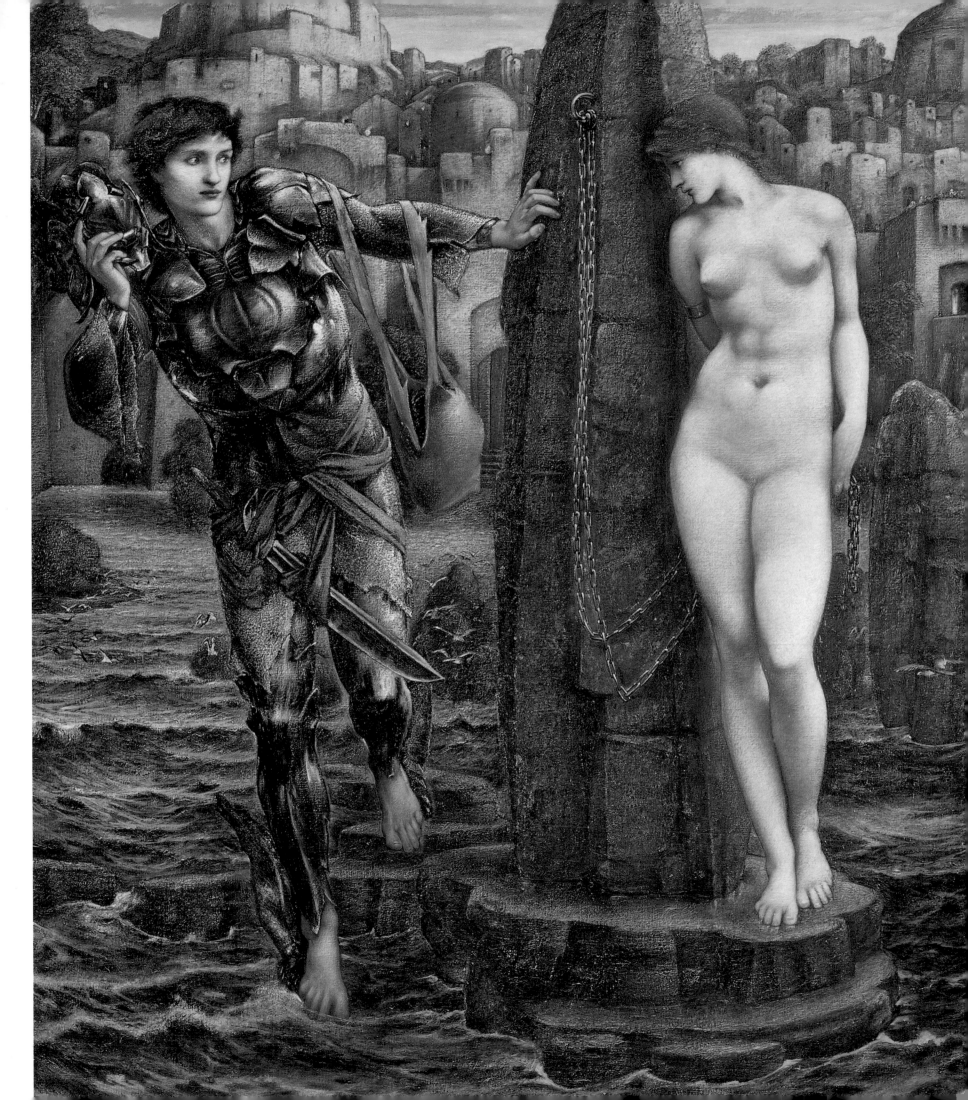

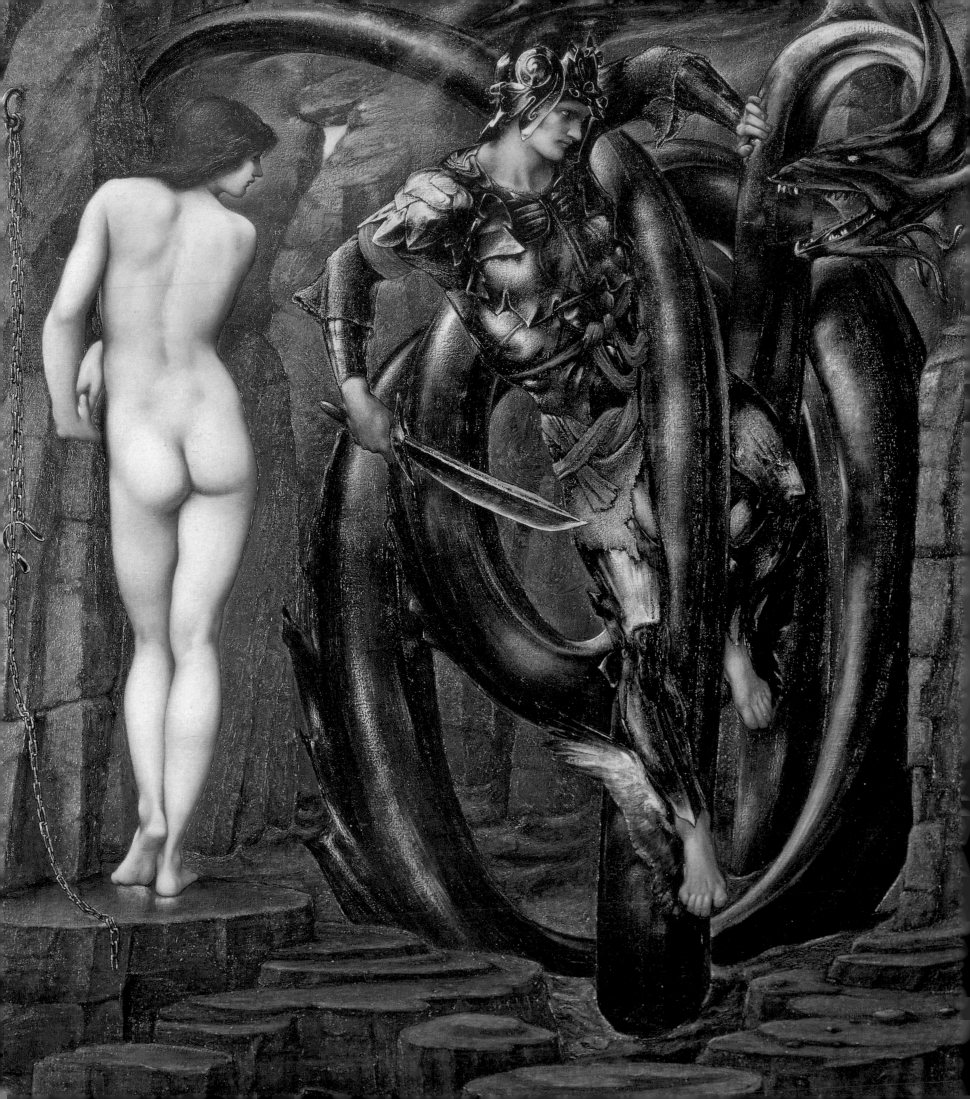

Mallarmé, Apollinaire, Gustave Kahn, Maurice Barrès, Jean Lorrain, Verlaine, and the novelist J. K. Huysmans, author of the most celebrated decadent novel of the 1890s, *A Rebours*. They regarded Baudelaire and Théophile Gautier as their spiritual forebears. Oscar Wilde provided a link between England and France; he was often in Paris, and knew most of the Symbolist writers. Among the painters now perceived as belonging to the group were Gustave Moreau, Odilon Redon and Fernand Khnopff. Symbolist ideas quickly spread to Belgium and Holland, and thence across Europe, even to Russia. Many artists who later went on to do other things were influenced by Symbolism in the 1890s, including Gauguin and the Pont-Aven painters, the Nabis, Rodin, Ferdinand Hodler, Eduard Munch, even the young Picasso. Both the abstract painters Mondrian and Kandinsky went through phases of Symbolism in the 1890s.

How much Burne-Jones knew the work of these Symbolists we can only guess. We know that he knew of both Puvis de Chavannes and Khnopff, yet neither of them is mentioned in the *Memorials* or the conversations with T. M. Rooke. One writer he did like was the Belgian playwright and poet, Maurice Maeterlinck. In 1897 Burne-Jones said to Rooke, 'Have you read anything of Maeterlinck's? People say his work is like mine, and I wonder what it is makes them say so. I like it very much; it's such beautiful poetry.' Certainly Burne-Jones might have been the ideal artist to design Maeterlinck's play *Pelleas et Melisande*. The chivalric themes and wistful nostalgia of Maeterlinck's work are indeed similar to the mood of Burne-Jones. Here was a Symbolist he could approve of.

Although Burne-Jones may have known little about the Symbolists, and cared less, there is no doubt that the Symbolists felt a sense of brotherhood with the Pre-Raphaelites. Of this there is concrete evidence, and many artists throughout Europe

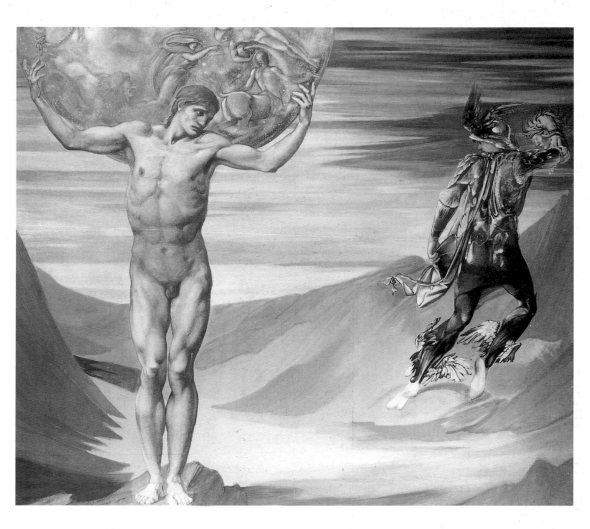

Opposite: **The Doom Fulfilled**, *1888. Perseus slays the sea monster. Originally this and* The Rock of Doom *were conceived as one picture.*
Above: **Atlas Turned to Stone**, *c. 1876. Another of the unused* Perseus *cartoons from the Balfour set.*

knew both Rossetti and Burne-Jones's work through photographic reproductions. From 1892 to 1897 the Symbolists organized a series of annual exhibitions, to which they gave the Rosicrucian title of the Salon de la Rose-Croix. The organizer and instigator of these exhibitions was an eccentric critic and novelist, Joseph Peladan, whom many regarded as a self-publicist and *poseur*. He drew up a series of rules, or guidelines, for the exhibitors. One of these read

The Order favours first the Catholic ideal and Mysticism. After Legend, Myth, Allegory and Dream, the Paraphrase of great poetry

and finally all Lyricism, the Order prefers work which has a mural-like character, as being of superior essence

The manifesto also stated, 'We will go to London to invite Burne-Jones, Watts and five other Pre-Raphaelites.' Burne-Jones received an invitation, but was put off by its tone. He wrote to Watts:

I don't know about the Salon of the Rose-Cross – a funny high fallutin' sort of pamphlet has reached me – a letter asking me to exhibit there, but I feel suspicious of it – it was so silly a piece of mouthing that I was ashamed of it – and I have had a letter from Paris a day or two back warning me in a friendly way against the thing ... at any rate I shall not [exhibit] at once ... but will make further enquiries and tell thee, my dear – the pamphlet was disgracefully silly, but I was in

149

the mood you are in, at first, to help anything that upholds the ideals I care for ... Do you know Puvis de Chavannes? Who has lifted the same banner.

This interesting letter reveals that Burne-Jones was not opposed to the ideals of the Symbolists. Legend, Myth, Allegory, Dream, Poetry – these are all key elements in his own art. Burne-Jones's definitions of painting, 'a beautiful romantic dream', or 'a reflection of a reflection of something purely imaginary', sound like phrases out of a Symbolist manifesto. Sleep and dreams were Burne-Jones's forte; the *Briar Rose* and *The Last Sleep of Arthur in Avalon* are two of the most outstanding hymns to sleep of the nineteenth century. His languorous and androgynous figures, sleeping or dreaming of lost bliss, are also typical of Symbolism. Burne-Jones's refusal had more to do with shunning the most extreme exponents of Symbolism; he also disliked their pretensions and high-flown language. He was not alone in distrusting Peladan; neither Moreau, Redon nor Puvis de Chavannes would exhibit at the Rose-Croix. Like them, Burne-Jones and Watts were established artists of the older generation, and inclined to be cautious.

There were many artists among the Symbolists whose work Burne-Jones might have liked, and with whom he might have sympathized, such as Khnopff, but also Carlos Schwabe, Levy-Dhurmer, Armand Point, Jean Delville, Georges de Feure and Aman-Jean. His fastidious spirit recoiled in horror from the decadence and near-pornography of Beardsley. He would have been equally horrified by the grotesque and macabre visions of some of the more extreme Symbolists, such as Odilon Redon, James Ensor, Jan Toorop, Felicien Rops, Max Klinger, Gustav Klimt or Frans von Stuck. In the hands of these artists, the chivalric dreams of the Pre-Raphaelites turned into nightmares, full of monsters, chimeras, gorgons, vampires and witches. The wistful

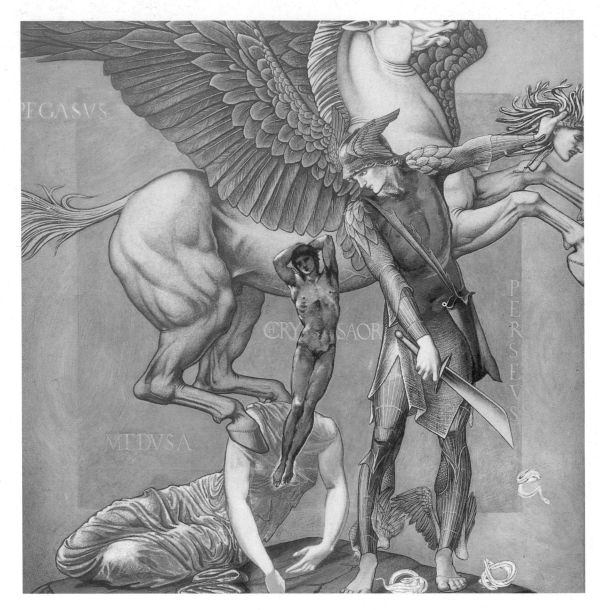

Beatrices, Ophelias, Ladies of Shalott and *Belles Dames sans Merci* of Pre-Raphaelitism had turned into the terrifying and devouring females of Symbolism – Salomés, Sphinxes, Sirens, Medusas. Rossetti's voluptuous vamps were clearly the ancestors of these Symbolist *femmes fatales*. Burne-Jones comes closest to the Symbolists in the *Perseus* series, especially the cartoons, and the scenes of the Medusa. These have a much more nightmarish and surreal feeling than any of his other work. They anticipate *Star Wars* and the world of science fiction. But the difference between Burne-Jones and the Symbolists is one of degree, not of type. There are a great many

Above: **The Birth of Pegasus and Chrysaor: The Death of Medusa I**,
c. 1876. This was one of the two unused cartoons.
Opposite: **The Baleful Head**, *1886–7.*
Perseus shows Andromeda the head of the Medusa in the reflection of a well. This is one of the four finished pictures of the Perseus series of eight, now in Stuttgart.

Symbolist elements in Burne-Jones's art, yet it would be wrong to classify him purely as a Symbolist. His art combines many elements – Pre-Raphaelite, Aesthetic, Classical and Italianate as well as Symbolist. Seen from an English standpoint, he is a Pre-

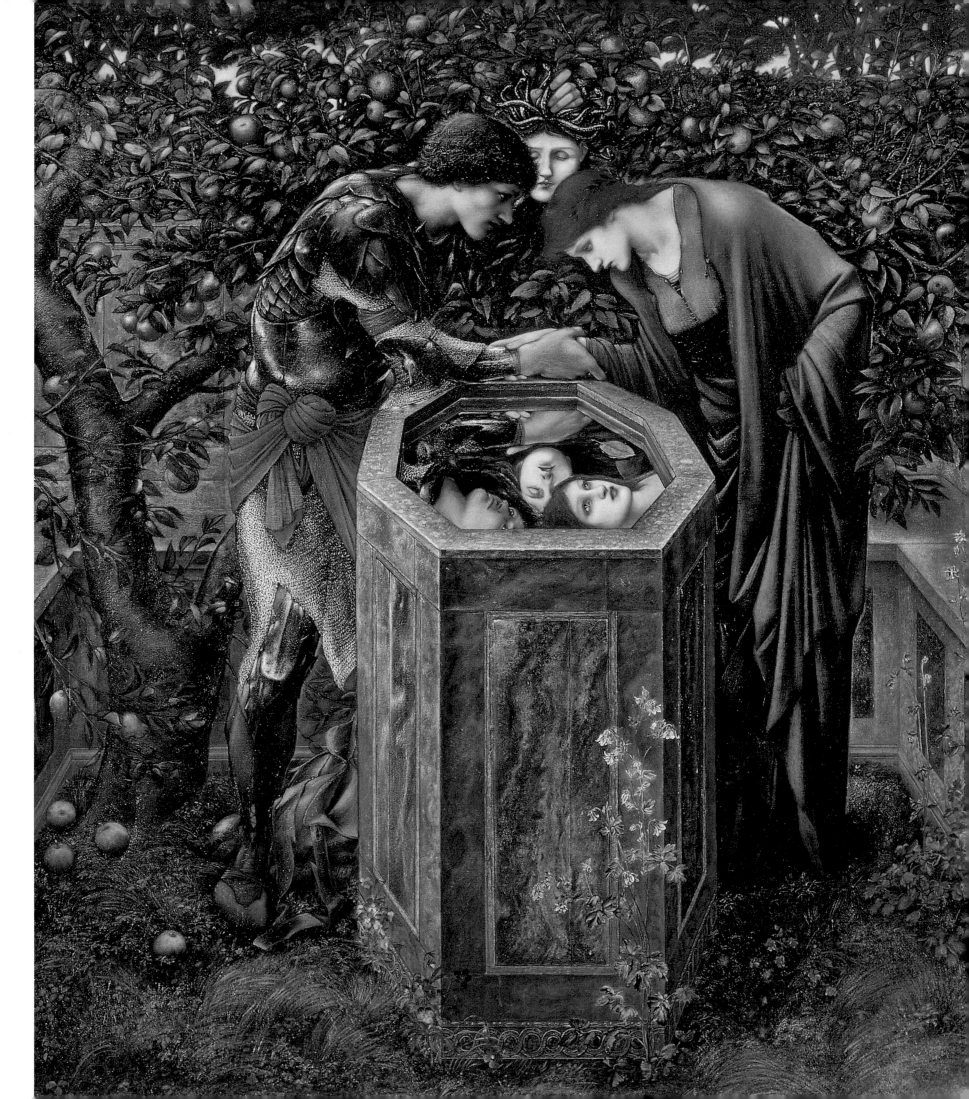

Raphaelite. He certainly thought of himself as a Pre-Raphaelite, to the end of his life. Seen from the European standpoint, he is now being claimed for Symbolism. The truth is that he is all these things, which is what makes his art so complex, and so fascinating. Like all great artists, Burne-Jones transcends classification.

Another European admirer of Burne-Jones was the Grand Duke of Hesse, grandson of Queen Victoria, ardent Anglophile and admirer of William Morris and the Arts and Crafts Movement. He set up a remarkable artistic colony in Darmstadt, much of which survives as a museum. It was mainly devoted to the decorative arts, and lasted until the First World War. Several of the artists involved with it went on to work in the Bauhaus. The Grand Duke furnished a room in his castle at Darmstadt in the Arts and Crafts style, and purchased an 1890s version of Burne-Jones's *St George*. This formed the centrepiece of the room, where it must have been seen by many German and Austrian artists. This establishes a definite link between Burne-Jones, Jugendstil and the Vienna Secession, even though this only opened in the year of Burne-Jones's death. A German art historian, Richard Muther, wrote a history of European art in the 1890s, in which he described 'the great four-leaf clover of modern Idealism' as the works of Böcklin, Moreau, Puvis de Chavannes and Burne-Jones.

In addition to exhibitions of Burne-Jones's work in Europe, it is important to remember to what extent photographs of his work were circulating. This was a new phenomenon, and very much a feature of the late nineteenth century. Very high-quality photographs of Burne-Jones's pictures and drawings were produced by Frederick Hollyer, and these found their way into the hands of artists, writers, collectors, dealers and art enthusiasts all over Europe. We know, for example, that the French writer Jean Lorrain sent Maurice Barrès photographic reproductions of

Burne-Jones and Rossetti, which he hung on his staircase. The dandy and Aesthete Robert de Montesquiou had albums full of such photographs. Linley Sambourne, a *Punch* cartoonist, whose house in Stafford Terrace, Kensington, is now a museum, lined his walls with reproductions of pictures by a wide range of European artists. He bought most of them from Goupil & Co., the French art dealers who also had a branch in London. By this means artistic ideas and styles were disseminated all over Europe. It is therefore by no means an excessive claim to see Burne-Jones as a forerunner not only of Symbolism, but also of Art Nouveau and Jugendstil. Both of the latter movements were chiefly concerned with the decorative arts, but Burne-Jones was after all both a painter and a designer. As Morris's chief designer and artistic collaborator, Burne-Jones is one of the antecedents of the design movements of the twentieth century.

Another potent force in the spread of artistic and design ideas all over Europe was the art magazine. The *Gazette des Beaux Arts*, the best of the French ones, devoted an article to Rossetti and Burne-Jones as early as 1883. The most influential of the English magazines was *The Studio*, founded in 1893. It enjoyed a wide circulation in Europe, and it is thought that the young Picasso, living in Barcelona, first saw the work of Burne-Jones in its pages. He also saw an exhibition of Burne-Jones's drawings in Barcelona, including several studies for the *Briar Rose* series. Picasso's picture of 1904, *Woman Ironing*, has distinct echoes of Burne-Jones, in both the angular pose and the mood of intense isolation. As a young man, Picasso had lived in Corunna, where the memorial to Sir John Moore had first aroused his interest in England. After seeing the Burne-Jones drawings in Barcelona, Picasso planned to come to London and see the work of the Pre-Raphaelites; he also wanted to see if English women really looked like the Pre-Raphaelite female image. However, he was diverted to Paris,

and the rest is modern art history.

Burne-Jones and Rossetti are also both mentioned in Kandinsky's *Concerning the Spiritual in Art*, as artists who searched for the abstract and the spiritual in art, rather than depicting mere reality, like the Impressionists. Kandinsky was trying to create a new abstract style of painting that combined both these qualities. All of this underlines the extent of Burne-Jones's international reputation in the 1890s; it also demonstrates the quite extraordinary fluidity with which artistic ideas and information were disseminated all over Europe at this period, to an extent never seen before or since. The same artistic language was being spoken in many different corners of Europe; thus there are innumerable instances of artists doing similar things in different places at the same time. The period 1890–1914 was a time of fantastic intellectual and artistic ferment, all over Europe; the old traditions of European art were coming to an end; modern art was being born. Thanks to improved communications, all the main art movements of the period were to some degree overlapping and interrelated. Some artists belonged to more than one group, or moved from one to another. Burne-Jones and the Pre-Raphaelites, as I have outlined in this chapter, were undoubtedly among the forerunners of Symbolism. They also anticipated many other movements in European art; the full extent of their involvement has yet to be charted.

The First World War was the catalyst which brought Victorian civilization to an end, and with it those time-honoured traditions of European art based on Greek sculpture and the Italian Renaissance. Modernism was triumphant, and the reputation of Burne-Jones and all his great Victorian contemporaries plummeted. The Bloomsbury critics and historians were utterly dismissive of the Pre-Raphaelites, who did not fit their preconceived notions of significant form. Roger Fry, Clive Bell, Collins Baker and R. H. Wilenski all wrote

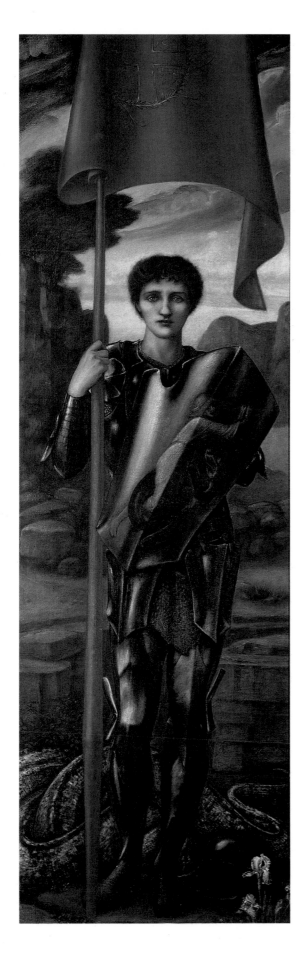

about the Pre-Raphaelites, but only to scorn and deride them. In Wilenski's *English Painting* of 1933, he describes *King Cophetua* as 'the silliest possible still-life record of two models posing in fancy dress on a heap of Wardour Street bric-à-brac'. Even art historians can be blinded by prejudice.

Nineteen thirty-three was the centenary of Burne-Jones's birth, and a small commemorative exhibition was held at the Tate Gallery. The aged T. M. Rooke contributed to the catalogue, and Stanley Baldwin, Burne-Jones's nephew by marriage, gave the opening address. Among the visitors was Burne-Jones's old friend and admirer, W. Graham Robertson. He described the opening as

> rather sad – a little crowd of forlorn old survivals paying their last homage to the beauty and poetry now utterly scorned and rejected.

Over the next twenty years, things were to get even worse. In 1943, *Love and the Pilgrim*, which had sold after Burne-Jones's death for £5,775, was sold to the Tate Gallery for under £100. After the Second World War, the tide slowly began to turn, although the prejudice against Victorian art was to linger on for many years to come. Nineteen forty-eight was the centenary of the founding of the Pre-Raphaelite Brotherhood, and several exhibitions were held. Some reviews were favourable, and Wyndham Lewis, writing in *The Listener*, was 'entranced' by Burne-Jones's *Perseus* series. He predicted that 'Burne-Jones ultimately will be valued more than any of these painters.' He also claimed him as 'a dazzlingly successful pioneer of Surrealism'. During the 1950s, the number of admirers of the Pre-Raphaelites began to grow, but they were still a tiny minority. Burne-Jones

Left: **St George**, *1898. This was the picture purchased by the Grand Duke Ernest of Hesse, and hung in his castle at Darmstadt, Germany.*

prices remained absurdly low. In 1956 the set of the four *Seasons* was sold for only £65. In 1957 the Grange was demolished to make way for a block of ugly council flats. It was not until the 1960s that the revival began in earnest. This was the decade when I, and many others of my generation, first discovered the work of Burne-Jones and the Pre-Raphaelites. We flocked enthusiastically to exhibitions of Madox Brown (1964), Millais (1967) and Holman Hunt (1969). Rossetti, perversely, had to wait until 1973, and Burne-Jones until 1975. Ironically, the swinging Sixties saw a revival of Art Nouveau, and so Burne-Jones's revival went with a cult of Aubrey Beardsley and Alphonse Mucha.

In 1972, *Laus Veneris* was sold at auction for £33,000. At the time this seemed a huge price, but now it appears an incredible bargain. Regrettably, foreign museums were quicker to appreciate Burne-Jones than our own. Hence the *Perseus* series is now in Stuttgart, and Burne-Jones's masterpiece, *The Last Sleep of Arthur*, is in Puerto Rico. In 1973, Bill Waters and Martin Harrison's lavish book on Burne-Jones was published, and A. C. Sewter's monumental survey of Morris & Co.'s stained glass. The next milestone was a major Arts Council exhibition of 1975, with a catalogue by John Christian. Even in the bleakly modernistic concrete of the Hayward Gallery, the exhibition was a great success. The *Orpheus* piano stood triumphantly in the centre of the first room. From that moment, Burne-Jones's importance, and his place in English art, were once again recognized. Now he is more admired, collected, and written about than ever. The centenary exhibitions of 1998 will finally restore him to his true position, as not only one of the greatest English artists of the nineteenth century, but also a major European figure.

SELECT BIBLIOGRAPHY

The most crucial source for Burne-Jones is the two-volume *Memorials* by his wife Georgiana, published in 1904. Also important is *Burne-Jones Talking*, a record of his conversations with T. M. Rooke, published in 1981. All the quotations from Burne-Jones's letters, diaries and conversations that I use in this book come from these two sources, unless stated otherwise.

Main Biographies:

Malcolm Bell, *Sir Edward Burne-Jones, A Record and Review* 1892

Julia Cartwright, *The Life and Work of Sir Edward Burne-Jones, Bart* Art Annual 1894

Aylmer Vallance, *The Decorative Art of Sir Edward Burne-Jones Baronet* Art Annual, 1900

O. von Schleinitz, *Burne-Jones* (Kunstler-Monographïen series) 1901

Georgian Burne-Jones (GBJ) *Memorials of Edward Burne-Jones* 2 vols 1904

T. Martin Wood, *Drawings of Sir Edward Burne-Jones* 1907

Malcolm Bell, *Sir Edward Burne-Jones*, 1907

J. Comyns Carr, *Coasting Bohemia* 1914

Sir Edward Burne-Jones, *Letters to Katie* 1925

W. Graham Robertson, *Time Was* 1931

Frances Horner, *Time Remembered* 1933

David Cecil, *Visionary and Dreamer* (Blake and Burne-Jones) 1969

M. Harrison and B. Waters, *Burne-Jones* 1973

P. Fitzgerald, *Edward Burne-Jones* 1975

Burne-Jones Talking Conversations with T.M. Rooke 1895–98, edited by Mary Lago, 1981

J. Hartnoll, *The Reproductive Engravings after E. Burne-Jones* by C. Newall and John Christian, 1988

General:

Jeremy Maas, *Victorian Painters* 1969 (repr.)

Christopher Wood, *The Pre-Raphaelites* 1981 (repr.)

Christopher Wood, *Olympian Dreamers – Victorian Classical Painters 1860–1914*, 1983

Christopher Newall, *Victorian Watercolours* 1987

Christopher Newall, *The Grosvenor Gallery Exhibitions* 1995

Exhibitions:

Sheffield Art Gallery, *Burne-Jones Exhibition* 1971

John Christian, *Catalogue of Burne-Jones Exhibition* Arts Council 1975

John Christian, *The Last Romantics* Catalogue of Exhibition at the Barbican Art Gallery, 1989

The Age of Rossetti, Burne-Jones and Watts – Symbolism in Britain 1860–1910, Catalogue of exhibition at Tate Gallery, 1997

Burne-Jones Catalogue of exhibition at the Metropolitan Museum, New York, 1998

Periodicals:

Apollo Magazine *Burne-Jones Issue*, November 1975

E. Casaretti *The Fatal Meeting* (Burne-Jones and Maria Zambaco), Antique Collector March 1989

LIST OF PLATES

and dated 'EBJ 1870', gouache, 91.5 x 45.8 cms (36 x 18 ins); Birmingham Museums and Art Gallery

pg. 35: *Cinderella (design for a tile)* 1861; pen and brown ink and wash on linen, 33.7 x 19 cm (13½ x 7½ ins); Fitzwilliam Museum, Cambridge

pg. 35: *The Madness of Sir Tristram* from 'The Story of Tristan and Isolde', stained glass window from the Music Room, Harden Grange, Near Bingley, Yorkshire, designed by Edward Burne-Jones, made by William Morris & Co.; Bradford Art Galleries and Museums/Bridgeman Art Library, London

pg. 36: *Chaucer's Dream of Good Women* 1865; signed and dated 1865, gouache, 29 x 39.5 cms (11½ x 15½ ins); Pre-Raphaelite Inc., by courtesy of Julian Hartnoll

pg. 37: *Green Summer* 1864; signed with initials and dated 1864, gouache, 29 x 48.5 cms (11 x 19 ins); Reproduced courtesy of Sotheby's

pg. 38: *A Study for Dorigen longing for the Safe Return of her Husband;* pencil on buff paper, 37 x 49.5 cms (14½ x 19½ ins); Reproduced courtesy of Sotheby's

pg. 38: *The Lament* 1864–6; inscribed EBJ 1866', watercolour and bodycolour on paper laid down on canvas,47.5 x 79.5 cms (31¼ x 18¾ ins); The William Morris Gallery, Walthamstow, London

pg. 39: *Dorigen of Bretaigne longing for the Safe Return of her Husband* 1871; signed with initials, gouache, 26.5 x 37.5 cms (10½ x 14¾ ins); Victoria & Albert Museum, London/Bridgeman Art Library, London

pg. 40: *Fair Rosamond and Queen Eleanor* 1861; gouache touched with gold, 51 x 38 cms (20 x 15 ins); Reproduced courtesy of Sotheby's

pg. 41: *Childe Roland* 1861; signed and dated 'EBJ 1861' lower left, scroll inscribed 'CHILDE ROLANDE TO THE DARK TOWER CAME', pen and ink with some grey wash, 43 x 24 cms (17 x 9½ ins); The Trustees, The Cecil Higgins Art Gallery, Bedford, England

pg. 41: *Cinderella* 1863; signed and dated 'EBJ 1863', watercolour and gouache on paper mounted on canvas, 67 x 31.5 cm (26⅜ x 12⅜ ins); Anonymous Gift in memory of Charlotte Beebe Wilbour, Courtesy, Museum of Fine Arts, Boston

pg. 42: *The Merciful Knight;* signed and dated 'EDWARD BURNE-JONES 1863', gouache, 100.3 x 69.2 cms (39½ x 27¼ ins); Birmingham Museums and Art Gallery

pg. 43: *Merlin and Nimue from 'Morte d'Arthur'* 1861; signed and dated 1861, gouache, 64 x 52 cms (25¼ x 20½ ins); Victoria & Albert Museum, London/Bridgeman Art Library, London

pg. 44: *Burne-Jones by George Howard, 9th Earl of Carlisle;* By courtesy of Julian Hartnoll

pg. 44: *The Grange, North End Road, Fulham*

pg. 45: *Two Studies of Draped Figures;* pencil; Courtesy of Peter Nahum at The Leicester Galleries

pg. 45: *Princess Sabra led to the Dragon* 1866; signed with initials and dated 1866, 118 x 108.5 cm (46½ x 42¾ ins); Reproduced courtesy of Sotheby's

pg. 46: *Princess Sabra reading in the Garden;* signed, pencil, 35 x 20 cms (13¾ x 8 ins); Courtesy of Mallett & Son (Antiques) Ltd

pg. 46: *Saint George fighting the Dragon* 1865; pencil, 35.1 x 41.6 cms (13¾ x 16¼ ins); Copyright © The British Museum

pg. 47: *Saint George and the Dragon* 1868; gouache, 61.9 x 48.4 cms (24⅜ x 19 ins);The William Morris Gallery, Walthamstow, London

pg. 48: *The Garden of the Hesperides,* 1870–3; watercolour and gouache on paper, 79 x 122 cms (31 x 48 ins); Hamburg Kunsthalle

pg. 49: *Caricature of William Morris and his wife Jane;* pencil on paper, 11.5 x 18 cms (4½ x 7 ins); Courtesy of Peter Nahum at The Leicester Galleries

pg. 50: *Venus Epithalamia* 1871; watercolour, gouache, metallic gold point, varnish on linen prepared with Chinese White; 37 x 26 cms (14½ x 10¼ ins); Courtesy of the Fogg Art Museum. Harvard University Art Museums. Bequest of Grenville L. Winthrop.

pg. 51: *Maria Zambaco;* inscribed on the paper wrapped round the arrow 'Mary Aetat XXVI August 1870 ebj pinxit' and signed again with initials lower right, gouache, 76.3 x 55 cms (30 x 21½ ins); Clemens-Sels-Museum, Neuss

pg. 52: *Study of a Woman's Head* c. 1860; red chalk, 49.5 x 23 cms (19½ x 9 ins); By courtesy of Julian Hartnoll

pg. 53: *Zephyrus and Psyche* 1865; signed, inscribed and dated on the reverse ' E. BURNE-JONES 1865/ZEPHYR & PSYCHE', watercolour and bodycolour, heightened with gum arabic, 37 x 25.5 cms (14½ x 10 ins); Private Collection, photograph courtesy of Sotheby's

pg. 54: *Study of the Head of a Girl with braided hair* 1876; initialled and dated 'EBJ 1876', pencil, 25.5 x 16.5 cms (10 x 6½ ins); Piccadilly Gallery

pg. 54: *Souls on the Banks of the River Styx* c. 1873; oil on canvas, 89.6 x 61 cms (35¼ x 28 ins); Courtesy of Peter Nahum at The Leicester Galleries

pg. 55: *The Aeneid – Iris appearing before Turnus* 1874–5; opening of Book IX, watercolour on blue ground, heightened with white, 13.5 x 14.3 cms (5¼ x 5¾ ins); Private Collection

pg. 56: *Self-Caricature by an Easel;* pencil on paper, 12 x 6.5cms (5 x 2½ ins); Courtesy of Peter Nahum at The Leicester Galleries

pg. 57: *Cupid and Psyche* 1867; inscribed 'EBJ 1867', oil on canvas, 77.5 x 92.7 cms (30_ x 36_ ins); Sheffield City Art Galleries/Bridgeman Art Library, London

pg. 58: *Cupid's Forge;* signed with initials, inscribed 'pinxit' and dated 1861, inscribed on the reverse 'painted in watercolours. October MDCCLXI', watercolour, bodycolour and gum arabic on paper laid down on linen, 32.5 x 50 cms (12¾ x 19¾ ins); Courtesy of Peter Nahum at The Leicester Galleries

pg. 59: *The Bath of Venus* 1873–1888 oil, 1.31m high x 0.46m wide; Calouste Gulbenkian Foundation, Lisbon

pg. 60: *Study for The Call of Perseus;* black and white chalk on buff paper, 48 x 32.5 cms (19½ x 13 ins);Reproduced courtesy of Sotheby's

pg. 60: *Mermaids in the Deep* 1882; inscribed on the reverse 'Study from nature at Rottingdean August 1882', coloured chalks and bodycolour, 29 x 23 cms (11½ x 9 ins); Photograph courtesy of Christie's

pg. 61: *Saint John the Baptist Preaching* 1877; design for stained glass at Monifieth Church, Nr Dundee,pencil, black and red chalks, 52.5 x 46.5 cms (20⅝ x 18⅜ ins); Courtesy of Christopher Wood Gallery

pg. 62: *The Three Graces* c. 1873; pastel, 136 x 70 cms (53½ x 27½ ins); Carlisle Art Gallery

pg. 63: *Love among the Ruins* 1893–4;

oil on canvas, 96.5 x 160 cms (38 x 63 ins) The Bearstead Collection (The National Trust) on indefinite loan to Wightwick Manor. Photograph courtesy of the National Trust Photographic Library

pg. 64: *Study for The Mirror of Venus* c. 1873; pencil, 25.3 x 17.5 cms (10 x 7 ins); Fitzwilliam Museum, Cambridge

pg. 64: *Study for Saint Cecilia;* signed 'EBJ to JR', pencil and red chalk, 35 x 16.5 cms (13¾ x 6½ ins); Private Collection, photograph courtesy of Christopher Wood Gallery

pg. 65: *The Mirror of Venus* 1867–1877; gouache, 79 x 122 cms (31 x 48 ins); Private Collection, photograph courtesy of Peter Nahum at The Leicester Galleries

pg. 66: *Vyner Memorial Window, Christ Church Cathedral, Oxford* 1872; stained glass; Photo © Woodmansterne

pg. 67: *L'Amore che Muove il Sole e l'altre Stelle;* study for needlework panel at Mells, Somerset; pencil on three sheets of paper, 213.3 x 106.7 cms (84 x 42 ins); Courtesy of Peter Nahum at The Leicester Galleries

pg. 68: *The Romaunt of the Rose;* oil, 155 x 305 cms (61½ x 120 ins); Courtesy of Christopher Wood Gallery

pg. 68: *Study of Shoes* 1877; watercolour, two drawings mounted together, 35.5 x 25.5 cms (14 x 10 ins); Private Collection

pg. 69: *Two Patrons, or Nasal Opposites Delineated;* pen and ink on writing paper, 22 x 18 cms (8¾ x 7 ins); Courtesy of Peter Nahum at The Leicester Galleries

pg. 69: *Edward Burne-Jones and William Morris;* By courtesy of the National Portrait Gallery, London

The Seasons:

pg. 70: *Spring* 1869; gouache, 122.5 x 45 cms (48¼ x 17¾ ins) pg. 71 *Summer* 1869 signed and dated EBJ MDCCCLXX, gouache, 122.5 x 45 cms (48¼ x 17¾ ins); *Autumn* 1869; gouache, 125.5 x 45 cms (49½ x 17¾ ins; *Winter* 1869; signed and dated; E BURNE-JONES MDCCCLXX, gouache, 122.5 x 45 cms (48¼ x 17¾ ins); Private Collection, photograph courtesy of the Piccadilly Gallery

pg. 72: *Study of the Head of Nimue* 1870 signed with initials, dated 1870, inscribed 'EB-J study for NIMUE in the picture of MERLINE AND NIMUE', pencil, 16.5 x 19.5 cms (6½ x 7¾ ins); Photograph courtesy of Christie's

pg. 73: *The Beguiling of Merlin from Idylls of the King by Alfred Tennyson (1809–92)* 1870–74; oil, 183 x 109 cms (72 x 43 ins); Lady Lever Art Gallery, Port Sunlight/ Bridgeman Art Library, London

pg. 74: *Study of the Head and Hair of Nimue, for Merlin and Nimue;* pencil on white paper, 18 x 25 cms (7 x 10 ins); Courtesy of Christopher Wood Gallery

pg. 74: *The Grosvenor Gallery* interior of the West Gallery, 1877, from *London Illustrated News*

pg. 75: *Study of the Head of an Angel* 1879 initialled and dated 'EBJ - 1879', pencil, 20.3 x 16.5 cms (8 x 6½ ins); Courtesy of Christopher Wood Gallery

pg. 76: *A Bathing Beauty;* pencil on paper, 17.5 x 11.5 cms (7 x 4¾ ins); Courtesy of Peter Nahum at The Leicester Galleries

pg. 76: *Study of Fanny Cornforth for Laus Veneris;* pencil, 26.5 x 36 cms (10½ x 14⅛ ins); Photograph courtesy of Christie's

pg. 76: *The Price of Success – Artist and Fat Lady;* pen and ink, 11.4 x 17.7 cms (4½ x 7 ins);

Copyright © The British Museum

pg. 77: *Laus Veneris;* signed and dated 'E. BURNE-JONES 1873–5' (but not completed until 1878); oil, 122 x 183 cms (47 x 71 ins); Laing Art Gallery, Newcastle upon Tyne, England (Tyne & Wear Museums)

pg. 78: *Chant d'Amour* 1868–1873; oil on canvas, 112 x 152.5 cms (44 x 60 ins); The Metropolitan Museum of Art, New York

pg. 79: *Pan and Psyche* 1872-1874; Retouched 1878; oil on canvas, 65.09 x 53.34 cms (25⅝ x 21⅜ ins); Bequest of Grenville L. Winthrop, © President and Fellows, Harvard College, Harvard University Art Museums

pg. 80: *Georgiana Burne-Jones playing the Piano;* pencil, signed with initials and inscribed 'GBJ by EBJ', 9.5 x 9.5 cms (3⅞ x 3⅞ ins); Courtesy of Christopher Wood Gallery

pg. 80: *The Orpheus Piano* 1879–80; painted wood, height 98 cms; width 142 cms; length 260 cms (38½ x 56 x 102½ ins) made by Broadwood; Private Collection

pg. 81: *Study for Le Chant d'Amour* initialled and dated, 'EBJ 1864' and inscribed 'FOR THE CHANT D AMOUR'; pencil and colour chalks, 23.5 x 18.5 cms (9¼ x 7⅝ ins); Photograph courtesy of Christie's

The Days of Creation

pg. 82: *the First Day* c. 1870–76; watercolour, gouache, shell gold and platinum paint on linen-covered panel, 102.2 x 35.5 cms (40¼ x 14 ins); *The Second Day* c. 1870–76; watercolour, gouache, shell gold and platinum paint on linen-covered panel, 101.9 x 35.6 cms (39¾ x 13¾ ins); pg. 83: *The Third Day* c. 1870–76; watercolour, gouache, shell gold and platinum paint on linen-covered panel, 102.2 x 35.9 cms (40¼ x 13¾ ins); *The Fifth Day* c. 1870–76; watercolour, gouache, shell gold and platinum paint on linen-covered panel, 102.2 x 35.9 cms (40¼ x 13¾ ins); Bequest of Grenville L. Winthrop, © President and Fellows, Harvard College, Harvard University Art Museums

pg. 84: *The Annunciation;* signed '18 EBJ 79', 250 x 104.5 cms (98½ x 41¼ ins); The Board of Trustees of the National Museums and Galleries on Merseyside (Lady Lever Art Gallery, Port Sunlight)

pg. 85: *Study for Figures in the Pygmalion Series;* By courtesy of Julian Hartnoll

pg. 85: *A Study for Adam in the Days of Creation* 1872; pencil, 25.5 cm x 18.2 cm (10 x 7½ ins); Fitzwilliam Museum, Cambridge

The Pygmalion Series 1868–70

pg. 86: *The Heart Desires;* signed and dated EB-J 1868, oil on canvas, 66 x 51 cms (26 x 20 ins); *The Hand Refrains;* signed EB-J, oil on canvas, 66 x 51 cms (26 x 20 ins); *The Godhead Fires;* signed and dated EB-J 1870, oil on canvas, 66 x 51 cms (26 x 20 ins); pg. 87 *The Soul Attains;* signed and dated EB-J 1870, oil on canvas, 66 x 51 cms (26 x 20 ins); Private Collection

pg. 88: *Study for Feet for The Golden Stairs* initialled, dated and inscribed, 'EBJ 1875 Studies of feet for the GOLDEN STAIRS'; initialled and dated 'EBJ 1878', pencil, 17.1 x 26.3 cms (6¾ x 10¼ ins); Fitzwilliam Museum, Cambridge

pg. 89: *The Golden Stairs* 1872–80; initialled and dated 'EBJ 1880', oil on canvas, 269.2 x 116.8 cms (106 x 46 ins); © Tate Gallery London

pg. 90: *Saint Mary Magdalen* 1886; signed with initials and dated 1886, pencil; Private Collection, photograph courtesy of the Maas Gallery, London

pg. 91: *Portrait of the Baronne Madeleine Deslandes* 1895–6; oil on canvas, 115.5 x 58.5 cms (45½ x 23 ins); Private Collection, courtesy of Agnew's

pg. 92: *Amy Gaskell* 1893; signed and dated 'EBJ 1893'; signed, inscribed and dated 'AMY GASKELL, 1893 painted by EDWARD BURNE-JONES and given to her Mother' on reverse, oil on canvas, 96.5 x 52 cms (38 x 20½ ins); Private Collection

pg. 93: *Portrait of Francis Jekyll;* dated, 1894; and inscribed 'EBJ to AJ' bottom right, 56 x 43 cms (22 x 17 ins); Private Collection, courtesy of Julian Hartnoll

pg. 93: *Phillip Comyns Carr* 1882; signed with monogram EBJ, inscribed with title, 'London' and 'to CAJ', dated 1882, oil on canvas, 71 x 48.5 cms (28 x 19 ins); Private Collection, photograph courtesy of Sotheby's

pg. 94: *Katie Lewis* 1886; signed with initials and inscribed lower left 'EBJ to GBL'; dated 1886 on the pages of the book, oil on canvas, 61 x 127 cms (24 x 50 ins); Courtesy of Mallett & Son (Antiques) Ltd

pg. 95: *Portrait of Georgiana* begun 1883 oil, 78.7 x 53.3 cms (31 x 21 ins); Private Collection

pg. 95: *Venetia Benson* 1890; signed with initials, inscribed and dated BV/EBJ/1890, pencil, 49.5 x 32.5 cms (19½ x 12¾ ins); Private Collection

pg. 96: *Portrait of William Graham;* chalk; Private Collection

pg. 96: *Study of an Angel for the mosaic in the American Church, Rome;* Private Collection, by courtesy of Julian Hartnoll

pg. 97: *Crucifixion* 1880s; design for a mosaic in American Episcopal Church Rome; Private Collection

pg. 98: *The Heart of the Rose* 1889; signed with initials and dated 1889, oil on canvas, 96.5 x 129.5 cms (38 x 51½ ins); Courtesy of Christopher Wood Gallery

pg. 99: The *Pilgrim at the Gate of Idleness* 1874–84; signed with initials and dated 1874 and 1884, 96.5 x 132 cms (38 x 52 ins); Courtesy of Christopher Wood Gallery

pg. 100: *Study for King Cophetua and the Beggar Maid;* pencil; By courtesy of Julian Hartnoll

pg. 100: *A study for the Slave in The Wheel of Fortune* 1879; inscribed with title, and inscribed with initials and dated 'EB-J 1879', pencil, 27.2 x 18 cms (10¾ x 7 ins); Copyright © The British Museum

pg. 101: *King Cophetua and the Beggar Maid;* inscribed 'EBJ 1884', oil on canvas, 293.4 x 135.9 cms (115½ x 53½ ins); © Tate Gallery London

pg. 102: *The Mill* 1870–1882; signed E B-J 1870 on the building on the right, oil on canvas, 90.8 x 97.5 cms (35¾ x 77¾ ins); Victoria & Albert Museum, London/Bridgeman Art Library, London

pg. 103: *Margaret Burne-Jones* 1877; inscribed 'MBJ DEC 31 – 1877', pencil; Courtesy of Christopher Wood Gallery

pg. 103: *Sibylla Delphica* 1886; signed with initials 'E.B.J.', oil on panel, 152.8 x 60.3 cms (60⅛ x 23¾ ins); © Manchester City Art Galleries

pg. 104: *Drawing on the envelope of a Letter to Katie Lewis* 1883; pen and ink, 9.5 x 12 cms (3¾ x 4¾ ins); Copyright © The British Museum

pg. 104: *The Tree of Forgiveness;* oil on canvas, 190.5 x 107 cms (75 x 42 ins); The Board of Trustees of the National Museums and Galleries on Merseyside; (Lady Lever Art Gallery, Port Sunlight)

pg. 105: *The Garden of Pan* 1886–7; initialled and dated 'EBJ 1886–7', oil on canvas, 152.5 x 186.7 cms (60 x 73½ ins); Felton Bequest, 1919, National Gallery of Victoria, Melbourne

pg. 106: *The Garden of Idleness: Love and Beauty* 1874; pencil, 89 x 118 cms (35 x 46½ ins); Private Collection

pg. 106: *Portrait of Philip Burne-Jones* (1861–1926); pencil, 23 x 28 cms (9 x 11 ins); Private Collection, photograph courtesy of the Piccadilly Gallery

pg. 107: *Danae or the Brazen Tower* 1887–8 oil, 231 x 113 cms (91 x 44½ ins); Glasgow Museums: Art Gallery & Museums, Kelvingrove

pg. 108: *A study for the Sleeping Princess in the Briar Rose series;* pencil, 24 x 32 cms (9½ x 12½ ins); Courtesy of Christopher Wood Gallery
The large Briar Rose series

pg. 109: *1. The Briar Wood* 1870–1890; oil on canvas, 122 x 249 cms (48 x 98 ins) **pg. 111:** *2. The Council Chamber* 1870–1890; oil on canvas, 122 x 239 cms (48 x 94 ins) **pg. 112** *3. The Garden Court* 1870–1890; oil on canvas,122 x 239 cms (48 x 94 ins); **pg. 113** *4. The Rose Bower* 1870–1890; oil on canvas,122 x 229 cms (48 x 90 ins); © The Faringdon Collection Trust
The small Briar Rose series

pg. 110: *The Briar Wood* 1870–73; oil, 61 x 130 cms (24 x 51 ins); **pg. 110:** *The King and his Court* 1870–73; oil, 61 x 134.5 cms (24 x 53 ins) **pg. 110:** *The Sleeping Beauty* 1870–73; oil, 61 x 117 cms (24 x 46 ins); The Museo de Arte de Ponce, The Luis A. Ferré Foundation, Inc., Ponce, Puerto Rico

pg. 112: *The Sleeping Beauty* 1871; signed 'E. Burne-Jones/ MDCCLXXI', watercolour and gold paint on vellum, 27 x 37.6 cms (10¾ x 15 ins); © Manchester City Art Galleries

pg. 114: *William Morris and Edward Burne-Jones being blessed by Chaucer* 1896; pen and ink cartoon; Location Unknown/Bridgeman Art Library, London

pg. 114: *Trial proof of first page to Prologue of Chaucer's Canterbury Tales;* printed by the Kelmscott Press 1896; e.t. archive

pg. 114: *William Morris and Edward Burne-Jones by Frederick Hollyer* (E. Walker); By courtesy of the National Portrait Gallery, London
The Holy Grail Tapestries

pg. 115: *The Knights of the Round Table summoned to the Quest by the strange Damsel;* part of a set woven for George McCulloch, 1898–99, 245 x 535 cms (96¼ x 171 ins); **pg. 116:** *The Departure of the Knights;* part of a set woven for Laurence Hodson of Compton Hall, Wolverhampton 1895–96, 244 x 363 cms (96 x 142½ ins); **pg. 117:** *The Attainment: The Vision of the Holy Grail to Sir Galahad, Sir Bors and Sir Perceval;* part of a set woven for Laurence Hodson of Compton Hall, Wolverhampton 1895–96, 245 x 693 cms (96¼ x 273 ins); **pg. 117:** *Verdure with Deer and Shields;* woven for Mrs Mary Middlemore, 1900, 156 x 319 cms (61½ x 124 ins); Birmingham Museums and Art Gallery

pgs. 118 & 119: *False Mercury and Witches' Tree from The Flower Book* 1882–1898; collotype touched with gouache, 14.5 cms diameter (6 ins diameter); Courtesy of Peter Nahum at The Leicester Galleries

pg. 120: *Study of Melchior in The Adoration of the Kings* 1887; signed with initials and dated, 'EBJ 1887', coloured chalks and heightened with gold paint on buff paper, 33 x 25.5cms (13 x

9¼ ins); Reproduced courtesy of Sotheby's

pg. 120: *Sponsa da Libano* 1891; gouache and tempera on paper, 332.5 x 155.5 cms (130½ x 61 ins); The Board of Trustees of the National Museums and Galleries on Merseyside (Walker Art Gallery, Liverpool)

pg. 121: *The Adoration of the Kings* late nineteenth-century tapestry designed by Burne-Jones, made by William Morris & Co., Merton Abbey, 264 x 396 cms (104 x 156 ins); Hermitage, St. Petersburg/Bridgeman Art Library, London

pg. 122: *William Morris at his Loom;* pencil on paper, 22.9 x 17.5 cms (9 x 6⅞ ins); The William Morris Gallery, Walthamstow, London/Bridgeman Art Library, London

pg. 122: *The Doors of Hell;* inscribed 'THE DOORS OF HELL', pencil, from a sketchbook, each page 25.5 x 19.5 cms (10 x 7¾ ins) Private Collection, courtesy of Julian Hartnoll

pg. 122: *Sir Edward Burne-Jones by Barbara Leighton;* By courtesy of the National Portrait Gallery, London

pg. 123: *The Sirens* begun in 1870s, worked on in 1891, never finished.; watercolour and gouache heightened with gum arabic, 50.5 x 69.5 cms (19¾ x 27½ ins); Private Collection

pg. 124: *Merlin and Nimue* c. 1880s; oil on panel, 33.5 x 19 cms (13½ x 7½ ins); Photograph courtesy of Agnew's

pg. 124: *Angeli Laudantes* c. 1887; Design for window in Salisbury Cathedral, also for tapestries, coloured chalks on paper, 212.8 x 154.3 cms (83¾ x 60¾ ins); Fitzwilliam Museum, University of Cambridge/Bridgeman Art Library, London

pg. 125: *Angeli Laudantes;* Tapestry designed by Henry Dearle with figures by Edward Burne-Jones, originally drawn in 1877/78, woven at Merton Abbey in 1894 by Morris and Co. Victoria & Albert Museum, London/Bridgeman Art Library, London

pg. 126: *Study for the head of a female figure in The Last Sleep of Arthur in Avalon* 1896; signed with initials, dated and inscribed 'EBJ 1896 AVALON', pencil, 12¾ x 9 ins; Courtesy of Christopher Wood Gallery

pg. 127: *The Last Sleep of Arthur in Avalon* 1881–98; oil on canvas, 282 x 570 cms (111 x 254 ins); The Museo de Arte de Ponce, The Luis A. Ferré Foundation, Inc., Ponce, Puerto Rico

pg. 128: *Photograph of an early stage of The Last Sleep of Arthur in Avalon;* The Museo de Arte de Ponce, The Luis A. Ferré Foundation, Inc., Ponce, Puerto Rico

pg. 128: *Study for The Last Sleep of Arthur in Avalon;* pastel on brown paper, 1.9 x 6.3 ft National Museum and Gallery of Wales, Cardiff

pg. 129: *North End House, Rottingdean*
pg. 129: *Cat and Kitten;* watercolour on paper laid down, 36 x 42 cms (14½ x 16½ ins); Private Collection

pg. 129: *A Dinner Party* c. 1890; watercolour, heightened with bodycolour, 27 x 19 cms (10½ x 7½ ins); Reproduced courtesy of Sotheby's

pg. 129: *A Rottingdean Venus – a scene for Tannhäuser at Bayreuth;* pen and grey ink on blue-grey writing paper, 18 x 11.5 cms (7 x 4½ ins); Photograph courtesy of Christie's

pg. 130: *Study of Frances Graham* 1877; signed with initials and dated 'EBJ 1877', pencil Piccadilly Gallery

pg. 131: *The Challenge in the Wilderness* 1874–1898; oil, 127 x 96.5 cms (50 x 38 ins);

Christie's Images/Bridgeman Art Library, London

pg. 132: *The Wedding of Psyche* 1894–5; oil on canvas, 122 x 213.5 cms (48 x 84 ins); Museés royaux des Beaux-Arts de Belgique, Bruxelles

pg. 133: *The Fall of Lucifer* 1894; signed and dated EBJ 1894, oil, 245 x 118 cms (96½ x 46½ ins); Private Collection

pg. 134: *Launcelot at the Chapel of the Holy Grail* c. 1890; signed and dated 'B-J 189?' (last figure indecipherable), oil on canvas, 138.5 x 169.8 cms (54½ x 67 ins); Southampton City Art Gallery/Bridgeman Art Library, London

pg. 135: *The Last Judgement* 1896; west window designed by Sir Edward Burne-Jones; St Phillip's Cathedral, Birmingham/Bridgeman Art Library, London

pg. 136: *The Wizard* c. 1896–8 unfinished oil, 91.5 x 54 cms (36 x 21¼ ins); Birmingham Museums and Art Gallery

pg. 137: *Love and the Pilgrim* 1896–7; inscribed 'Pted by E. Burne-Jones 1896–7 dedicated to his friend A C Swinburne'; oil on canvas, 157 x 304 cms (62 x 120 ins); © Tate Gallery London

pg. 138: *Letter with a caricature of Cleaner;* pen and ink, 18 x 22 cms (7 x 8¾ ins); Reproduced courtesy of Sotheby's

pg. 138: *The Dining Room of the Grange, Fulham,* by Philip Burne-Jones; By courtesy of Julian Hartnoll

pg. 139: *The Prioress's Tale;* signed and dated 'EBJ 1865–1898', gouache,112 x 63.5 cms (44 x 25 ins); Delaware Art Museum

pg. 140: *Edward Burne-Jones with his grandchildren, Denis and Angela;* By courtesy of the National Portrait Gallery, London

pg. 141: *The Battle of Flodden* 1882; signed with initials, gouache on brown paper, 56 x 103 cms (22 x 40½ ins); Courtesy of Peter Nahum at The Leicester Galleries
The Perseus Series

pg. 142: *The Call of Perseus* oil, 152.5 x 127 cms (59¾ x 50 ins); **pg. 143:** *Perseus and the Graiae;* signed and dated 'EBJ 1892', oil on canvas, 153.5 x 170 cms (60½ x 67 ins); **pg. 144:** *The Arming of Perseus;* oil, 153 x 127 cms (60¼ x 50 ins); **pg. 145:** *The Finding of the Medusa;* oil, 152 x 137 cms (59¾ x 54 ins); **pg. 146:** *The Death of Medusa;* oil, 152 x 137 cms (59¾ x 54 ins); **pg. 147:** *The Rock of Doom* 1885–8; oil on canvas, 155 x 130 cms (61 x 51¼ ins); **pg. 148:** *The Doom Fulfilled;* signed and dated 'EBJ 1888', oil on canvas, 155 x 140.5 cms (61 x 55¼ ins) **pg. 151:** *The Baleful Head* 1886–7oil on canvas, 155 x 130 cms (61 x 51¼ ins) Staatsgalerie, Stuttgart **pg. 149:** *Atlas Turned to Stone* c. 1876; gouache on paper laid onto linen canvas, 152.5 x 190 cms (59¾ x 74¾ ins); **pg. 150:** *The Birth of Pegasus and Chrysaor: The Death of Medusa I* c. 1876; gouache on paper laid onto linen canvas, 124 x 116 cms (48¾ x 45¾ ins); Southampton City Art Gallery/ Bridgeman Art Library, London

pg. 153: *Saint George* 1897; oil, signed with initials and dated 'EBJ 1897', 150 x 59 cms (59 x 23¼ ins); Collection Hessische Hausstiftung, Kronberg, Germany

Poetry: 'In the Orchard', p. 39; 'Rosamond', p. 39; 'Hermaphroditus', p. 40; 'Laus Veneris', p. 61, all from *Poems and Prose* by A. C. Swinburne, Everyman Library, J. M. Dent, 1940; 'Daydream'. p. 110, from *Poems* by A. Tennyson, Moxon, 1857. Extract from *The Earthly Paradise* by William Morris (p. 45) from *Poems* by William Morris, World's Classics, 1914

INDEX